W9-ACH-391

DATE DUE

AUG 2016

CHARLESTON COUNTY LIBRARY

3 2 0 3 3 6 6 5 6 0 2 6

WITHDRAWN

CHARLESTON COUNTY LIBRARY

STABLES

Beautiful Paddocks, Horse Barns, and Tack Rooms

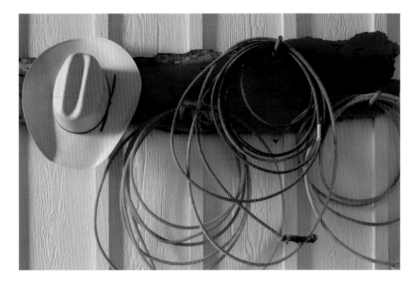

STABLES

Beautiful Paddocks, Horse Barns, and Tack Rooms

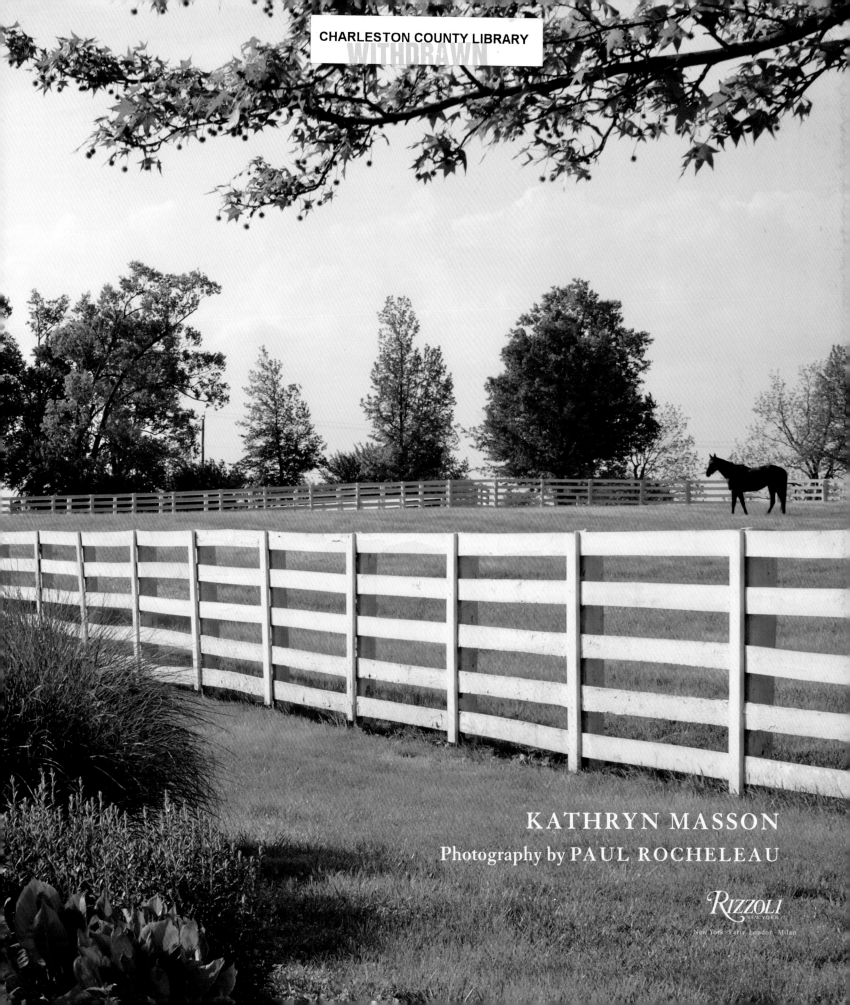

CHARLESTON COUNTY LIBRARY
WITHDRAWN

KATHRYN MASSON

Photography by PAUL ROCHELEAU

RIZZOLI
NEW YORK

New York · Paris · London · Milan

This book is dedicated with admiration to
MONTY ROBERTS AND HIS FAMILY

*for their work with horses and people for the
past forty years that has had a global impact in
spreading the message that trust, either equine
or human, is best earned by gentleness and
nonviolence. Their commitment, proven insight,
and incredible energy has truly made, and will
continue to make, the world "a better place
for horses and people, too."*

This book is also dedicated to my friend
CLEO VAN ZELST,

*who, with incredible dedication and
determination, has through the years done
the tremendous work of rescuing, caring for,
training, and loving dozens of horses.*

First published in the United States of America in 2010
by Rizzoli International Publications, Inc.
300 Park Avenue South
New York, NY 10010
www.rizzoliusa.com

© 2010 Kathryn Masson
Photographs (unless otherwise indicated) © 2010 Paul Rocheleau

All rights reserved. No part of this publication may be reproduced,
stored in a retrieval system, or transmitted in any form or by any
means, electronic, mechanical, photocopying, recording, or other-
wise, without prior consent of the publishers.

2015 2016 2017 2018 / 10 9 8 7 6 5 4

Designed by Abigail Sturges

Distributed in the U.S. trade by Random House, New York

Printed in China

ISBN-13: 978-0-8478-3314-6

Library of Congress Catalog Control Number: 2009933345

ENDPAPERS *Sagamore Farm, Glyndon, Maryland.*

PAGE 1 *A rustic hat and rope rack in a Texas stable.*

PAGES 2–3 *Donamire Farm, Lexington, Kentucky.*

ABOVE *A well-used Western saddle at a Texas ranch.*

CONTENTS

FOREWORD

Arthur B. Hancock III

OPPOSITE *Coach barn, Shelburne Farms.*

Throughout history, the horse has been our faithful companion and workmate. Shakespeare wrote in *Richard III*, "A horse, a horse, my kingdom for a horse." Horses have names and quickly become members of the family. They are very special creatures. An old saying says it all: "There is something about the outside of a horse that is good for the inside of a man."

Although the position of the horse in today's technological society is not what it once was, that same love, attachment, and closeness that existed between man and horse for centuries still abounds. I have often wondered what my life would be like without horses. To those of us who love them and whose lives are intertwined with theirs, it would be hard to imagine life without them.

These magnificent creatures, who have given their owners so much pleasure and companionship, deserve nothing less than the finest homes, and many beautiful abodes are depicted in this charming book. Horse stables and their grounds are no less than shrines and mini state parks. They are immaculately maintained, and the architecture is flawless and intriguing. They possess a rustic charm and simplistic elegance all their own. Each is a timeless narrative that captures the imagination. The stables and their inhabitants could tell a thousand tales, and the exploits of many of these horses are nothing short of heroic.

If you have a chance to visit any of these beautiful stables and gaze into the horses' eyes, you will find yourself entering into a world you may scarcely have been aware of. It is a world of beauty, serenity, enthrallment, and excitement. It will make you glad to be alive and feel as though your wishes may come true. As Peter Rowan says in his song "Wings of Horses": "I know that you will believe too, on the wings of horses. I know someday, I'll fly away, on the wings of horses, so free . . . you and me."

THE HISTORY OF
THE AMERICAN STABLE

PERKY BEISEL, D.A.

PRECEDING PAGES *A nineteenth-century homestead near Lower Saucon Township, Pennsylvania, shows the close proximity of the barn (with stables in the lower level) to the farmhouse, typical for that area.*

BELOW *A fieldstone wall separates the pastures at Glen Farm in Portsmouth, Rhode Island.*

RIGHT *Streaks of golden sunlight lend a mystical quality to the stallion barn at Om El Arab International in Santa Ynez, where Om El Shahmaan, the leading sire, poses with perfect confirmation.*

Horses have been a part of life in the United States since well before the nineteenth century. Although often neglected in historical examinations of American industrial and urban growth, the country's millions of workhorses played a crucial role in the United States's economic success well into the twentieth century. It was during these same years that for some Americans, horse ownership and participation in horse sports became a lifestyle and, for others, a way to join the upper class. Families who reaped the benefits of nineteenth-century expansion in industries such as railroads and manufacturing had seemingly unlimited wealth with which to satisfy their desires. While some families became notable art collectors, yachters, or horticulturalists, others became active participants in horse sports. In so doing, not only did they create a new upper class, but they also transformed the physical landscape of equestrian recreation and leisure.

In a manner often reminiscent of antebellum plantations or European aristocratic manor houses of the early nineteenth century, the wealthy social elite built country houses and rural estates that included professionally designed homes and outbuildings in a unified architectural style. They hired professionals to oversee their sporting stables,

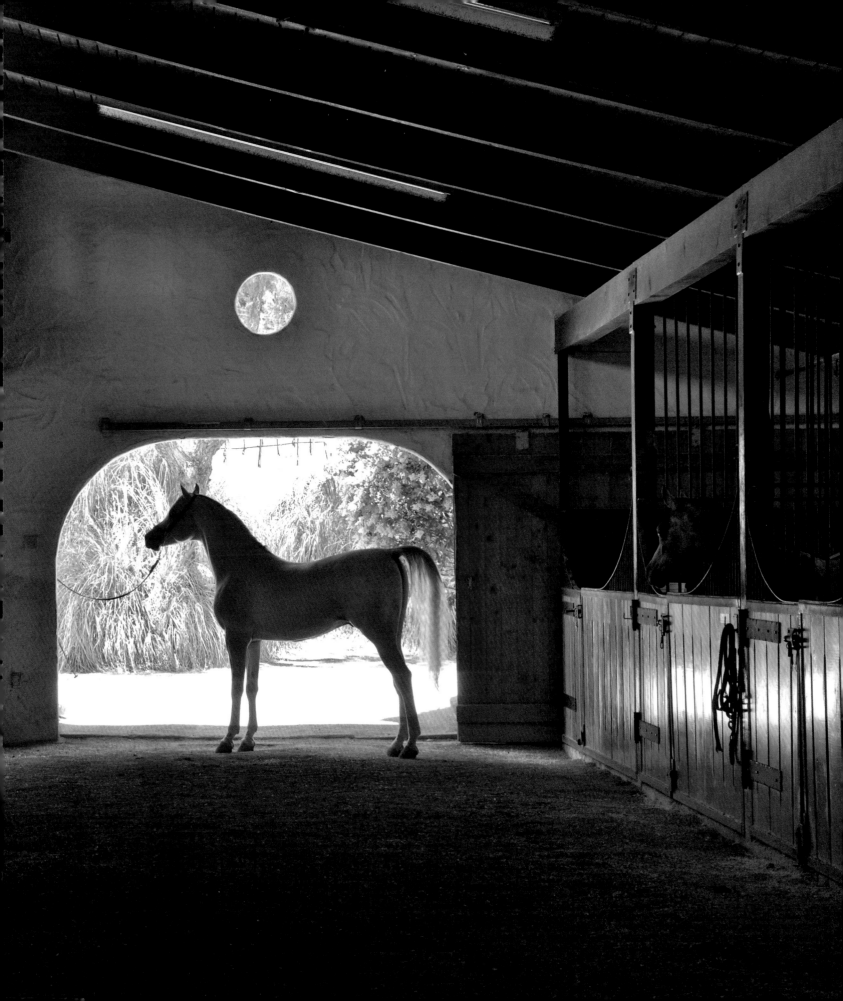

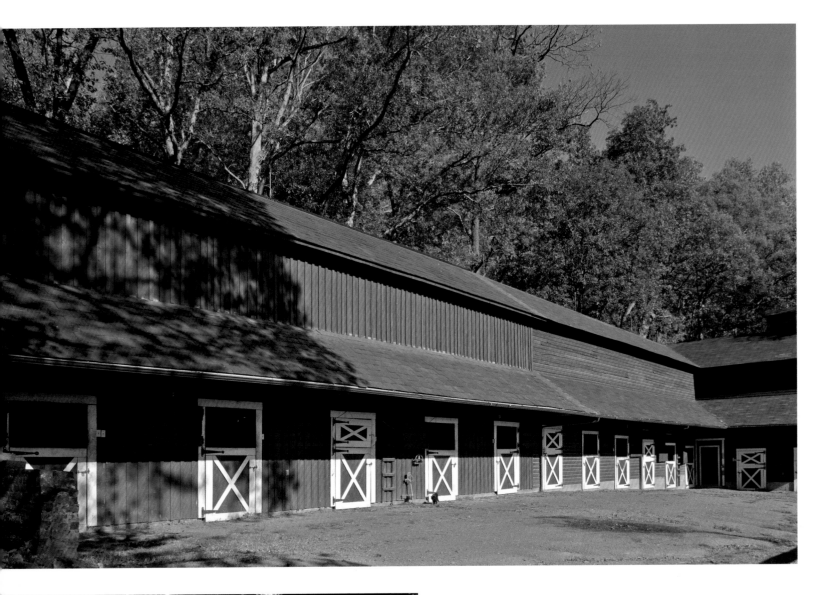

to train their horses, and to manage their competitions. Participation in foxhunting, flat racing, steeplechasing, polo, harness racing, coaching, and horse shows provided year-round opportunities for newly wealthy families and their horses to garner recognition and appreciation beyond the business world. In the Gilded Age, stables (buildings constructed solely for the purpose of housing horses and their equipment) became luxurious settings for these refined horses, bred for recreational and sporting activities. By the 1920s the new sporting stable had become a building form distinct from its nineteenth-century predecessors—the livery stables, workhorse stables, private stables or carriage houses, and military stables.

In urban areas there existed a variety of stable types depending on need or use of the horse. Livery stables, usually located in downtown business districts, often boarded horses so urban and suburban

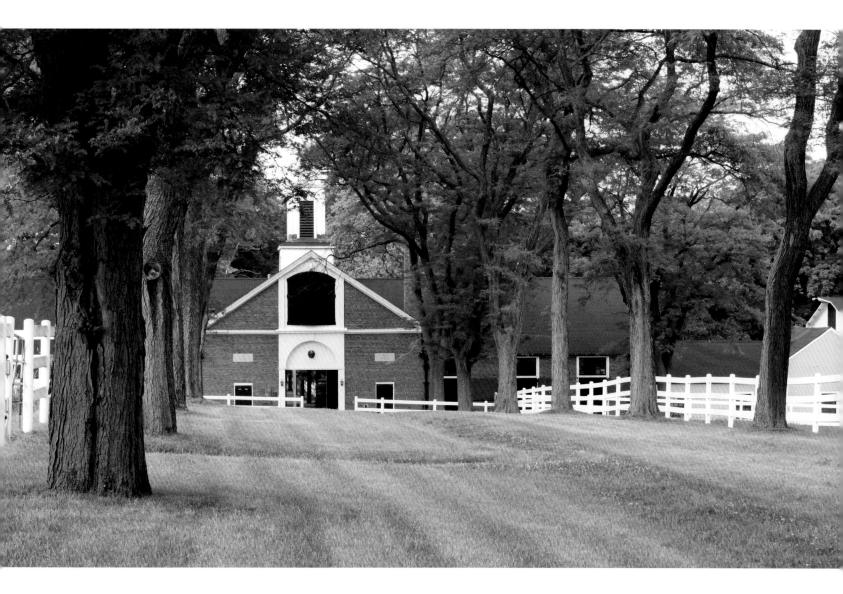

residents did not have to care for their own riding or carriage horse. Visitors hired livery horses and carriages just as today's travelers rent cars. In rural areas livery stables also doubled as stagecoach or mail stops. Livery stables continued as viable businesses into the 1910s in most of the country, and in rural areas they remained profitable even longer due to lack of mass transit and poor road conditions. Livery stables are quite distinctive with their typically tall false fronts, prominent wide carriage entrances, and rectangular shape.

It was along the city streets that many late-nineteenth-century Americans came in contact with horses, generally used as draft animals in industry for the delivery of goods and services. The rapid expansion of railroads after the Civil War had eliminated the need for horse-drawn coaches and wagons in long-distance travel. However, businesses still needed horsepower to carry out their day-to-day

OPPOSITE *James Madison's Montpelier in Orange, Virginia, in its ongoing efforts to creatively care for and reuse its barns, has partnered with the Thoroughbred Retirement Foundation to provide both temporary and permanent shelter for sixty to seventy retired racehorses to keep them from possible neglect or slaughter. At top, the yearling barn, built by the duPonts in the early 1900s, is finding a new use housing retired Thoroughbreds while they rest, recuperate, and are retrained for adoption or retirement on the Montpelier plantation, bottom.*

ABOVE *St. James Farm, the former private retreat of the McCormick family and once a premier equestrian facility, is now St. James Farm Forest Preserve, an approximately 600-acre park located within a nearly 4,000-acre natural setting in DuPage County, Illinois. On select days the public may now enjoy the exquisitely restored farm complex that includes fine equestrian architecture and farm buildings, as well as open fields, wetlands, and woodlands. Photo courtesy of the Forest Preserve District of DuPage County.*

The Museum of the Cowboy in Solvang, California, holds a treasure trove of magnificent Western gear, books on Western heritage, and an outstanding display of etchings and ink drawings by master artist Ed Borein. The large collections of silver-embellished saddles, handworked silver bridles in the California Vaquero tradition, spurs, jewelry, boots, hats, chaps, and one of the largest assemblages of fine rawhide gear by famed braider Luis Ortega are the culmination of decades of travel and research by owners Linda and Jim Grimm. Open by appointment.

activities, so they often built stables in or alongside their factories, warehouses, or headquarters. In major cities such as Boston, Philadelphia, and New York, railroad, trolley, or omnibus companies often built stables that would hold more than a hundred horses. Municipal fire and police departments built stables for each station to ensure ready access. According to the U.S. Census Bureau, approximately three million horses lived in towns and cities in 1900 and 1910. Industrial stables, usually quite large and several stories tall, housed many of these horses. By 1920 the number of nonfarm horses had dropped dramatically, and industrial stables were among the first to be converted, closed, or demolished after widespread adoption of the automobile in the 1920s. Few of these stables remain today.

In rural areas, most horses were stabled in barns that included a few standing and box stalls next to spaces for cattle and other animals. Draft horses, or in the South predominately mules, pulled the plows and reapers, raised hay into barn mows, and snaked logs to the lumberyards. After the Civil War land-grant universities, established to promote scientific agricultural production in addition to providing a broad liberal education, began to publish barn and stable plans promoting efficiency and cost-effectiveness. During the farmers' prosperous decade ending in 1918, tractors and trucks began to replace rural workhorses, and those owners who did not keep their horses converted the former stalls to meet new needs. Although many barns remain on the old farmsteads and ranches as proud symbols of the past, numerous others have been dismantled or allowed to fall into disrepair.

Before 1920 the carriage house, located beside or behind the family home, was a common structure for most new family residences. Carriage houses, the forerunner of today's detached garage, often contained a small buggy, a larger carriage, and fewer than ten horses, usually just two or three. Even as automobile prices dropped and road construction boomed in the 1910s and 1920s, it remained quite common for families, especially in small towns or suburban developments, to maintain a private stable at home. During those first two decades in the twentieth century, wealthier families' carriage houses added space for automobiles. Many of these small private stables, eventually converted into full garages or apartments, survive in what are now older suburban developments.

Until the final mechanization of the armed forces after World War II, the military had large stable complexes for its thousands of horses and mules, especially those used in the cavalry. The Indian Wars of the 1870s and 1880s, the Spanish-American War, the Philippine-American War from 1898 to 1903, and the American Expeditionary Force in World War I relied on horsepower. Military stables became testing grounds for new design and horse management practices. Just like most industry stables, military stables were built for large numbers of horses, although these stables were usually a single story and quite long, much like their caretakers' barracks. In the interwar years, several forts and remount stations became nationally renowned in horse sports and breeding. In fact, until 1952 the American Olympic teams

consisted solely of military personnel and their horses, most of whom trained at Fort Riley in Kansas. Some members of the wealthy elite became quite involved in the military's equine programs as a way to improve the quality of privately owned horses.

Opportunities for participation in horse sports increased noticeably after the Civil War. Throughout the old colonial states, businessmen and their wives joined new hunt clubs whose membership not only had to ride well, but also had to meet an exacting social standard. Autumns and winters in New York City and other major cities were filled with coaching parades showcasing the whip's ability to negotiate the streets and parks with four- or six-horse carriages. Summer's open-air resort horse shows led to year-end competitions in venues such as Madison Square Garden. The time-honored tradition of horse racing also inspired nationally recognized events and stars such as steeplechasing's Maryland Hunt Cup, flat racing's Kentucky Derby, or harness racing's legendary horse Dan Patch.

As the "horsey set" of the elite became increasingly invested in horse sports, they needed more specialized and larger stables. Across the country, enthusiasts established breeding and training farms, especially in Kentucky, for the racing industries, which provided a steady supply of horses. At the same time, there was a noticeable trend to establish "working farms" that combined the most up-to-date landscape design theories, animal management practices, and architectural styles. Although the majority of these properties were located in still-exclusive suburban or quasi-rural areas such as Tuxedo Park, New York; the Main Line of Philadelphia; or Lake Forest, Illinois, others such as Shelburne Farms in Vermont were far from an urban hub. These properties were influenced by the Country Life and City Beautiful movements in the United States and the Model Farm and Garden City movements in Great Britain, albeit often on a much more extravagant and costly scale. These country houses and rural estates provided an opportunity for the owners and their friends to combine horse sports and agricultural production with seasonal country living.

Architects designed sporting stables in a variety of shapes and styles. Some large properties had individual stables for stallions and separate stables for broodmares and young horses in training. Certain stable shapes, due to stall configuration, became closely associated with a particular breed or sport, such as the long shed rows popular at racetracks or the two distinctive wings of coaching stables. All stables strived to ensure that the horses' living conditions included natural light, fresh air, and easily cleaned and well-built stalls. Beginning in the early nineteenth century, numerous British and American military officers and prominent trainers, breeders, and owners had begun to publish manuals for gentlemen horse owners that usually included detailed descriptions of the "right" way to design and manage a stable. By the end of the century, whether one was a business owner protecting his investment or a sportsman caring for his favorite hunter, late-nineteenth-century stable owners also had access to a growing cadre of architects who specialized in stable design for city homes or country estates.

A worn door on one of the stalls at the stables of the original late-nineteenth-century Saratoga Springs racetrack is a rustic work of art.

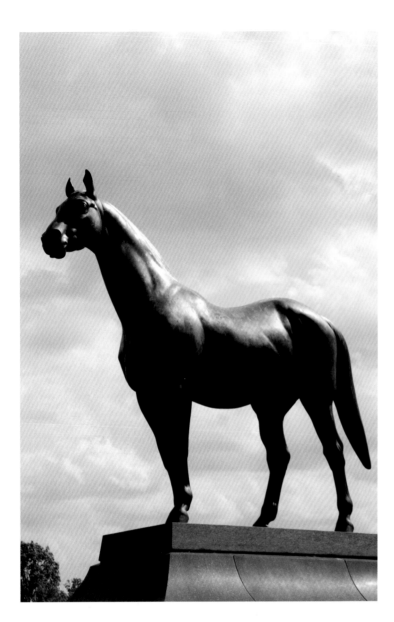

ABOVE *The powerful life-size bronze statue of the champion Man O'* *War (1917-1948) by Herbert Haseltine is set in the entry courtyard at the* *Kentucky Horse Park in Lexington, Kentucky. The Kentucky Horse* *Park's outstanding calendar of activities and educational exhibitions* *include The International Museum of the Horse, the American Saddle-* *bred Museum, the Parade of Breeds, the Breeds Barn with an* *outstanding display of twenty-four of the park's fifty breeds of horses, the* *Hall of Champions with resident champions, life-size bronze equine* *statues, and presentations in the show ring. The park is open to the public* *year-round.*

CENTER *The original Saratoga Race Course in Saratoga Springs, New* *York, opened in 1863, making it the oldest racetrack in America. It is* *now a training track. The historic stables are fully booked with horses* *that train daily during the racing season at the newer Saratoga Race* *Course across the street.*

As the wealthy began building stables, they found ways to combine agricultural and recreational elements. Outlying pastures and pad- docks, individual stalls, and haylofts are just some of the more than twenty elements that comprise a typical stable. Architects were able to adapt external architectural styles to accommodate the internal ele- ments' requirements based upon the owner's preferences. Thus sta- bles are usually described with regard to their internal elements (the number and arrangement of stalls) rather than according to the exte- rior architectural style (which often matched the house and other buildings on the property). The stables, along with their ancillary structures—the manager's house or an outdoor riding ring—formed a larger complex that not only provided a venue for the owner's horses but also expressed their architectural and landscaping aesthetics.

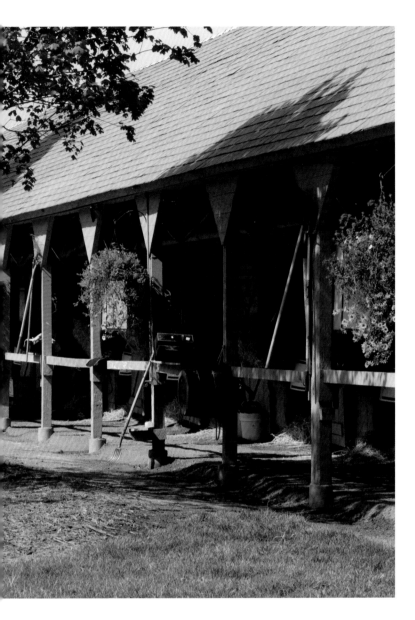

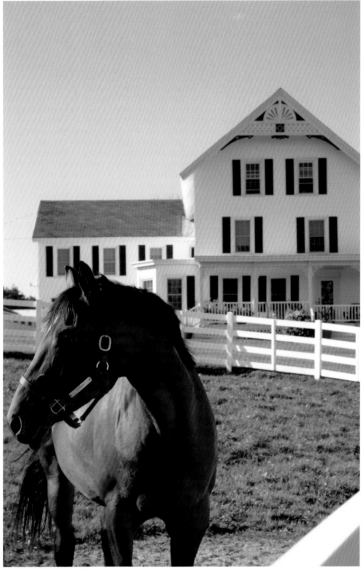

The stables featured in this book provide a glimpse into a time when the horse was of paramount importance in American society for people of all social classes. Oftentimes the surviving livery stables, military stables, carriage houses, and industrial stables of the late nineteenth and early twentieth century have been so altered it is difficult to reconnect with their past. However, each sporting stable here, regardless of its location and the type of horses it houses, provides an opportunity to learn about those who devoted their lives to horses in the past and about individuals today whose passion for horses has resulted in their willingness to create luxurious yet eminently functional stables that epitomize the long tradition of horsemanship.

ABOVE *Horse farms in rural upstate New York often include Victorian farmhouses.*

FOLLOWING PAGES *His Highness Sheikh Mohammed bin Rashid al Maktoum, Ruler of Dubai, a champion equestrian and the owner of the most Thoroughbreds in the world, endorsed the New York Racing Association and horse racing in general when he made a decisive move to support racing in Saratoga Springs, New York, by purchasing the historic Whitney estate Greentree Stud in 2007 and installing his American racing operation Darley USA. A complete renovation of the facility included stables for ninety-six horses and a new, state-of-the-art, one-mile racetrack that is not only serenely beautiful but an excellent all-weather training track with an innovative design that includes safe, flexible railings and synthetic footing.*

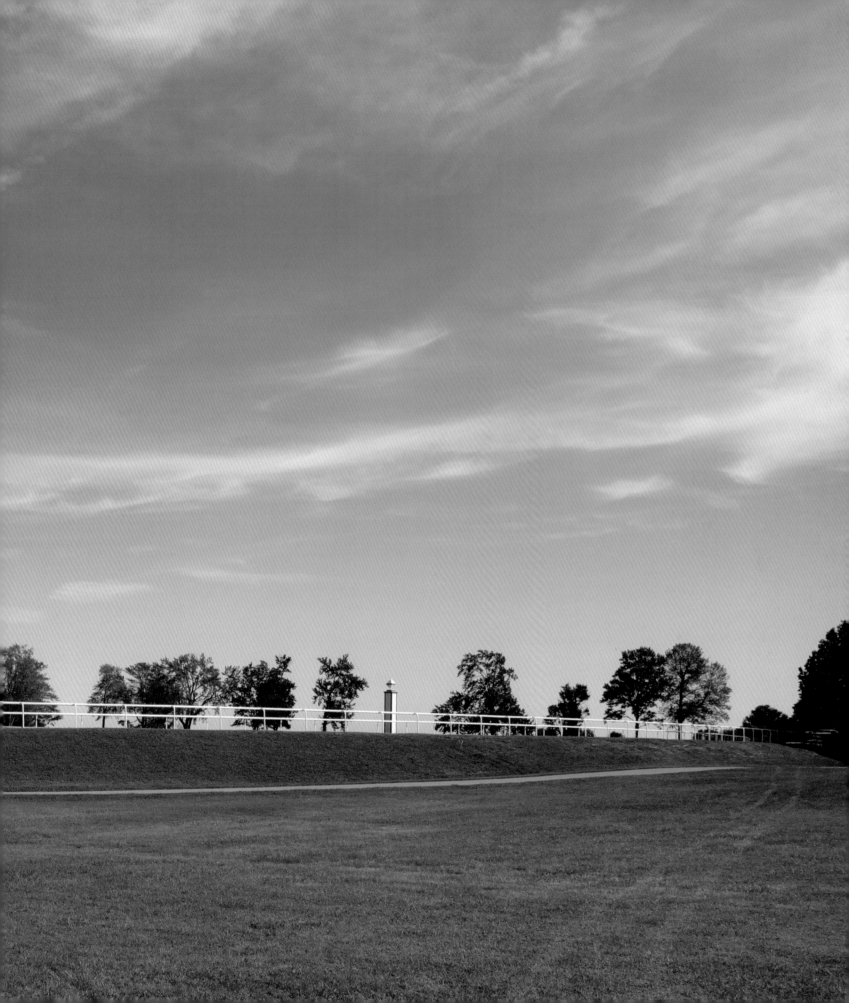

The East

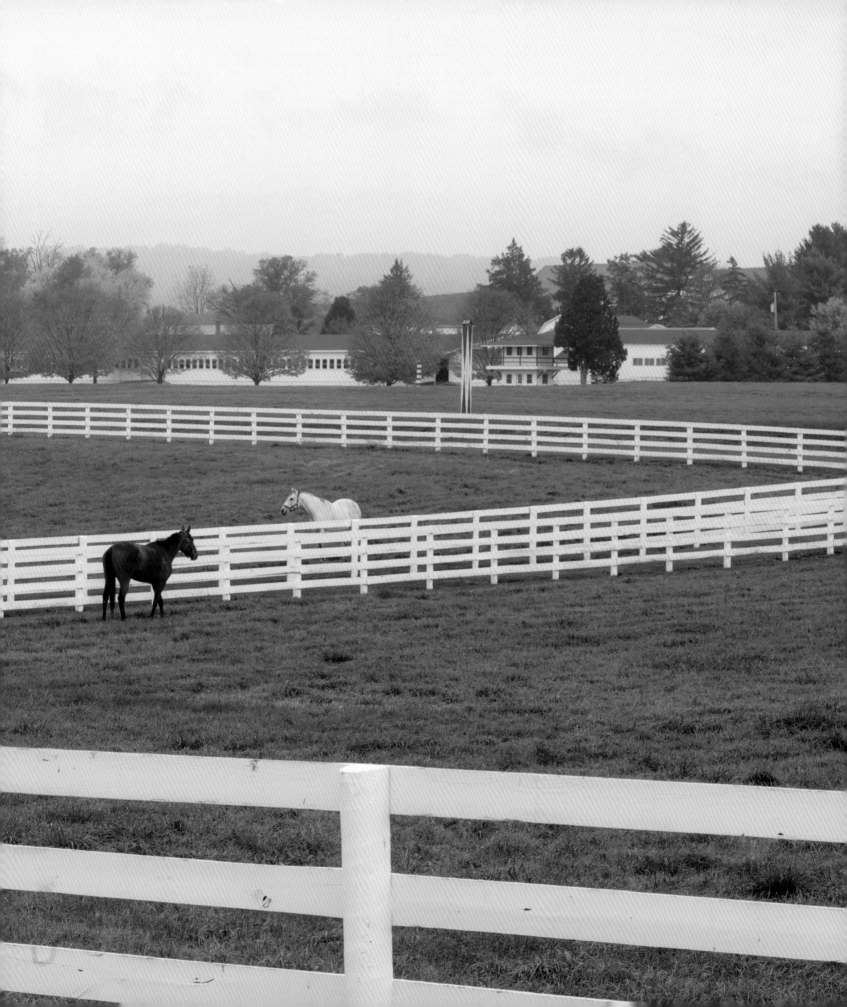

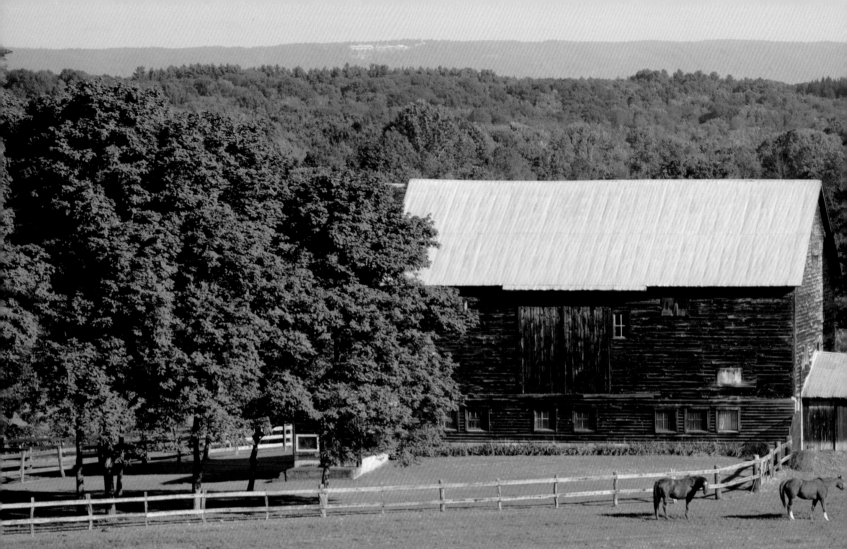

EMERALD HILLS FARM

TOWN OF SARATOGA, NEW YORK

PAGES 20–21 *Historic Sagamore Farm in Glyndon, Maryland, has miles of pristine new white-painted fencing.*

PRECEDING PAGES *Seen from a hilltop, the monolithic mid-nineteenth-century English barn is the centerpiece of the bucolic estate of Emerald Hills Farm.*

BELOW AND RIGHT *A self-sufficient farm established in Saratoga in the early nineteenth century grew to include a collection of utilitarian buildings. A massive barn complex housed a threshing floor and spacious hay storage area on the upper level and stalls for livestock on the lower level. A silo added after 1860 provided year-round feed and enabled a more productive dairy operation.*

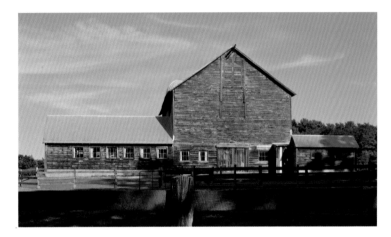

From the quaint yachting harbor on Saratoga Lake in the Town of Saratoga, a country road lined with swaying willow trees and steadfast elms leads to a series of horse farms, of which Emerald Hills Farm is among the oldest. Vincent and Lillian Fay purchased the farm in 1966 and have never regretted their move to the historic farm on 20 acres of bucolic countryside.

The farm's most striking feature is its massive weathered barn, a beautiful example of the masterful building techniques used in English barns throughout New York during the nineteenth century. The structure has a large rectangular three-bay upper floor for threshing and hay storage and a stable area below for livestock.

The 1855 census of the County of Saratoga provides insight into daily activities that were necessary for the farm's success as well as a vision of the life of the small farming community that existed in the Town of Saratoga during the nineteenth century. The farm was established by the Viele family (year unknown) and was sold twice before Michael Doty purchased it in 1849. By 1855 Doty's self-sustaining farm was larger than average for that area, with 37 unimproved acres and 175 improved (cleared) acres, and it demanded a tremendous amount of work from Doty, who had a wife and seven children. Among Doty's livestock were twenty-three cows, five horses, and twenty-five sheep, and his crops were wheat, rye, corn, and potatoes—an abundance that would have filled the massive barn.

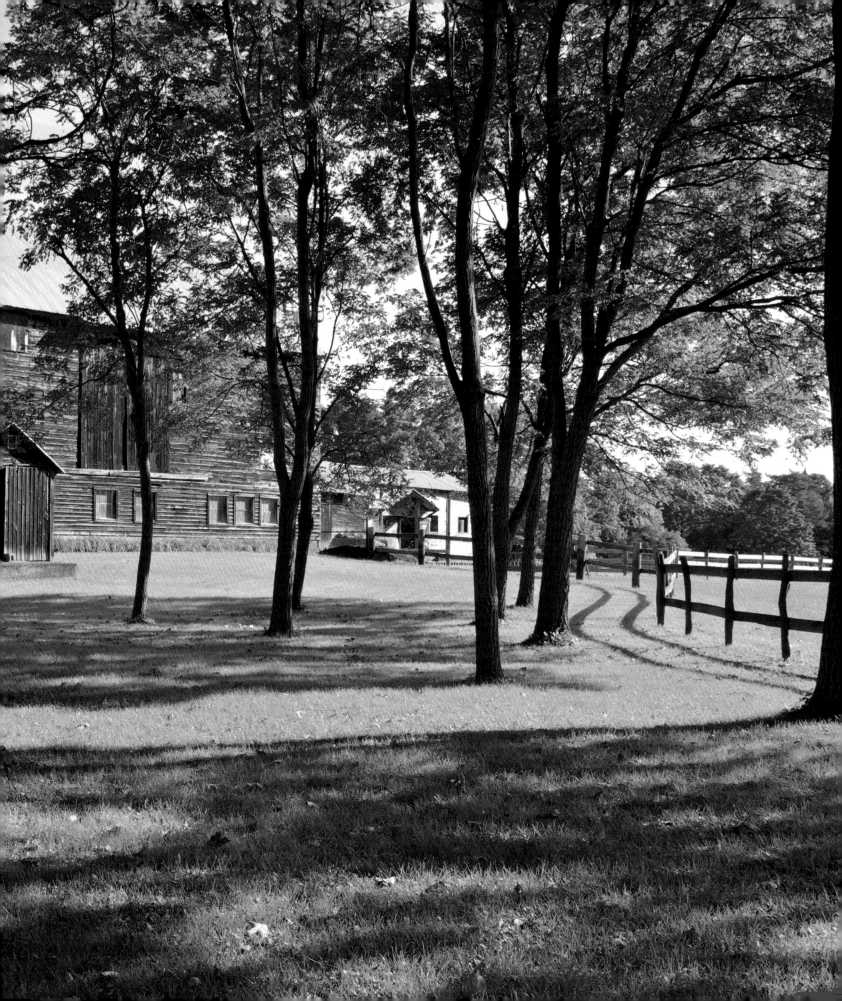

ABOVE *Stables in the lower level of the barn that were once used for livestock and draft horses were re-conformed for the retired racehorses that are now the owner's polo ponies.*

RIGHT *The configuration, the roofline, and the beam system identify the massive structure as a traditional, three-bay English barn, c. 1830. The strong supportive infrastructure is constructed of hand-adzed timbers of hardwood.*

After the 1860s, industry publications brought widespread knowledge of modern agricultural practices and equipment, including methods for managing ensilage and the construction of silos, such as the one at Emerald Hills Farm. With this European invention for storing fodder year-round, farmers could keep and feed productive cows throughout the winter.

The farm stayed in the Doty family until 1938, when it was purchased by Charles L. and Rebecca Clausen. The Fays' purchase in 1966 made them the sixth owners in the farm's history. The land is no longer farmed and the stalls in the barn's lower level have been remodeled to accommodate the retired racehorses that have become polo ponies. In taking up the sport of polo, Vincent not only gets great exercise and enjoyment, but has also achieved his goal of rescuing horses. He hires a trainer for their therapeutic work.

The romance of America's rural past that seduced the current owners almost a half a century ago has been preserved at Emerald Hills Farm. The grandly scaled, sturdy barn is an integral part of the region's architectural heritage and remains a valued historical and cultural resource.

Chronology
After 1830: English barn
After 1860s: Silo
Owned by Vincent and Lillian Fay

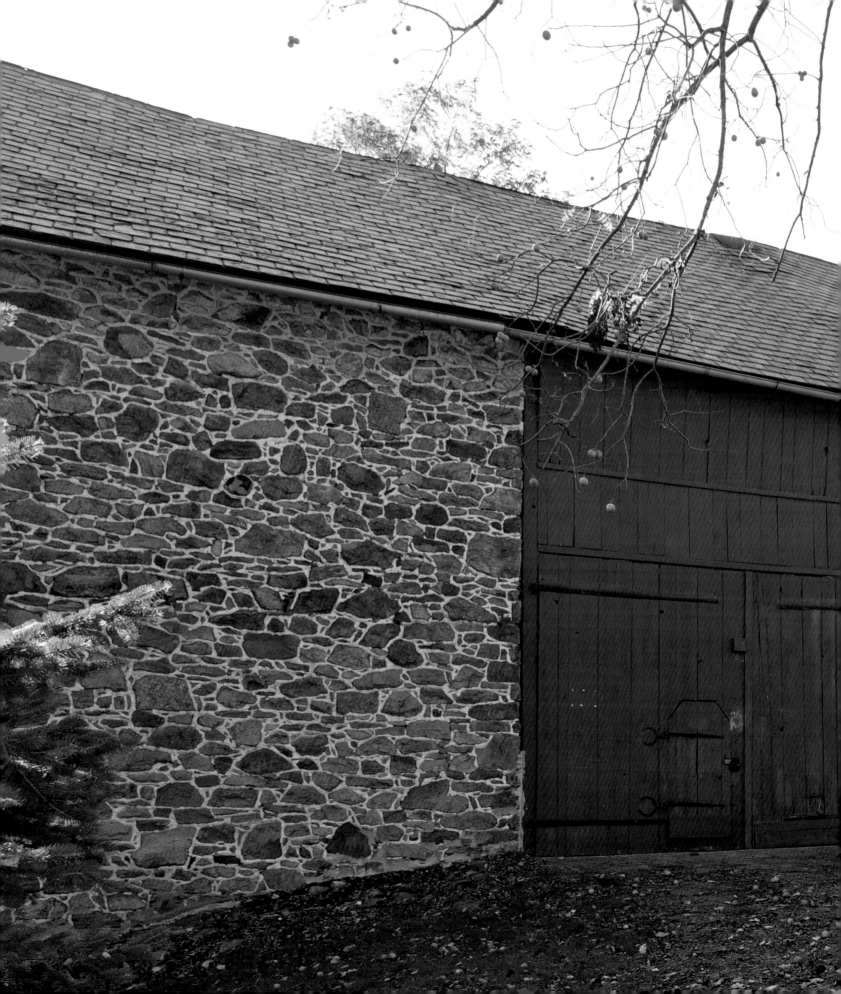

STONE HOLLOW FARM

HELLERTOWN, PENNSYLVANIA

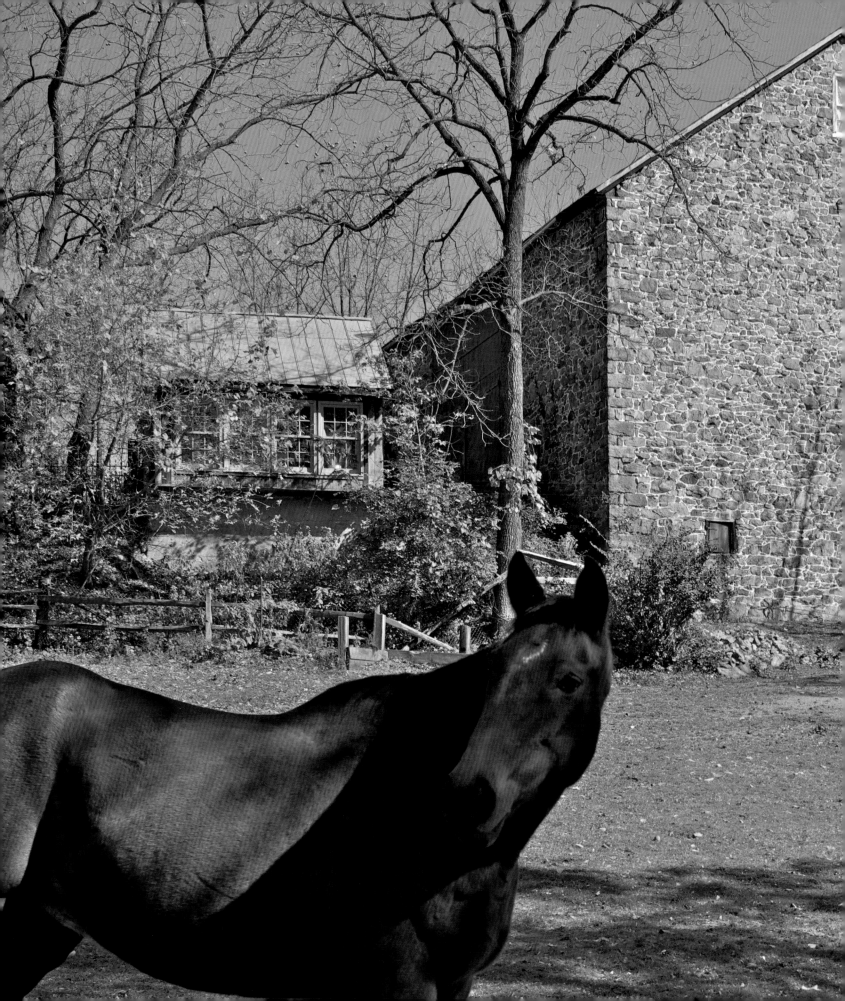

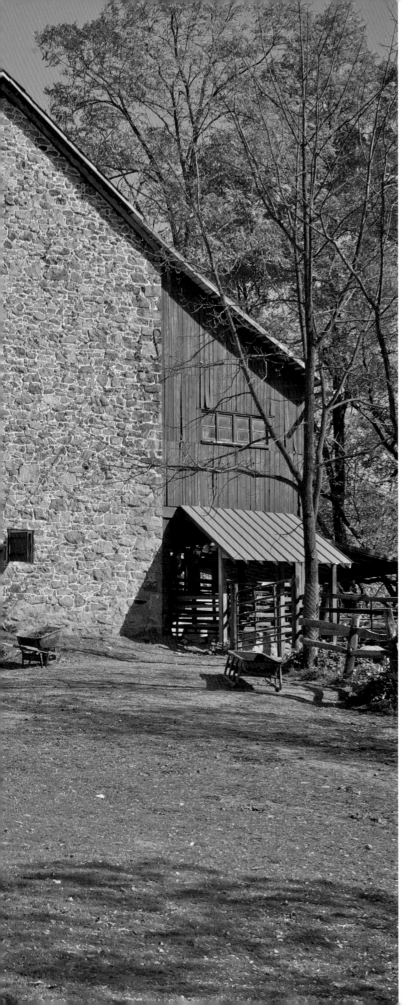

PRECEDING PAGES *Stone Hollow Farm was established in 1752 by Christopher Stoffel Wagner, an early settler in the Hellertown area. Today the stone structures of the picturesque farm complex include a two-story farmhouse, a tenant house (the former summer kitchen), and a c. 1840 Pennsylvania fore-bay bank barn. The layout is strategically planned so that the barn is close to and facing the entrance to the house as well as conveniently accessible from the road. Handwrought iron door hardware uses designs from the late eighteenth century.*

LEFT *The 60-by-40-foot Pennsylvania Standard bank barn is constructed on three sides with local fieldstone and the front stable wall is stone and wood. In the adjoining pasture is one of farm owner Dr. Donna Bristol's horses, Slew's Magic, a grandson of Seattle Slew.*

S tone Hollow Farm is an historic homestead of evocative stone structures set beside a creek on 10 acres of land. Dr. Donna Bristol purchased the property in 1982 to enjoy her horses and own a part of Pennsylvania history. Its stone bank barn, main farmhouse, and tenant cottage, a former summer kitchen, are architectural gems. Now Bristol's historic barn houses a variety of horses that includes an Appaloosa, an Arabian, a Quarter Horse, a Quarter-Draft mix, and a Thoroughbred who is a grandson of champion Seattle Slew.

The history of the farm property reaches back to the settlement of Pennsylvania. Englishman and Quaker revolutionary William Penn was granted a charter by King Charles II in 1681 of a Proprietary of 45,000 square miles of property. In 1718 the title of proprietor and lands of the proprietary were inherited by Penn's three sons, Thomas, Richard, and John. Thomas remained a proprietor until his death in 1775. In 1752, 180 acres that include today's Stone Hollow Farm property were purchased from Thomas Penn by Christopher Stoffel Wagner, an early settler in the area.

The striking, monolithic barn that dwarfs the main farmhouse and tenant cottage is a 60-by-40-foot Standard bank barn constructed around 1840, with stables and feed rooms below and three bays on the upper level. Its timbers are oak, three sides are constructed with local

OPPOSITE *The forebay joists are cantilevered over the stable wall with doors to stalls and the* foddergang, *or food alley, where the farmer had access to the area between the animal stalls. Footing for the protected area is handmade bricks and the original threshold is solid stone. Hewn oak beams that relate to the framing above and rustic white washed stone walls provide evocative elements in the lower level of the barn.*

RIGHT *One of the stalls was used as a harness tack room. It contains a curry box, necessary for storing brushes and other tack supplies, built into the stone wall. Harness hook beams on either side of the stall door contain large holes for pegs that once held huge draft horse harnesses.*

BELOW RIGHT *The opening in the top portion of the stall door was cut between 1890 and 1910 to provide extra ventilation for the stall. The door frame molding is unusual in its detailing.*

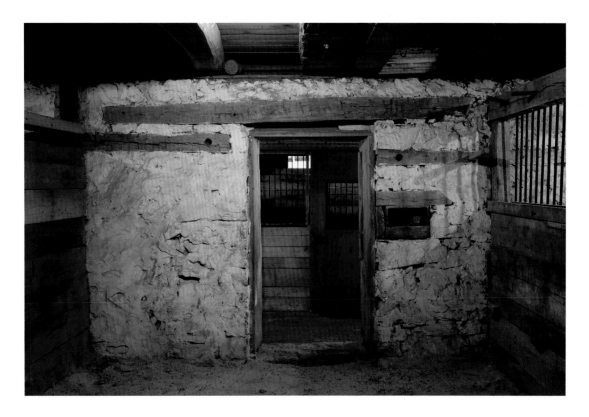

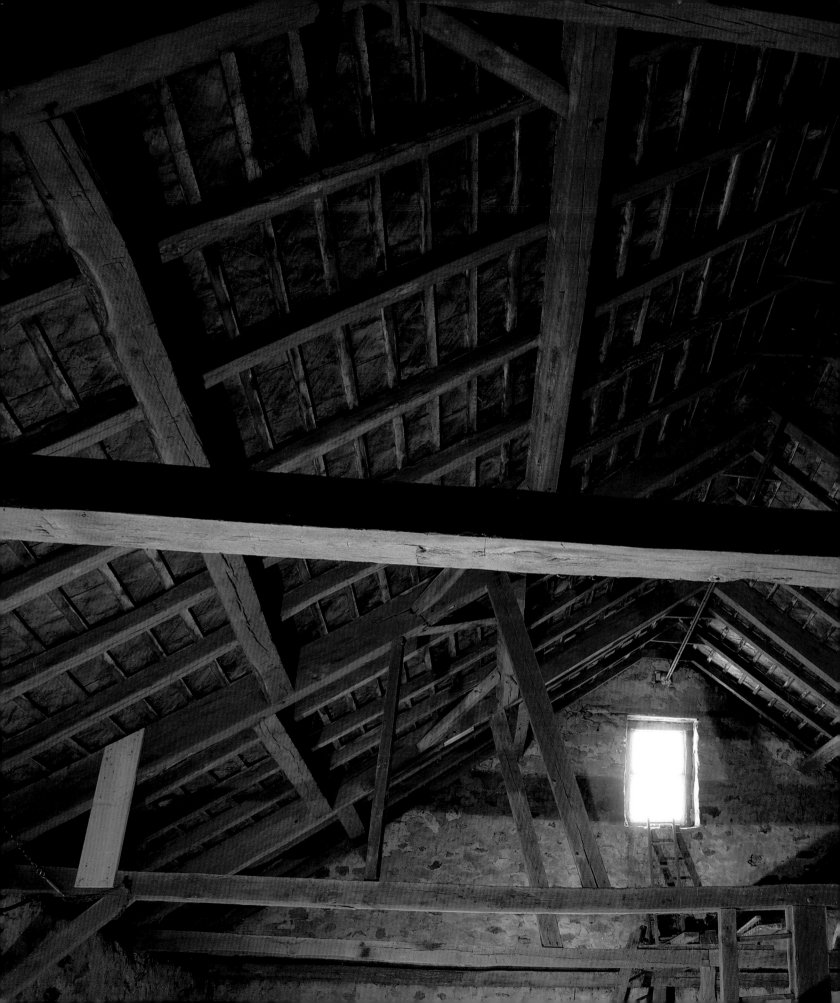

LEFT *The framing of the massive timber structure is that of German-style barns prevalent in Pennsylvania. Here, a ladder has been incorporated into the framing design for convenience.*

fieldstone, and the front stable wall is stone and wood. Nails used were of two types—cut and wrought. Both types were in use after 1820.

The Standard bank barn design is found throughout Pennsylvania, especially in this region. Construction typical of that time period (early to mid-nineteenth century) is evident in the wooden rafter system, flooring on the second floor, and the framing. As noted by Robert F. Ensminger in his book *The Pennsylvania Barn, Its Origin, Evolution, and Distribution in North America*, this type of barn, which has evolved over the last 450 years or so, originated in Switzerland and debuted in early America in southeastern Pennsylvania. The type and its derivatives are now found throughout the United States.

Chronology
1752: Original land grant
c. 1840: Barn
Owned by Dr. Donna Bristol

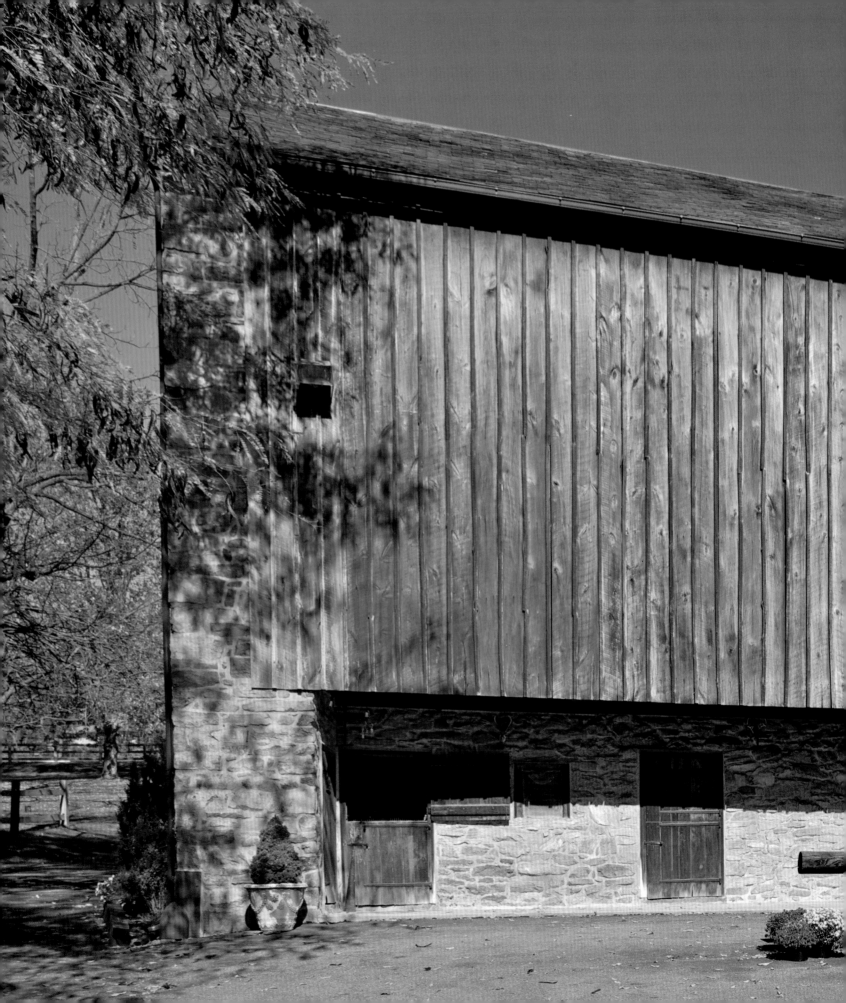

K BROOK FARM

LOWER SAUCON TOWNSHIP,
PENNSYLVANIA

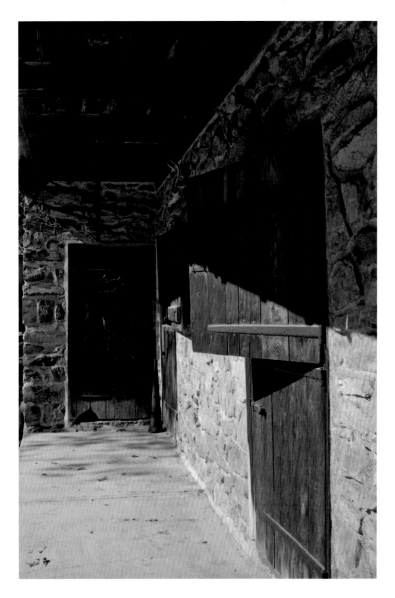

PRECEDING PAGES *K Brook Farm in Lower Saucon Township, Northampton County, Pennsylvania, is a stone-to-roof-peak Standard barn of impressive dimensions, measuring 65 feet at each side wall and 40½ feet at each end wall. The three-bay barn contains an intact granary and original threshing floor on the upper level and six stalls each with original stable doors and storage space on the lower level.*

ABOVE *There is a door cupboard on one side of the front wall in one of the exceptionally wide large stone L-shaped pier corners, a formation that also adds extra needed strength for the stone gable walls. As architectural historian and barn expert Gregory Huber explains, "A distinctive feature of some of the Standard barns in this area of Pennsylvania is the joining of the basement ceiling joists directly to the vertical side of the forebay sill at the front wall bottom."*

OPPOSITE *Tom and Mary Ann Rowe originally bought the large barn and the 60 acres surrounding it for Mary Ann's quarterhorse, K Brook. They now raise miniature horses, which often enjoy the spacious stalls originally built for draft horses.*

K Brook Farm is the site of one of the most picturesque homestead barns in Northampton County, Pennsylvania. Believed to have been built between 1840 and 1850, the barn is also one of the region's largest, with dimensions that measure 65 feet by 40½ feet. The barn's design is similar to other mid-nineteenth-century bank barns in the area, with post-and-beam construction that may be fully appreciated inside the voluminous second-floor working area. Its intricate rafter system is not only an engineering masterpiece but a work of art. Heavy, hand-hewed timbers support the threshing floor, which serves as the ceiling of the horse stalls and the remaining basement-level area of the barn.

"The K Brook barn is a stone-to-roof peak Standard barn," explains architectural historian Gregory D. Huber, an authority on Pennsylvania barn architecture. He adds that it has a very rare treatment in which the plastered rear and southwest gable walls are etched to create a faux brick effect. Huber notes that the horse and cow barn, built of local fieldstone and wood, has other unusual features, including very wide *peiler ecks*, the German dialectic word for the large stone L-shaped pier corners that protrude four feet from the front of the *stahlwand*, or stable wall. These substantial pier corners also add extra support for the stone gable walls. Typical of all Pennsylvania bank barns, the area on the second floor forms an overshoot that overhangs the stable wall and provides a sheltered area for entrances to the basement stable areas. At the K Brook barn the six original wood stable doors are halved, a typical German design (Dutch door) found in German bank barns that allows the upper section to be opened, providing light and air to the interior stalls while the lower section contains the animals.

Tom and Mary Ann Rowe originally bought the barn and the 60 acres surrounding it for Mary Ann's quarterhorse, K Brook. They now raise miniature horses that are kept in an adjacent pasture or in one of the spacious stalls of the barn, originally built for draft horses. K Brook Farm was opened to the public for two days when it was featured on the Annual Saucon Valley Conservancy Barn Tour in 2008, giving visitors an authentic and magnificent look at the past.

Chronology
c. 1840–1850: Barn
Owned by Tom and Mary Ann Rowe

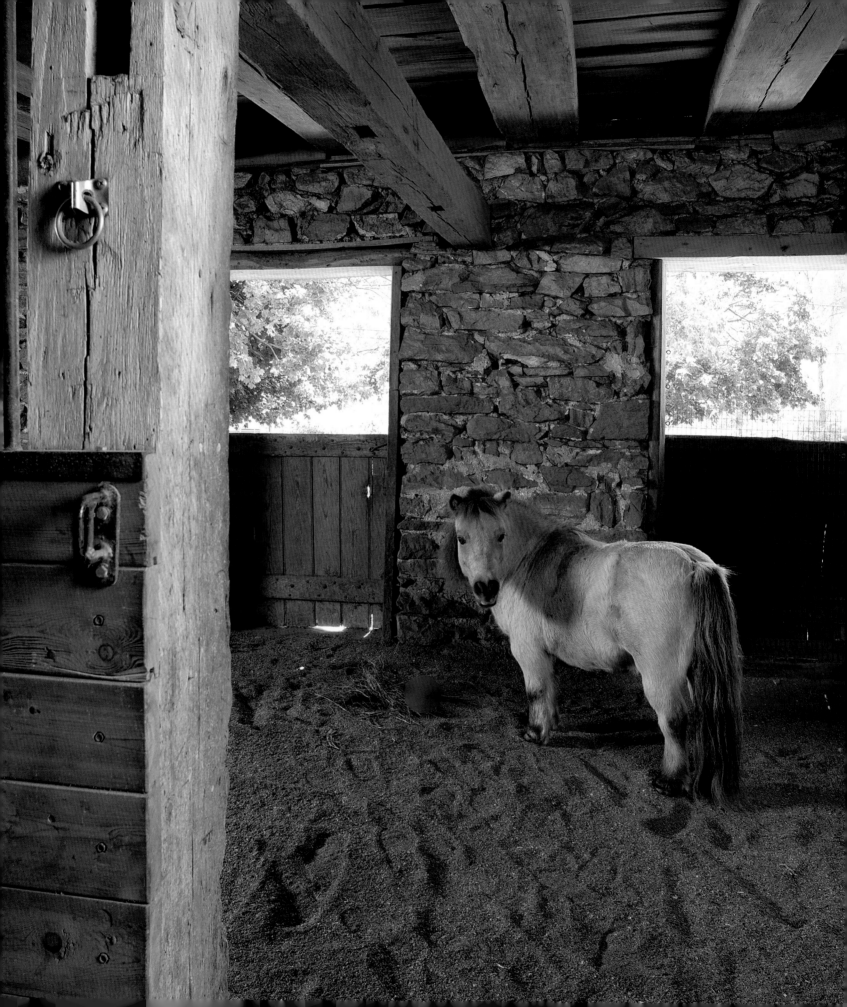

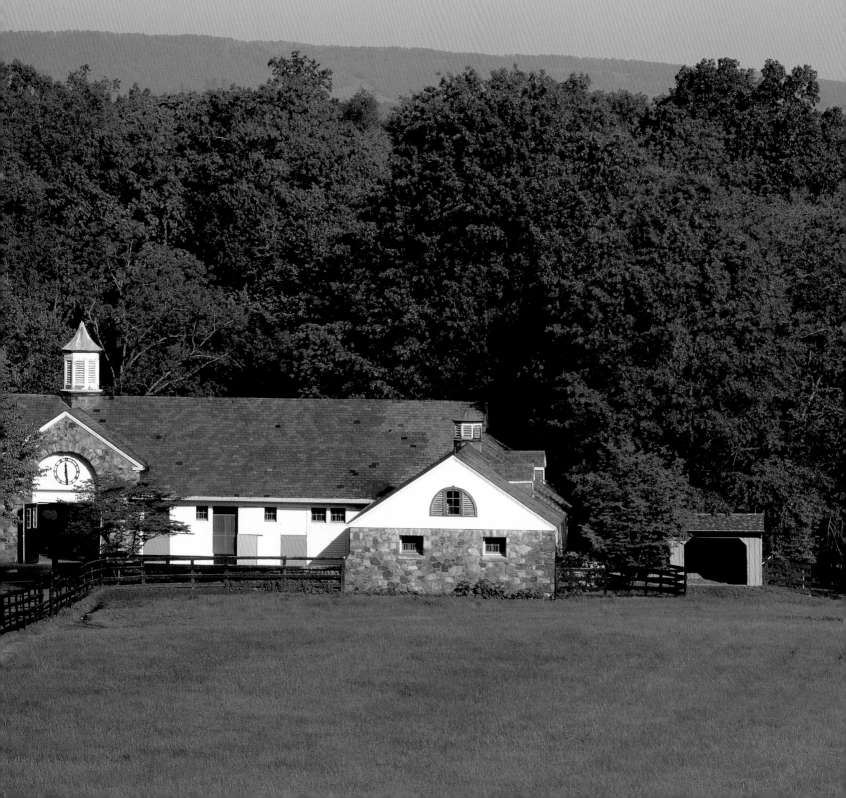

LOCUST HILL FARM

MIDDLEBURG, VIRGINIA

PRECEDING PAGES *Locust Hill Farm is a 1,037-acre sustainable working farm. One of its operations is as a recuperation and breaking facility for many of the owner's racehorses who train at a variety of racetracks in the United States. The broodmare barn, constructed in 1935, is the centerpiece of the barn and stable complex which sports the owner's racing colors of white and two tones of blue.*

RIGHT *The training barn was constructed in the early 2000s for the training and recuperation of hunters and Thoroughbred racehorses.*

Locust Hill is a handsome, historic horse farm near Middleburg, in the beautiful hunt country of northern Virginia. The boundary lines of the eighteenth-century farm were surveyed by the young George Washington, as was much of the property in the Northern Virginia Piedmont. From humble beginnings more than 150 years ago, Locust Hill has evolved into a productive, sustainable farm. It is also an important facility for the recuperation of many of the owner's racehorses, who train at a variety of racetracks in the United States.

Locust Hill has more than 1,000 acres and five major working barns. The original barn, which stands in a field behind the farm's other structures, was built in the mid-1800s and is now used for hay storage. Another of the working hay barns from the same period is also post-and-beam construction of sturdy oak, using dowels. The farm has been expanded over time, with the earliest stable, the broodmare barn, built in 1935; a riding ring; the latest stable, the training barn, built in the early 2000s; and the most recent hay barn, completed in 2008. The farm is an integral part of the horse community of Middleburg, hosting the Orange County Hunt Point-to-Point Races each year, bush-hogging its trails for foxhunters, and opening its doors for the annual Stable Tour benefiting Trinity Episcopal Church in Upperville.

Locust Hill today is a multifaceted, sustainable farm with Registered Angus cattle, Thoroughbred horses, and high-quality hay production that has been brought into the twenty-first century by its innovative farm manager, Michael Webert. His enthusiasm and respect for the historic property were important as he created the agricultural business that now thrives there. Webert worked closely with

ABOVE *The oldest barn on the property, a post-and-beam structure, dates from the mid-1800s and is used for hay storage. It is separated from the stables, located in the back part of the farm where the main cattle operation is.*

OPPOSITE *The 1935 broodmare barn has a convenient passage from the entrance directly into the front pastures.*

the Virginia Tech Mare Center, various agricultural experts, and the cowmen of the area to apply the latest farming methods at Locust Hill.

Webert intends to grow the operation as much as possible. He now averages two to three cuttings of orchard grass each year, the best hay for foals and growing horses, supplementing the fiber-rich product with energy-giving alfalfa. His hay production on 250 acres has succeeded so well that he sells overages to a nearby farm and clients, and plans to farm 100 more acres in the near future.

Chronology

Mid-1800s: Post-and-beam barn in back field
Mid to late 1800s: Original post-and-beam hay barn
1935: Broodmare barn
c. early 2000: Training barn
2008: Hay barn

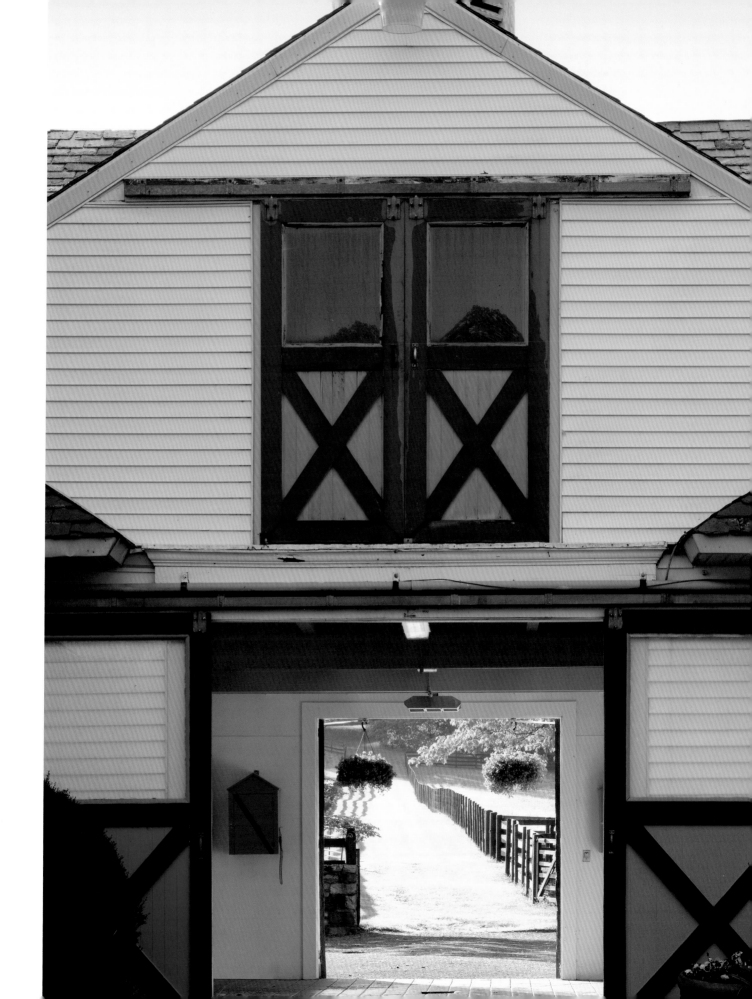

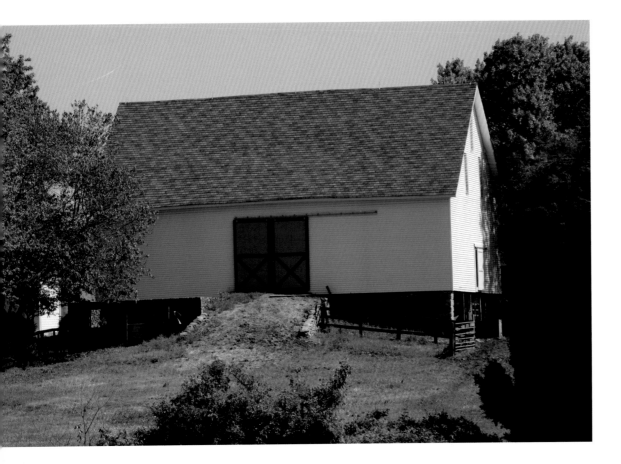

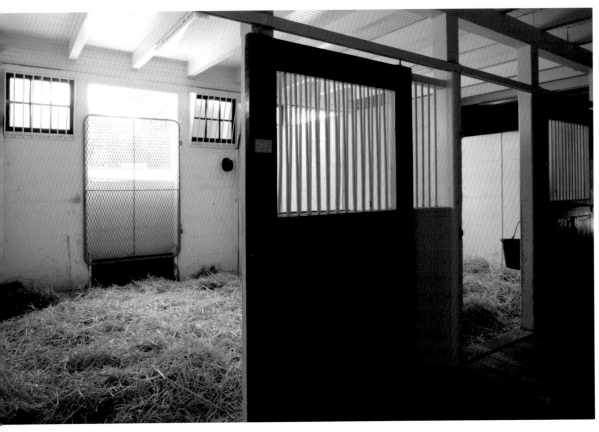

OPPOSITE TOP *The post-and-beam bank hay barn that dates from the mid 1800s is set on a rise of hill among the other farm buildings.*

OPPOSITE BOTTOM *The broodmare barn has twenty-two spacious 12-by-14-foot stalls for mares and foals.*

ABOVE AND RIGHT *The broodmare barn has stunning stonework and a distinctive clock in the center of the building. The clock was the main timepiece for the farmworkers during the Great Depression.*

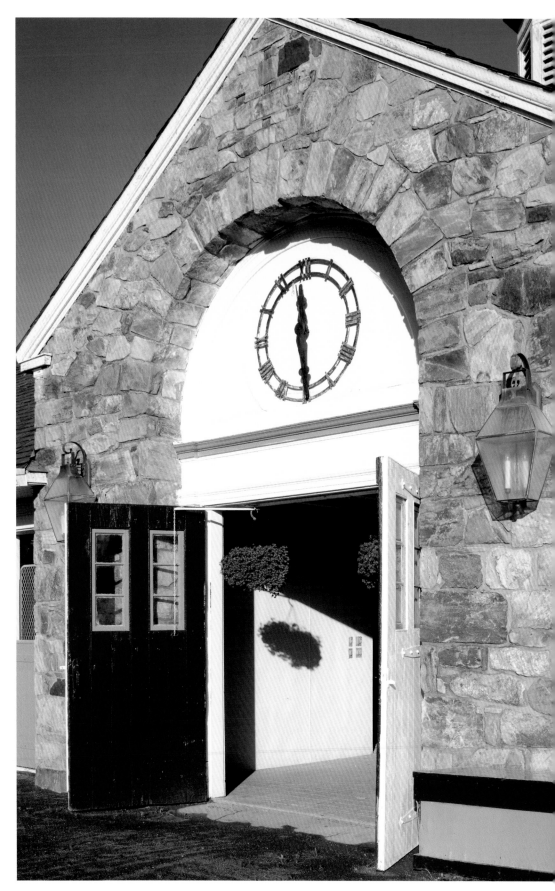

LEFT AND ABOVE *The interior of the new training barn is finished in shellacked pine that gives a warm feeling to the heart of the Thoroughbred training operation.*

FOLLOWING PAGES *Looking out from the broodmare barn on a misty morning, the front paddocks are ethereal in the early sunlight. The complex of stables and barns is set amidst woodlands, pastures, and hay fields.*

SHELBURNE FARMS

SHELBURNE, VERMONT

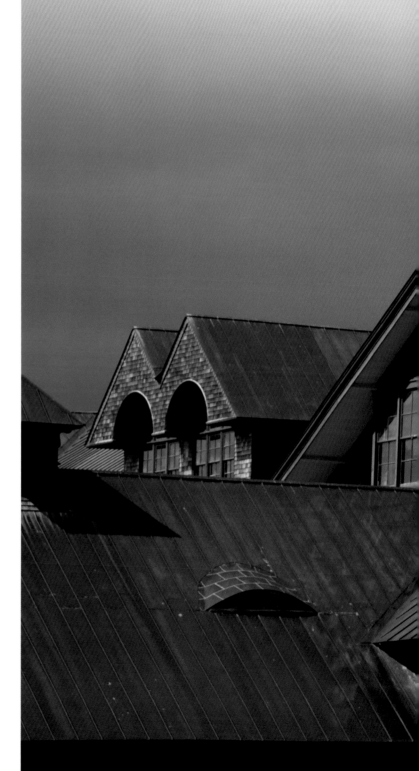

PRECEDING PAGES *The second of four barns built at Shelburne Farms, the 1891 Breeding Barn was the center of William Seward Webb's ambitious breeding program for Hackney horses. Shelburne Farms and other non-profits now use it for special events.*

RIGHT *Shelburne Farms' long-term plans for the entire Breeding Barn complex include restoring the old Dairy Barn into an ecologically designed residential learning center, an important part of the farm's vision for the future. With these new facilities, Shelburne Farms will expand its scope to offer more multiple-day courses, programs, and workshops to educators and other program participants.*

Shelburne Farms began in 1886 with the first purchases of contiguous, small Vermont farms at Shelburne Point by Dr. William Seward Webb and his wife Lila Vanderbilt Webb. They had a grand dream of creating their country estate as a beautiful and important "model" agricultural farm. Horses were an integral part of this vision. By 1902 their 3,800-acre estate had become the vision of an ideal world created with a plan by the great American landscape architect Frederick Law Olmsted and the evocative architecture of Robert Henderson Robertson. Robertson's large-scale buildings, designed with an eclectic mix of Queen Anne Shingle and Richardson Romanesque styles, were set within the private park of a gently rolling landscape that had been cleared and then augmented with thousands of specimen trees and shrubs to create pastoral vistas and a picturesque landscape.

Shelburne Farms has undergone various managerial transitions since its ownership by the Webbs. In 1972, Webb descendants formed a nonprofit organization dedicated to using the property to teach and demonstrate environmental stewardship. Originally conceived as a farm to demonstrate innovative design and management techniques, it has expanded the nineteenth-century goals with innovative twenty-first-century programs that promote outdoor conservation at all levels. Shelburne Farms, the nonprofit, continues to own and operate the farm today, as well as its related enterprises and all its educational programs.

Special events such as the annual Harvest Festival, the award-winning world-class cheese-making operation, and educational field trips and workshops serve the local community. The teacher training, hands-on education programs, and publications of the 1,400-acre working farm, such as *Shelburne Farms Project Seasons: Hands-on Activities for Discovering the Wonders of the World*, which focus on land conservation, agriculture, and forestry, have been nationally and internationally influential and will continue to be part of the living legacy of Shelburne Farms.

* Shelburne Farms is a 501(c)3 nonprofit organization.

Chronology
National Historic Landmark
1886: Established
1890: Farm Barn;
1891: Breeding Barn and Broodmare Barn;
1894: Conversion of Broodmare Barn to Dairy Barn; and
1902: Coach Barn
(Robert Henderson Robertson, architect)
2008: Restoration of Breeding Barn

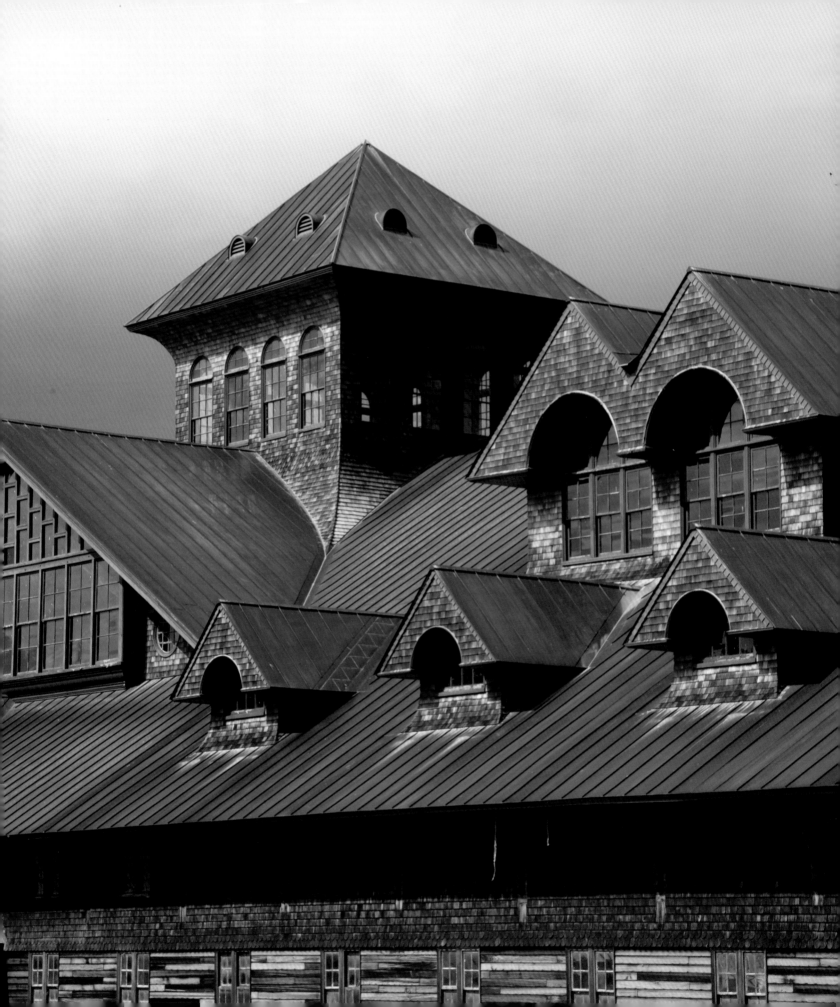

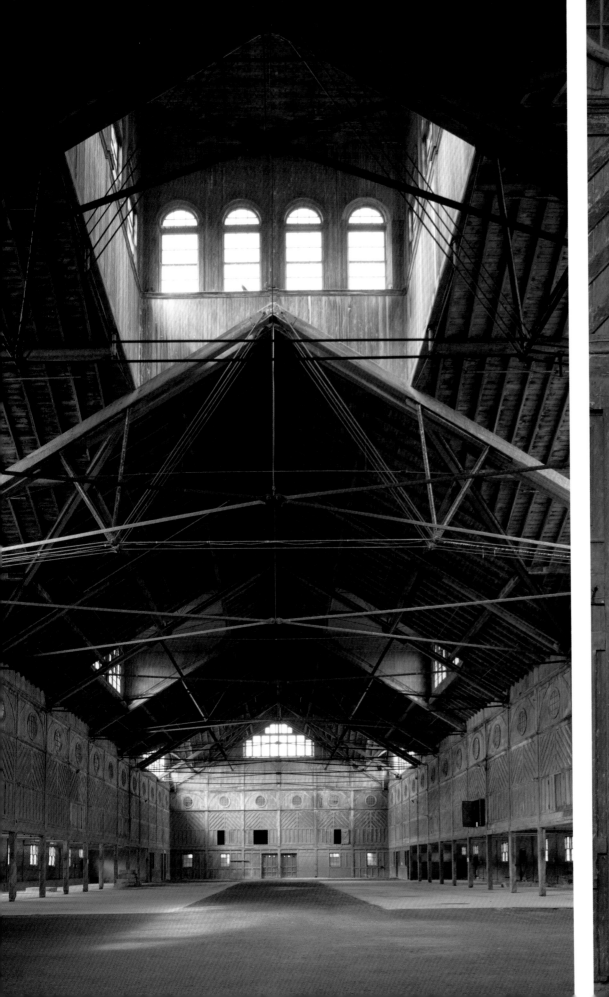

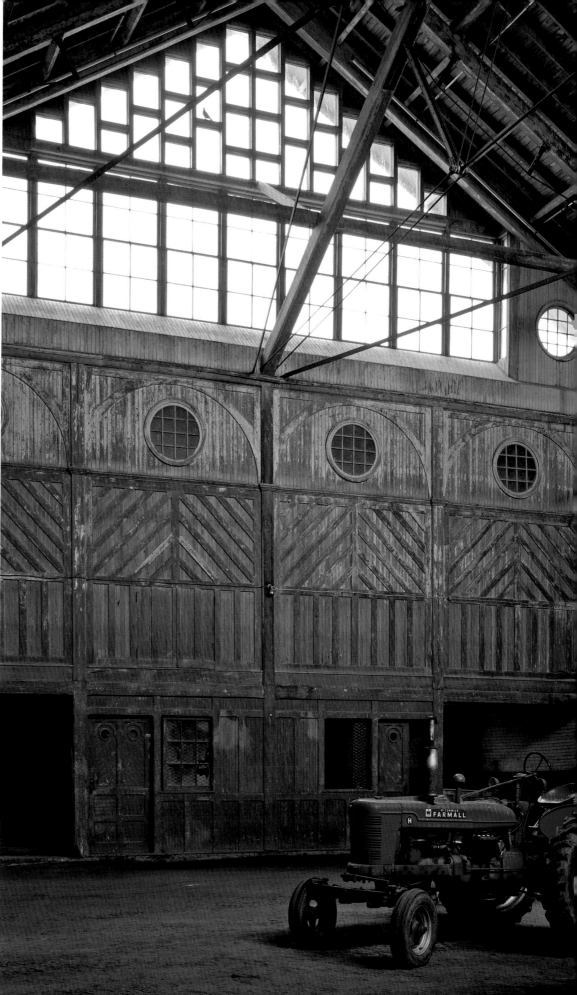

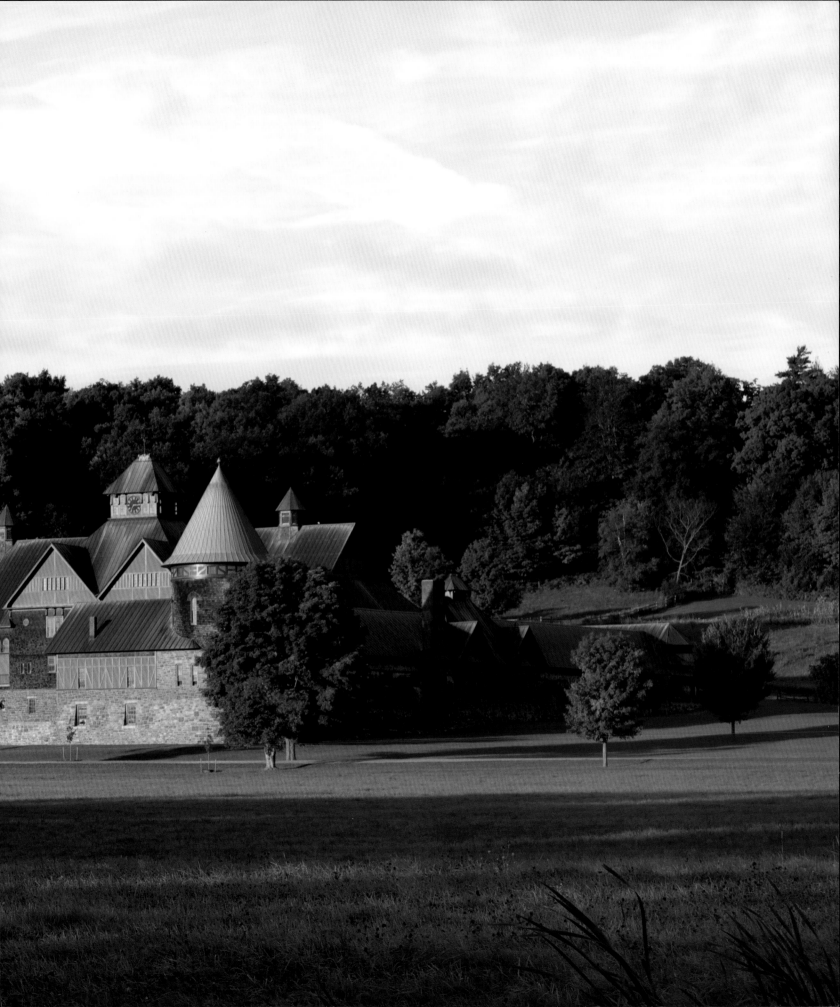

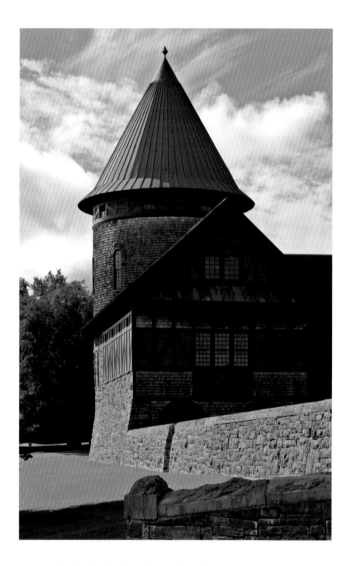

PAGES 56–57 *Inside the Breeding Barn the cathedral-like great hall measures 360 by 72 feet. The barn began as fifty-six finished box stalls surrounding an interior exercising ring for Dr. Webb's English Hackneys. It later became a cattle barn, and is now used for special community and agricultural events. The pine woodwork has faded whitewashing that gives the space an unequalled, graceful antique charm.*

PRECEDING PAGES *The 416-foot-long, 50-foot-deep, 4-story Farm Barn was the headquarters of the original "model farm" enterprise. Grain crops were processed and stored in the 1,500-ton-capacity upper levels, while carpenters, blacksmiths, and wheelwrights had workshops in the wings. Today, these areas now house administrative offices, an education center, and a children's farmyard. The stables that once housed forty teams of working mules are now home to an independent school, interpretive space, and a cheese-making facility for the farm's award-winning cheddar.*

ABOVE AND RIGHT *The Farm Barn's foundation and first story are monkton quartzite and the upper portions of the exterior are wood-shingled, as is the gabled roof. Wings of similar construction are set at right angles, forming a square courtyard in front.*

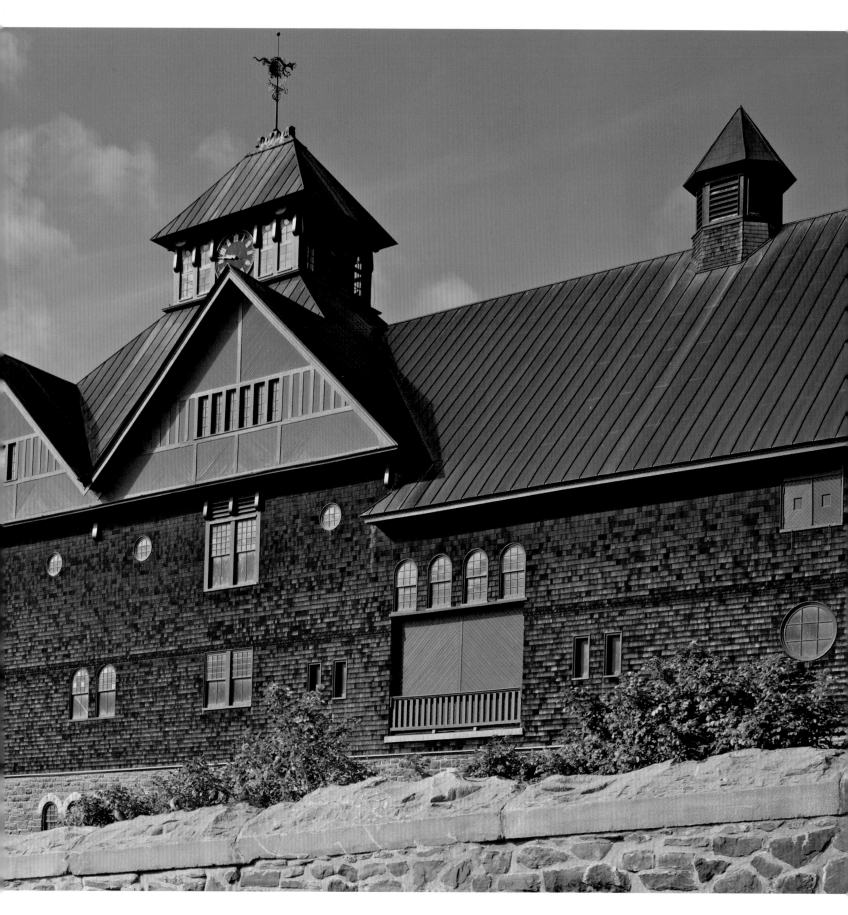

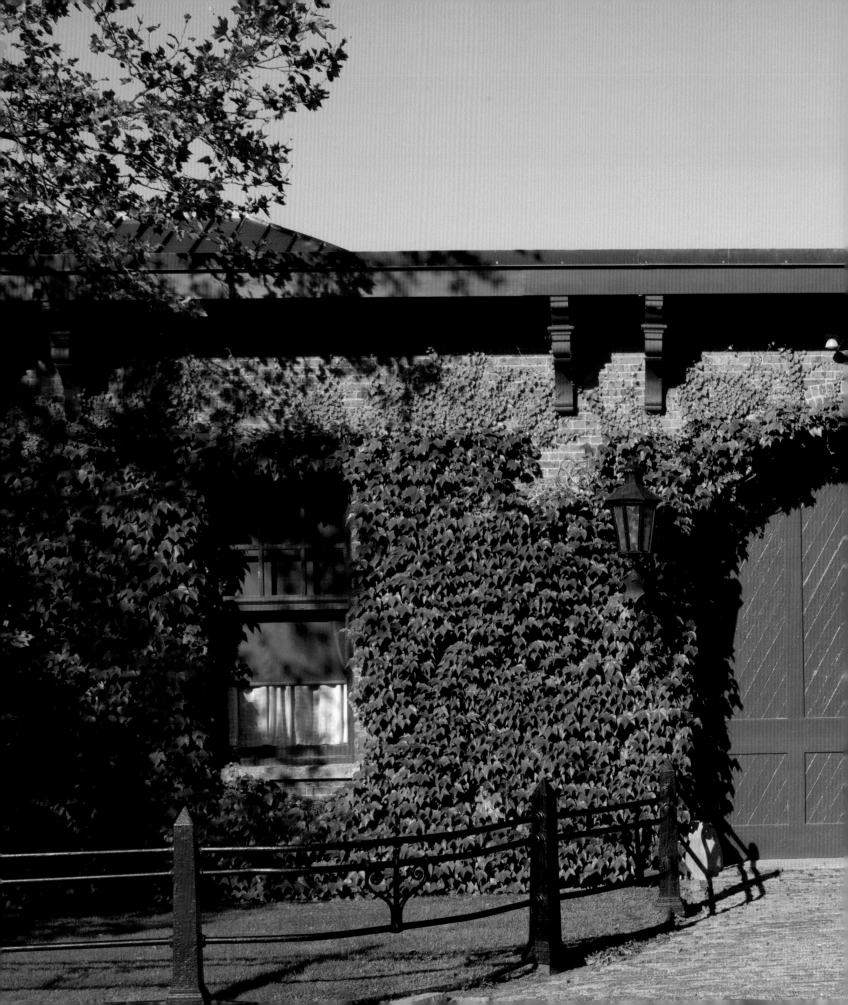

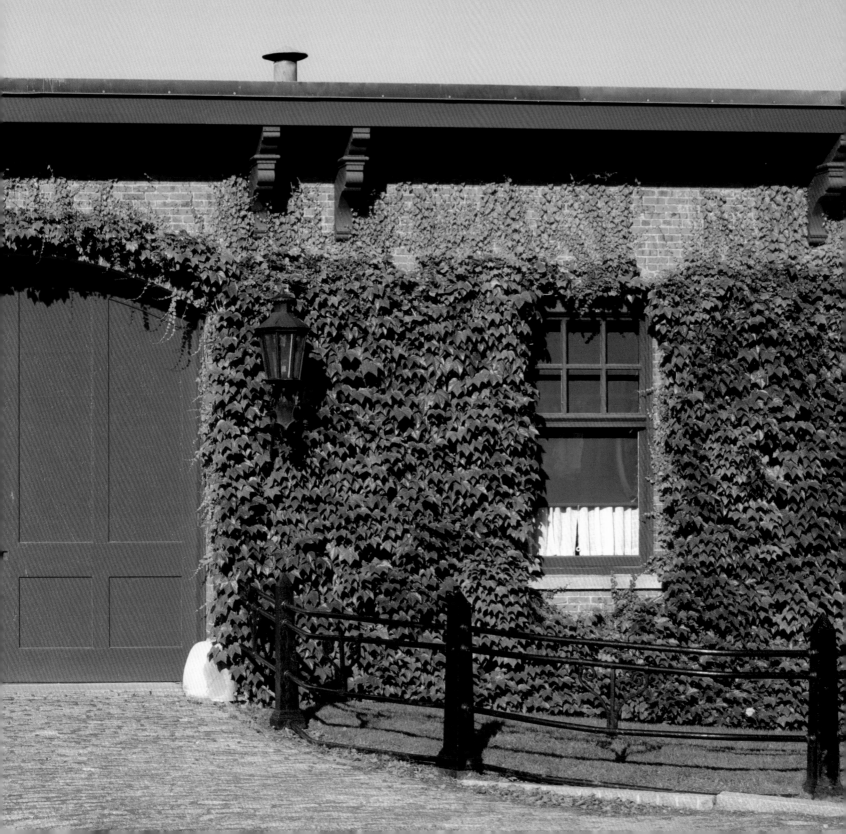

THE BREAKERS STABLES & CARRIAGE HOUSE

NEWPORT, RHODE ISLAND

PRECEDING PAGES *The 150-by-100-foot stable and carriage house was built straightforward like a bank barn, with two double-door entrances for the heavy traffic of the coach and twenty-five carriages used by Cornelius Vanderbilt II and his guests. The Breakers Stables & Carriage House is owned and administered by The Preservation Society of Newport County and is open to the public during the season.*

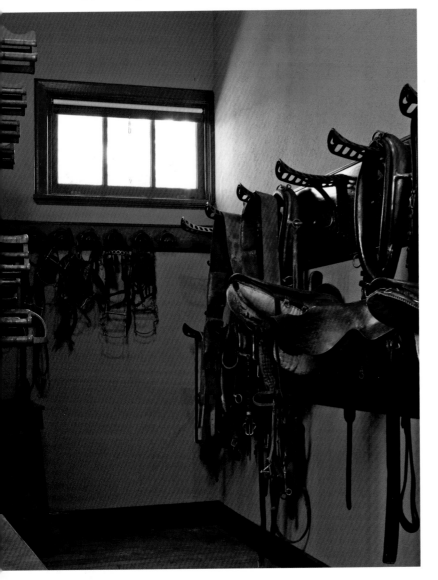

ABOVE *The tack room held well-polished leather tack for the horses that included a large selection of harnesses decorated with ornate silver trim.*

OPPOSITE *Along the back of the entire 150-foot width of the building's upper street level are twenty-six open stalls and two box stalls, with a wide aisle for maneuvering. The immaculate stalls had neat straw bedding, woven straw mats were placed around each divider post, and white sea sand was spread on the aisle that ran along the open ends of the stalls.*

When it was completed in 1895, The Breakers was a breathtaking mansion in Newport, Rhode Island, that became the summer home for Cornelius Vanderbilt II, at that time one of the wealthiest men in the world. This virtual palace was the monumental achievement of architect Richard Morris Hunt, the first American to graduate from the prestigious École des Beaux-Arts in Paris, who became one of the country's most prominent architects. Hunt's strong design was a successful blending of the fine-lined Classical and opulent Italian Renaissance styles of architecture. In contrast to this enormous marble and gilt structure, the stables and carriage house that Hunt designed was inauspicious, built of sturdy brick and 100 percent functional.

The original brick stables and carriage house had two stories with a basement. It measured 100 by150 feet and was banked into a hill a few blocks from the main house. Its street-level main floor had two sets of double doors for coach, carriage, and horse entrance and exit, a spacious carriage room, offices, and tack and livery rooms. There were also twenty-six open-tie stalls and two box stalls that opened onto a wide aisle.

The second story that had contained a large hayloft and grain storage area and two separate apartments for staff living quarters was destroyed by fire in 1970. Storage and offices in the basement open onto the 2-acre summer garden and greenhouses.

When the Vanderbilts entertained, they did so lavishly. Guests who summered at The Breakers were given access to the array of Vanderbilt horses, carriages, and drivers. While a horse-drawn vehicle was a necessity as a mode of travel, a well-appointed carriage with a pair of matching Hackneys was a fashion statement. The elegant gold-trimmed maroon livery and monogrammed brass harness fittings said *Vanderbilt* without a word. Vanderbilt fashion sense even led them to dress to match carriage interiors, a twist on the unspoken rule in English society that the satin interior of a carriage should not clash with a lady's dress.

The stables bustled with activity and provided a functional space for the continual maneuvering of many large carriages, numerous horses, and much equipment, as well as for the coordinated performance of a large staff to meet the transportation needs of many family members, household servants, and guests. In the stable there was no reason for gilt, fine carving, or imported marble—only a state-of-the-art design for maximum efficiency.

Chronology
Richard Morris Hunt, architect
1895: Stables and Carriage House
Owned by The Preservation Society of Newport County

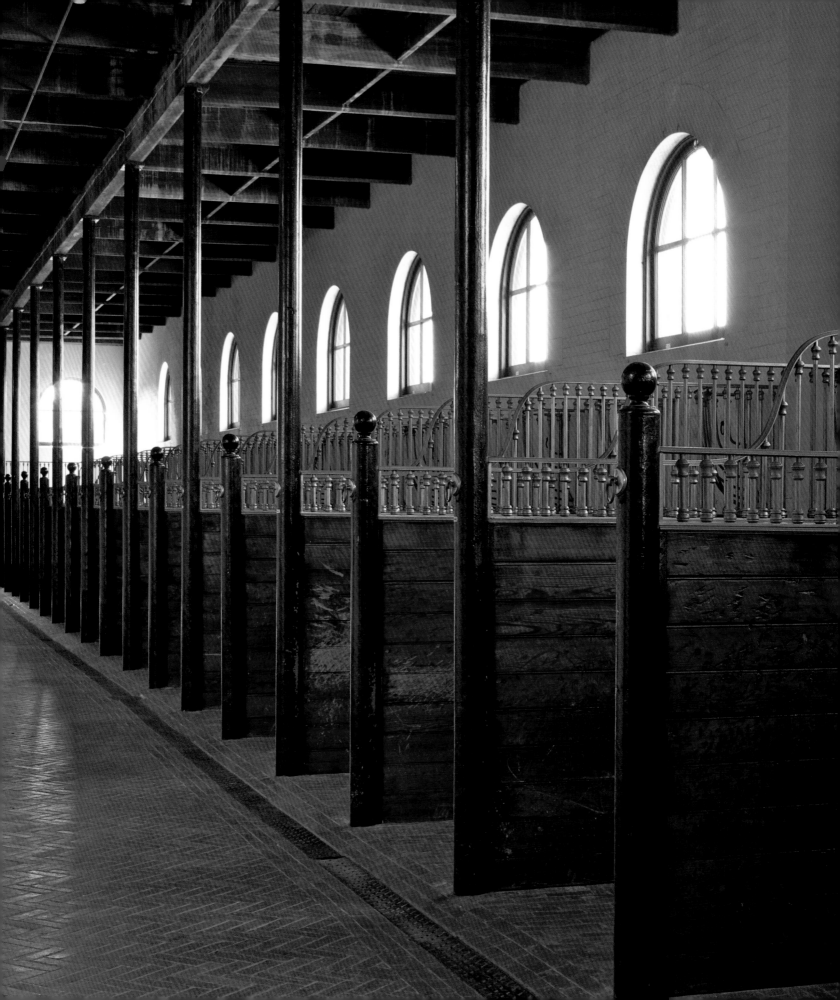

BELOW AND RIGHT *The magnificent Arts & Crafts–style stable complex at Sandy Point Stables that was originally constructed in 1906 has been undergoing phases of extensive restoration since 1994 by its new owner Ms. Jay Sargent. Completed work includes structural reinforcement and restoration of the exterior. The proud building is an important historical asset of the Portsmouth area.*

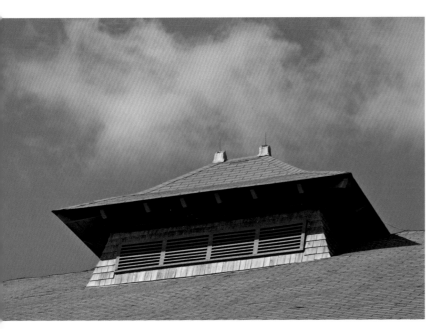

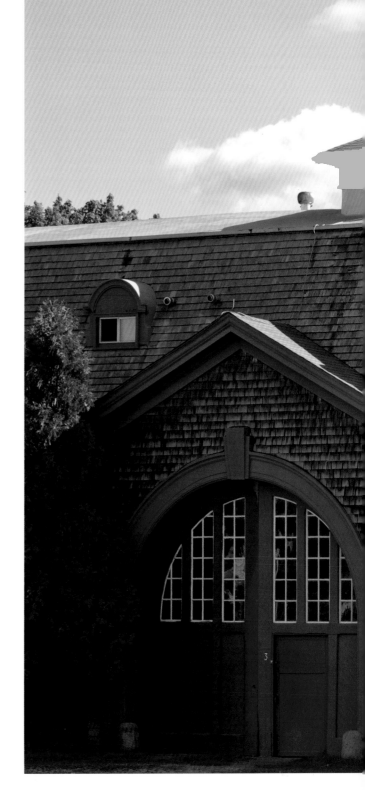

S andy Point Farm was one of the most prestigious horse farms in America during its heyday, from its grand opening in 1906 to its closing in 1925. Its owner during these years, Reginald Claypoole Vanderbilt, spared no expense in creating a spectacular showplace that was often the center of Newport, Rhode Island, society during "opening of the season" festivities.

Reginald C. Vanderbilt was a son of Cornelius Vanderbilt II who grew up at The Breakers in Newport and, when he was twenty-one, inherited $7.5 million of his father's estate and a $5 million trust fund. Although the bon vivant and avid horseman depleted most of his fortune during his lifetime, in testament to his love of horses and horse sports he created an exquisite farm that was renowned for its prominence in the horse industry and praised nationally for its prize-winning horses and other successfully bred livestock.

Vanderbilt bought the 180-acre Sandy Point Farm in Portsmouth, Rhode Island, in 1902 and developed a gentlemen's farm, the fashionable enterprise for wealthy men at the time. He restored the existing villa, constructed barns and a spectacular stable, and established what would become a leading horse breeding operation. Architect A. S. Walker designed the voluminous Arts & Crafts–style stable to include an indoor riding ring surrounded by fifty-two box stalls and

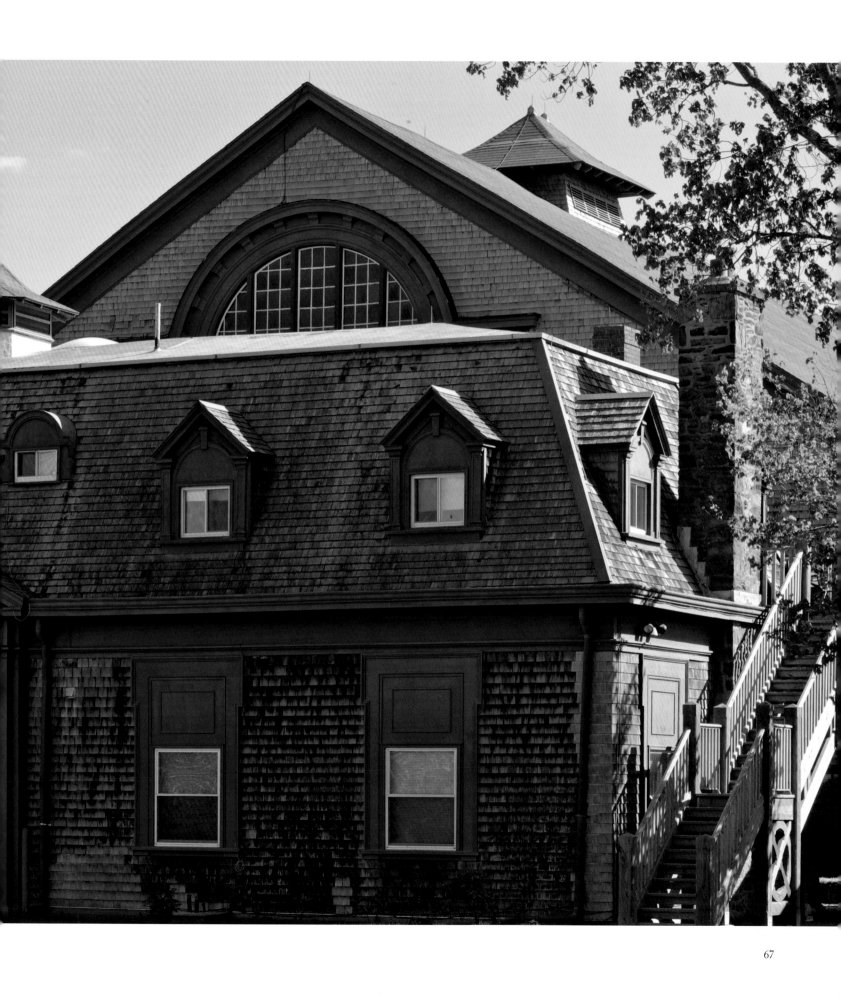

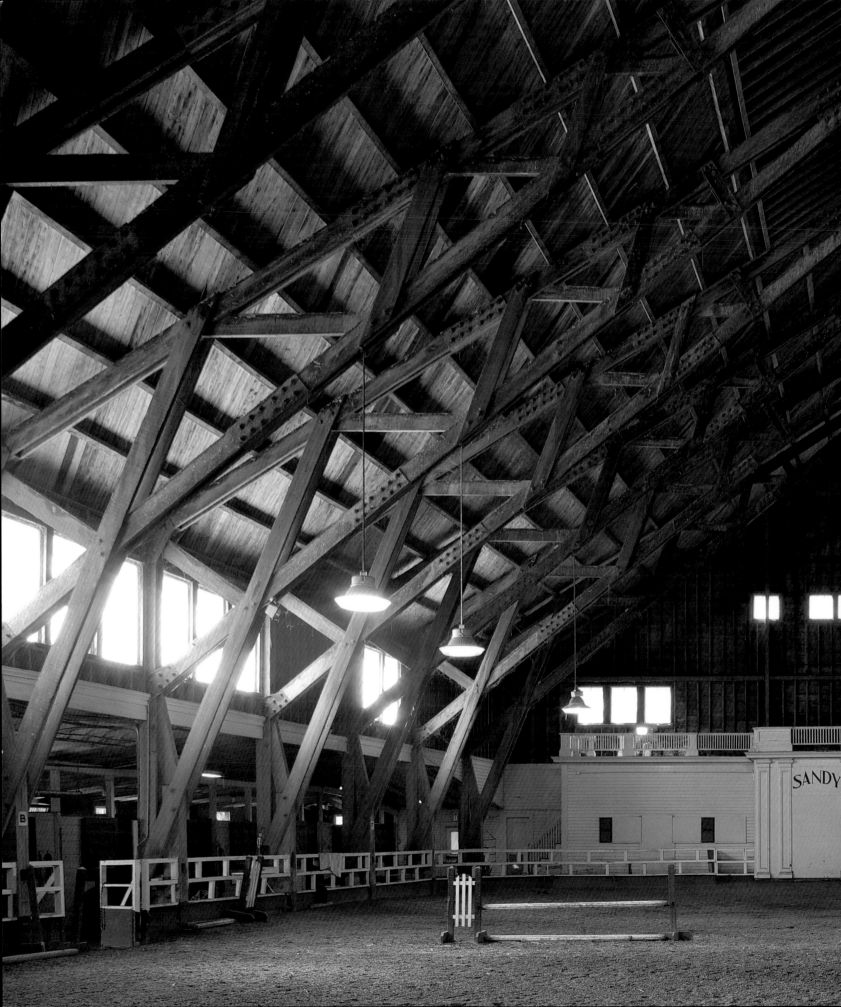

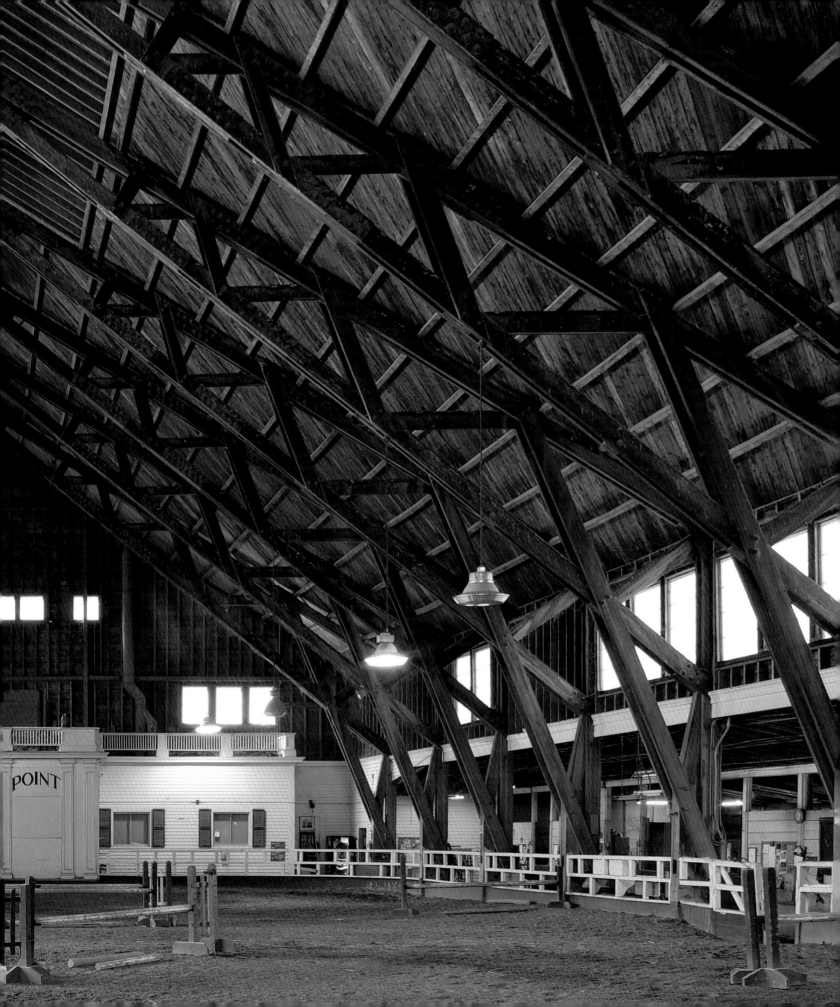

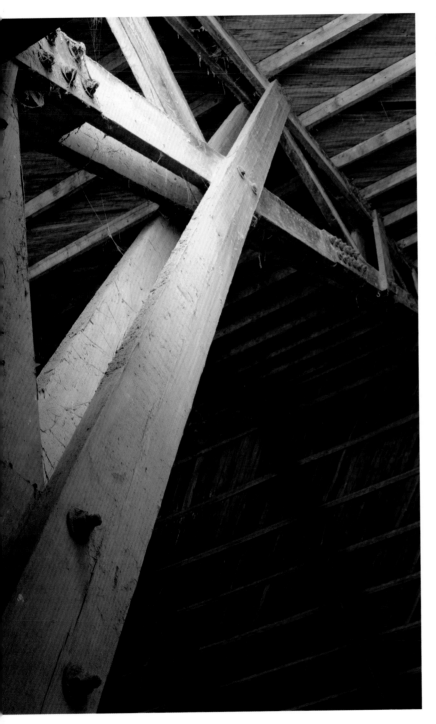

PRECEDING PAGES, LEFT, AND OPPOSITE *Beginning in 1906 with its dedication, Sandy Point Stables was an impressive showplace for its owner Reginald C. Vanderbilt, who grew up at The Breakers, his family home in Newport. He was an avid sportsman and horse breeder who produced many horse shows and exhibitions at Sandy Point Stables during the Newport society season. The mammoth space contains a training ring with a second-floor viewing gallery, stalls that surround the ring, and various offices and apartments.*

On any given day, riders and trainers may be found exercising in the huge indoor ring when they are not at horse shows throughout the country. Nine acres of Sandy Point Stables also includes pastures and outdoor riding rings that are located adjacent to the stable structure.

FOLLOWING PAGES *Sandy Point Stables is an award-winning training farm with a national reputation for excellence. It is also a show facility offering fourteen U.S. Equestrian Federation shows, including a medal day with a costume class and hunter classic.*

various functional rooms. Several barns, a coach house, a carriage house, an automobile garage, and a polo field completed the farm complex.

Vanderbilt spent his fortune extravagantly and rapidly, enjoying the world. He died in 1925, leaving his nineteen-year-old widow, Gloria (née Morgan), to sell Sandy Point Farm. In 1926 an auction dispersed the horses, equipment, and furnishings, and Moses Taylor, owner of nearby Glen Farm, bought the once grand estate. In 1965, during Glen Farm's dismantling, the portion that had been Sandy Point Farm was sold.

In 1994 Ms. Jay Sargent purchased the historic stable and 9 acres that surround it and immediately began a multimillion-dollar renovation of the historical gem. She re-roofed the structure, reframed and replaced the many windows, installed new electrical and plumbing systems, and renovated the apartments. Under her leadership, Sandy Point Stables is once again an award-winning horse training farm of national prominence. The magnificent building now stands as an integral part of the history of Rhode Island and a reminder of a glorious era in American horse sports.

Chronology

A. S. Walker, architect
1906: Stable completed and dedicated
1994–present: Restoration of stable
Owned by Ms. Jay Sargent

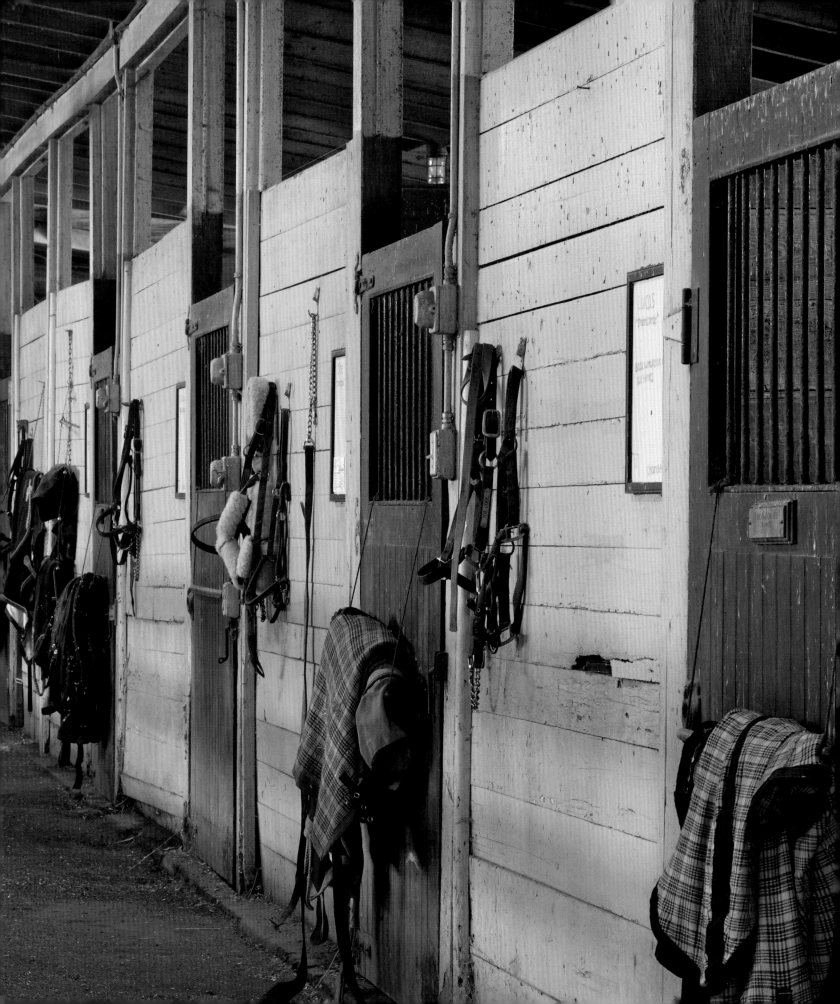

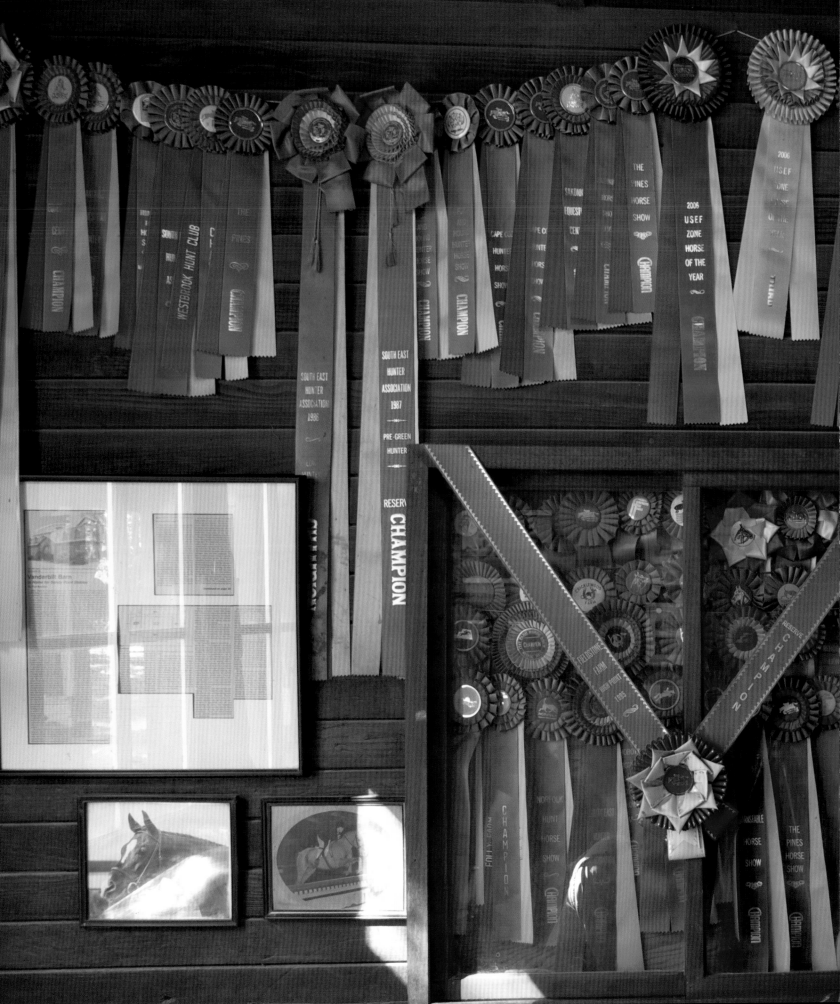

GLEN FARM STABLES

AT GLEN FARM EQUESTRIAN CENTER

PORTSMOUTH, RHODE ISLAND

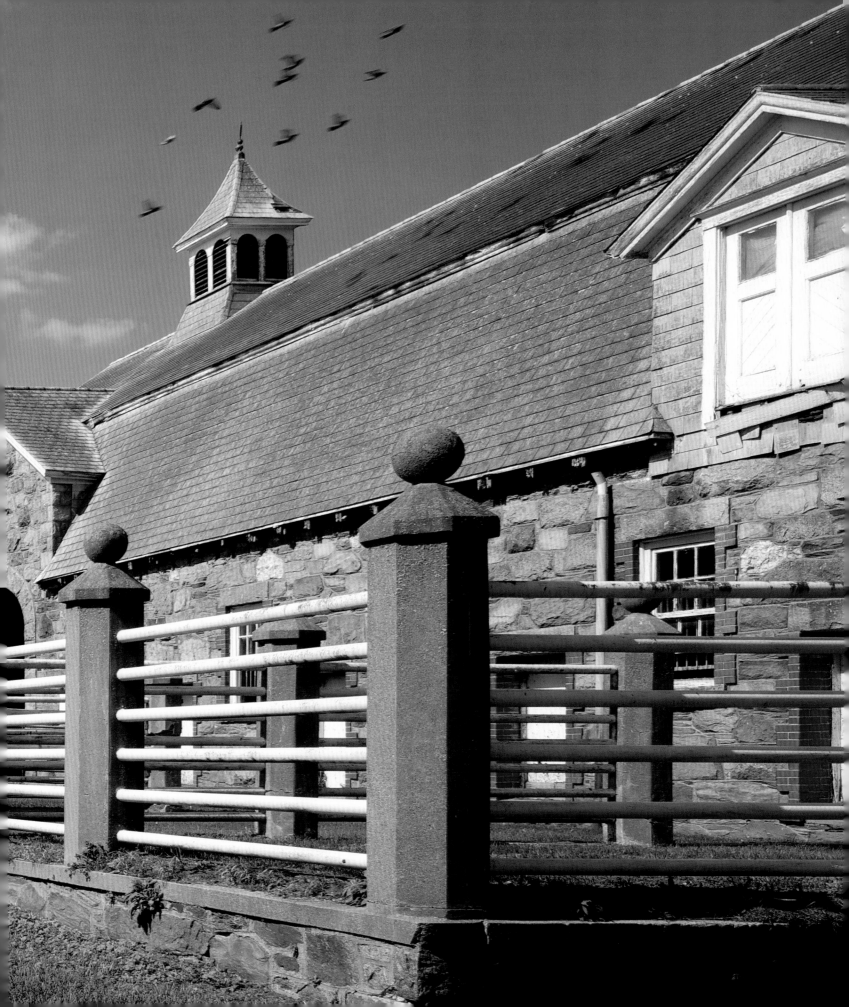

PRECEDING PAGES *The stone barns of Glen Farm Stables at Glen Farm Equestrian Center were completed between 1902 and 1911. An L-shaped structure built in 1911 has an archway at the elbow that leads to the pastures in back. On either side of the arch are the training barn and the coop that once held prizewinning bulls.*

ABOVE AND RIGHT *The main horse barn is a freestanding structure constructed in 1907 that is located beside the training barn and coop (seen here to the right). The main horse barn once stabled the original owner's prizewinning Thoroughbreds, Percherons, and Saddlebreds.*

A valley of broad, fertile fields traversed by streams close to the ocean was the home of the Native American Narragansett tribe prior to European settlement. Religious followers of Roger Williams, founder of Providence Plantation, established the town of Portsmouth in 1638 and began to farm the Rhode Island valley. During the nineteenth century the Industrial Revolution turned many entrepreneurs into multimillionaires for whom a second home was an important status symbol. It became fashionable for the wealthy from New England and the Midwest who summered in Newport to have nearby country places in addition to their houses in town. On these the owner could live in an extravagant country seat and become a gentleman farmer.

From 1882 to 1909, Henry A. C. Taylor, a member of Newport's society set, purchased contiguous farm properties in Portsmouth and created the 700-acre Glen Farm. Here he ran an innovative livestock and dairy operation and an impressive horse breeding and training program that brought Glen Farm national prominence. Moses Taylor, Henry's son and a successful New York businessman, succeeded his father as

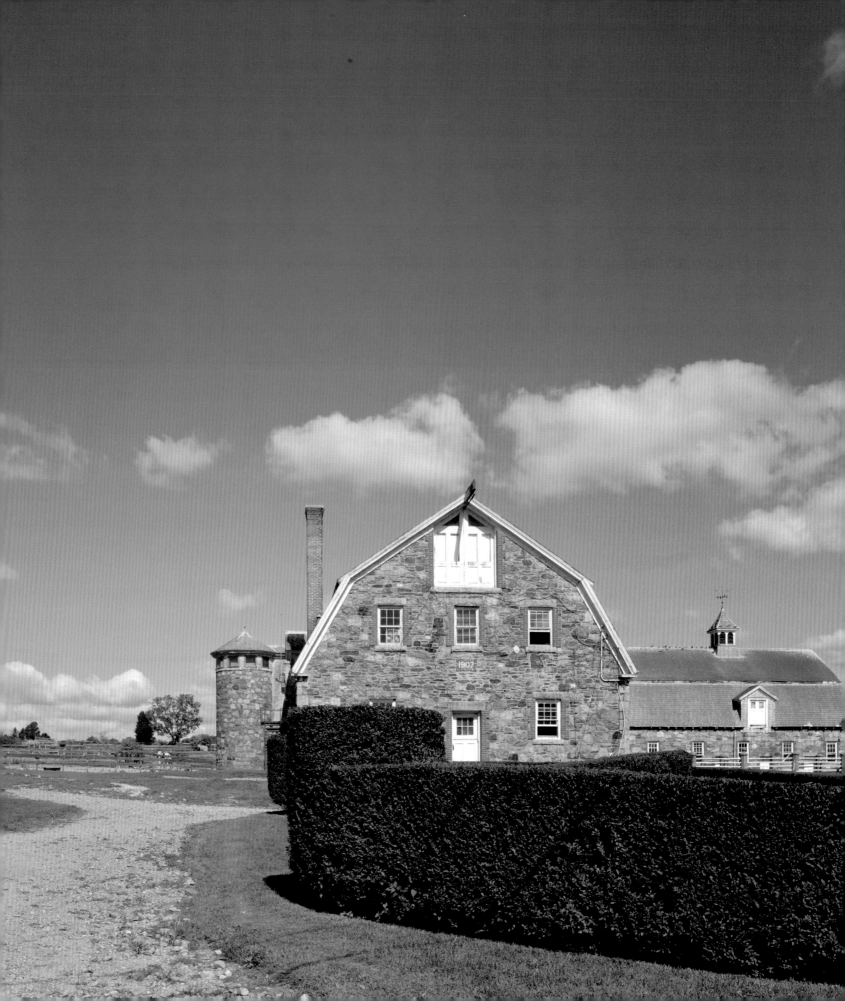

LEFT AND RIGHT
The main horse barn has eighteen spacious stalls and is used to house show horses.

FOLLOWING PAGES
Chill Factor, a 28-year-old bay Thoroughbred, peruses the back fields of Glen Farm. The 1926 wood-shingled schooling barn compliments the stone structures. Today it is used for rough-board and full-board horses, and for polo ponies of Newport polo players who come for the summer season.

farm owner in 1921, continuing to produce prizewinning Guernsey cows as well as Percherons, Thoroughbreds, and Saddlebreds.

The wooden schooling barn was built in 1926, but the limestone and wood barns were completed between 1907 and 1911. The Arts & Crafts–style buildings create one of most picturesque horse farms on the East Coast.

The fortunes of Glen Farm have fluctuated, and in 1989 it and the surrounding 86 acres were sold to the Town of Portsmouth. One year later businessman Dan Keating began a monumental ten-year renovation that returned Glen Farm to excellent condition and established it as home to the Newport Polo Club and the Newport International Polo Series. Today Ted Torrey holds the lease. Torrey is a lifelong equestrian, international eventing competitor, and polo player who trained horses for many years, then coached the polo and jumping teams at Valley Forge Military Academy and College. He now runs a training and boarding facility at the Glen Farm Equestrian Center and heads the polo competition for the Newport Polo Association.

The Newport Polo Club is still registered in its original name, the Westchester Polo Club, which was the first in the country. With its prestige and popularity, Newport is considered by many to be the polo center of America. Glen Farm, evocative for its Arts & Crafts architecture, wide-open polo fields, and country lanes, represents a bygone era, but more importantly, has become a vital and active equestrian facility.

Chronology

1907: Main horse barn
1911: Training barn and coop (cow barn)
1926: Schooling (polo) barn
1990: Restoration

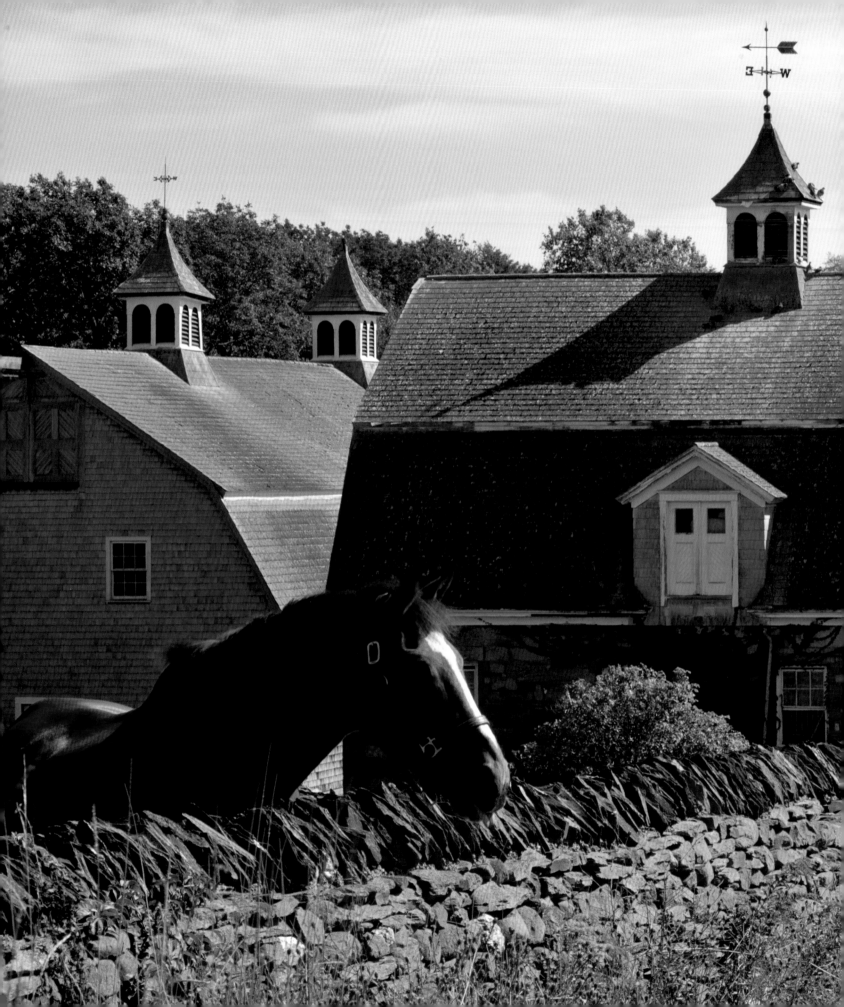

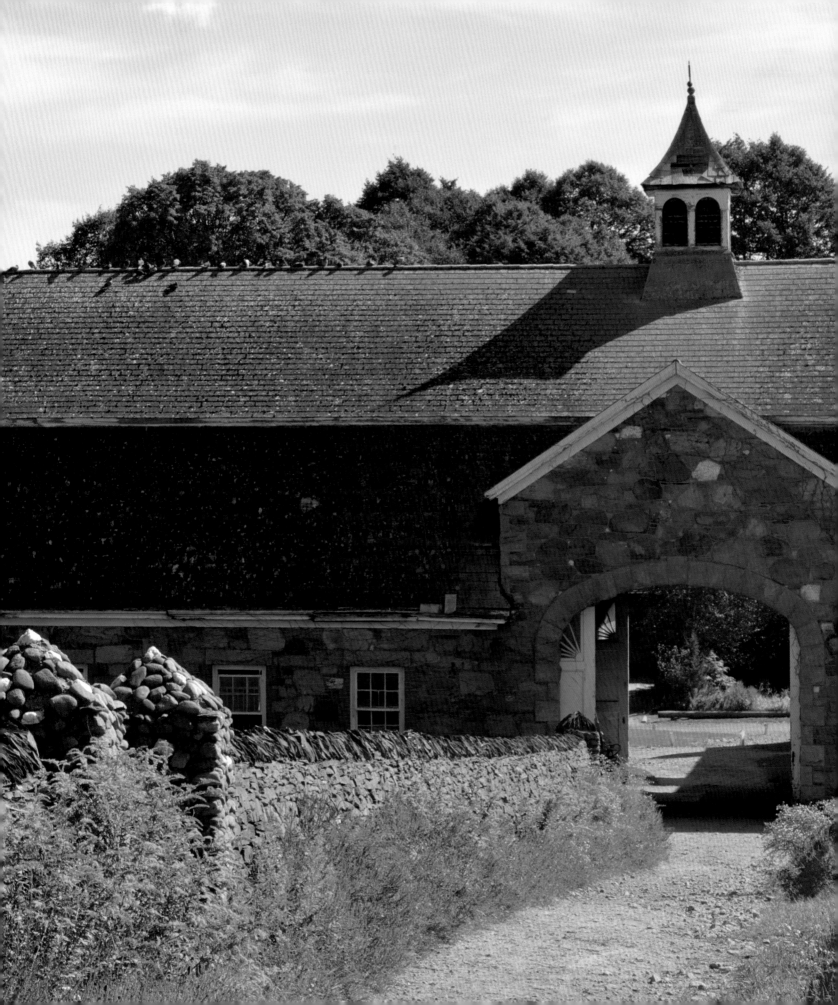

HUNTLAND

MIDDLEBURG, VIRGINIA

PRECEDING PAGES *The Georgian-inspired stable complex at Huntland has thirteen hunter boxes, four straight standing stalls for workhorses, a tack room and washroom, a carriage house and lift, and a second story with grooms' living quarters, haylofts, and grain storage. Huntland was reputedly America's preeminent sporting complex during the years 1911 to 1927. Photo by Janet Hitchen.*

ABOVE AND OPPOSITE *The multimillion dollar, historically accurate restoration of every detail of the stables is done by a team of experts led by master carpenter Clifford Heaven, from Surrey, England, and the contracting firm of Jerry Coxsey, under the careful eye of Dr. Parker. Extensive work includes unseen work on the infrastructure, resurfacing the courtyard and all of the stalls, re-stuccoing and repainting all of the stucco surfaces, refinishing all original wood, installing new standing-seam metal roofs, and refurbishing all of the ironwork. A new riding ring for show hunters and jumpers was also built.*

Ideally, the project of preserving valuable historic architecture that includes, in this case, a fine manor house and significant kennel and stable complexes would take the exactness of a scientist, the discernment of a vicar, the passion of a lifelong equestrian, and the patience and love of a mother. Fortunately for Huntland, one of the most famous and yet, until now, unrestored plantations in the hunt country of northern Virginia, its new owner, Dr. Betsee Parker, is all of these. For years she and her late husband, Irwin Uran, had admired Huntland, but its purchase always seemed to elude them. In 2007, however, Parker was able to purchase the property and suddenly found herself the owner of an historic gem and an incredibly large and complex restoration project.

The original plantation house, a fine brick manor then called New Lisbon, was designed in the Federal style and built in 1837 by William Benton. Huntland owes its enduring presence in part to the sturdy construction of the main house, kennels, and stables, all structures whose strong bones enable Parker's worthwhile and painstaking restoration.

The theme of the estate changed in 1911 when Joseph B. Thomas, a wealthy New York developer with a superior talent for breeding hounds and a passion for foxhunting, bought New Lisbon. He changed its name to Huntland and began its transformation into a country seat. He became an active member of the foxhunting community, serving as master of both the Piedmont and Middleburg hunts before his departure and sale of Huntland in 1927. By that time

Huntland was American's preeminent foxhound breeding enterprise and foxhunting stable.

Thomas enhanced the historic property with state-of-the-art kennel and stable complexes in 1911 and 1913 respectively, designed to match the elegant Federal manor house, which was transformed into a magnificent country house where he and his wife, the former Clara Fargo, welcomed the leading socialites and politicos of the day. The quadrangle layout and design of the stables were derived from those Thomas had seen in Europe and England, and together with the kennels it comprised arguably the finest hound and hunter facilities in America.

Parker is dedicated to an authentic, detailed restoration that ensures respect for the integrity of the structures. Her vision includes not only the resurrection of Huntland's manor house but the protection of more than 300 acres put into conservation easement and a fully functional sports center alive with show horses, hunters, and riders enjoying each other and the ambiance of a now-again glorious estate.

Chronology
1837: Manor house; 1915: Remodel; 2009: Restoration
1911: Kennels
1913: Stables
2009: Stable restoration; training ring
Owned by Dr. Betsee Parker

OPPOSITE TOP *Stalls were painted using the original colors of creamy-white and terra-cotta red with sharp bands of black. In the oversized wash stall, an authentic pine bead board ceiling was stripped and stained to match the initial color. After Parker deciphered the original herringbone pattern on the wash stall floor from a few remaining patterns in the old masonry foundation, she had the entire floor installed in antique period bricks to match.*

OPPOSITE BOTTOM LEFT *The original grain cleaner, patented in 1893 by J.W. Fiske Co. in New York, uses a series of chutes to innovatively separate the whole grain from the chaff as it descends from the grain bins above.*

OPPOSITE BOTTOM RIGHT *All ironwork, of which ninety-five percent is original, was stripped, repainted, and reinstalled.*

RIGHT *Stall door hinge poles are bowed outward, allowing doors to stay open. The brass flashing on the tops of the lower stall doors is a useful, elegant design detail.*

FOLLOWING PAGES *Georgian symmetry gives the sporting compound an organized, formal air. An arch at the back of the stable quadrangle leads from the courtyard to the back pastures and a new state-of-the-art riding ring with synthetic footing. The stables are home to Parker's many hunters and her acclaimed ponies Vanity Fair, For the Laughter, Elation, and Liseter Clever Star. Among numerous championships, in 2009 Vanity Fair was Grand Champion Pony Hunter at Devon, and For the Laughter was Grand Pony Champion at the Pony Finals in Lexington, Kentucky. Photo by Janet Hitchen.*

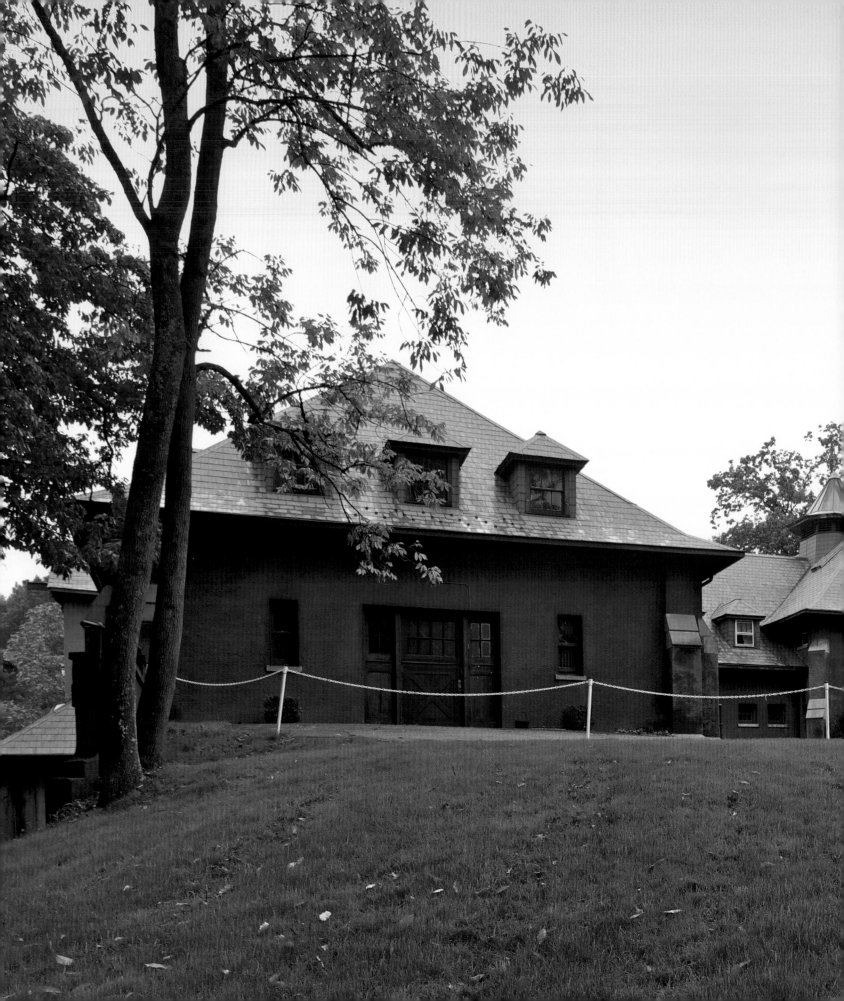

UNITED STATES EQUESTRIAN TEAM FOUNDATION CENTER

AT HAMILTON FARM

GLADSTONE, NEW JERSEY

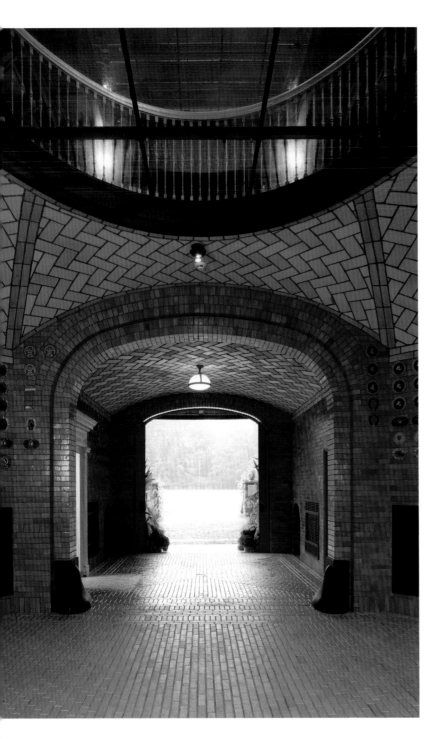

PRECEDING PAGES *Hamilton Farm was an extensive 5,000-acre working farm with an impressive stable complex that was completed in 1917 by owner James Cox Brady, who made the stables the most popular site for hunt meets and social gatherings. Today the stable complex is owned by the U.S. Equestrian Team Foundation and used as its headquarters. The Foundation supports the participation of U.S. athletes in all disciplines who represent the United States in all major international competitions including the Olympic Games and the Pan American Games.*

LEFT *The interior of the stable complex is a spectacular, gleaming showplace. All surfaces are entirely covered in glazed terra-cotta tiles or laid in patterns of terrazzo bricks.*

OPPOSITE *A display case at the top of the stairs in the upper level meeting room houses a selection of prize ribbons won by outstanding equestrian athletes throughout the U.S. Equestrian Team's history.*

Hamilton Farm in New Jersey, created by James Cox Brady, was an immense working farm of 5,000 acres that included an extensive stable complex that was state of the art when it was finished in 1917. The land thrived as a working cattle, sheep, pig, chicken, and dairy farm until Brady's death in 1927, at which time the enterprise ended.

The horse stable was the spectacular centerpiece of the farm and was designed by William Weissenberger Jr., a New York architect, to be the most beautiful, functional, and extensive facility in America at that time. The building is large and elegant, turned into a sparkling showplace by its exceptional interiors, where walls and vaulted ceilings are covered in shiny, glazed tiles, floors of the spacious octagonal foyer and halls are laid with terrazzo bricks in interwoven patterns, and fifty-four 12-by-12-foot box stalls are fitted with solid brass hardware.

During World War II the large stable complex was used as an emergency hospital, but in 1961 horses again filled the stalls when the U.S. Equestrian Team leased the property for its headquarters and training facility. In 1978 Beneficial Management Corporation purchased the stables, other buildings, and 500 surrounding acres, and in 1988 it donated the equestrian facility and 7 ½ acres that surrounded it to the United States Equestrian Team. Historically, equestrian teams that represented the United States at international events, including

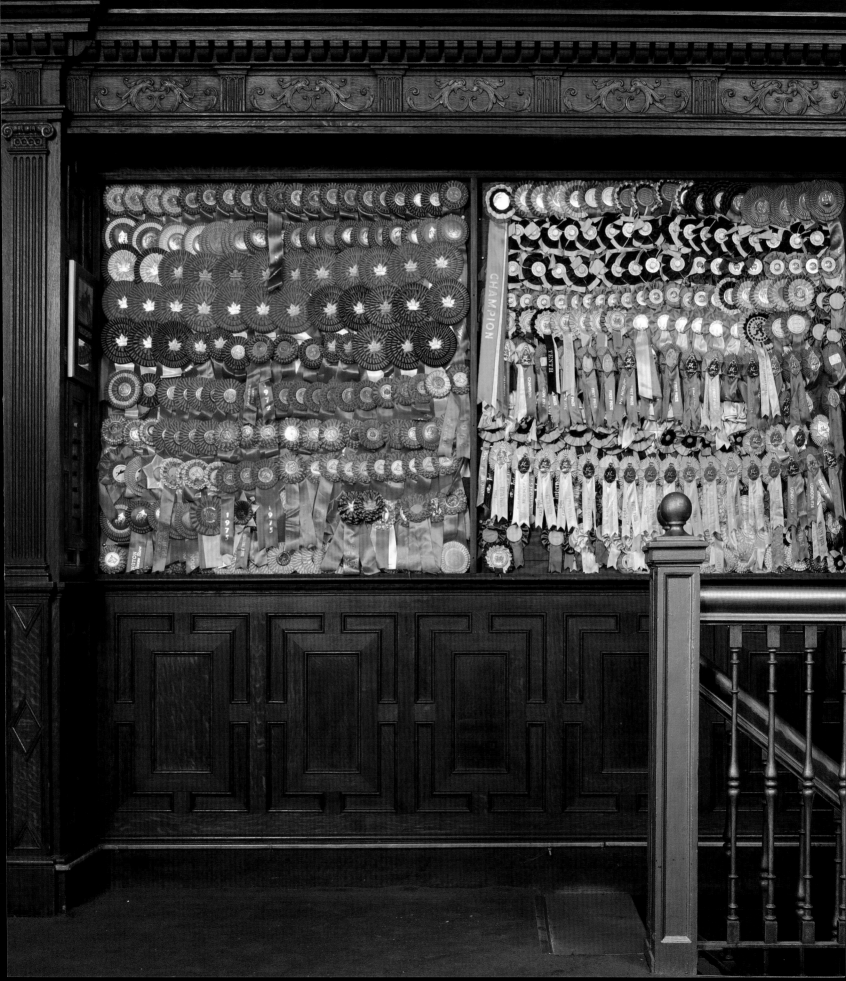

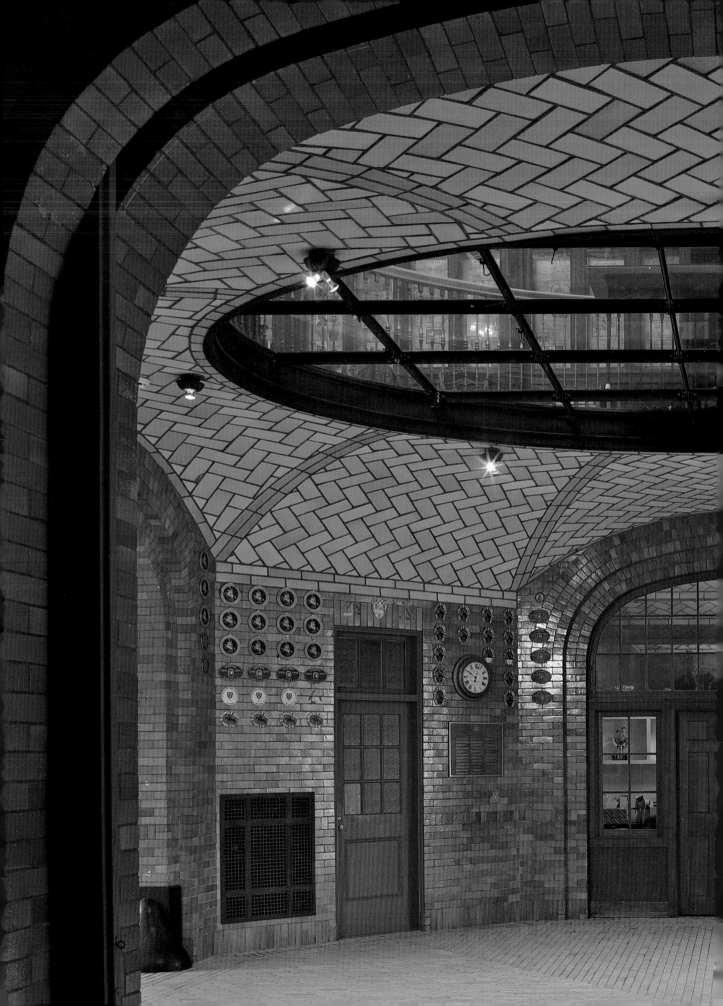

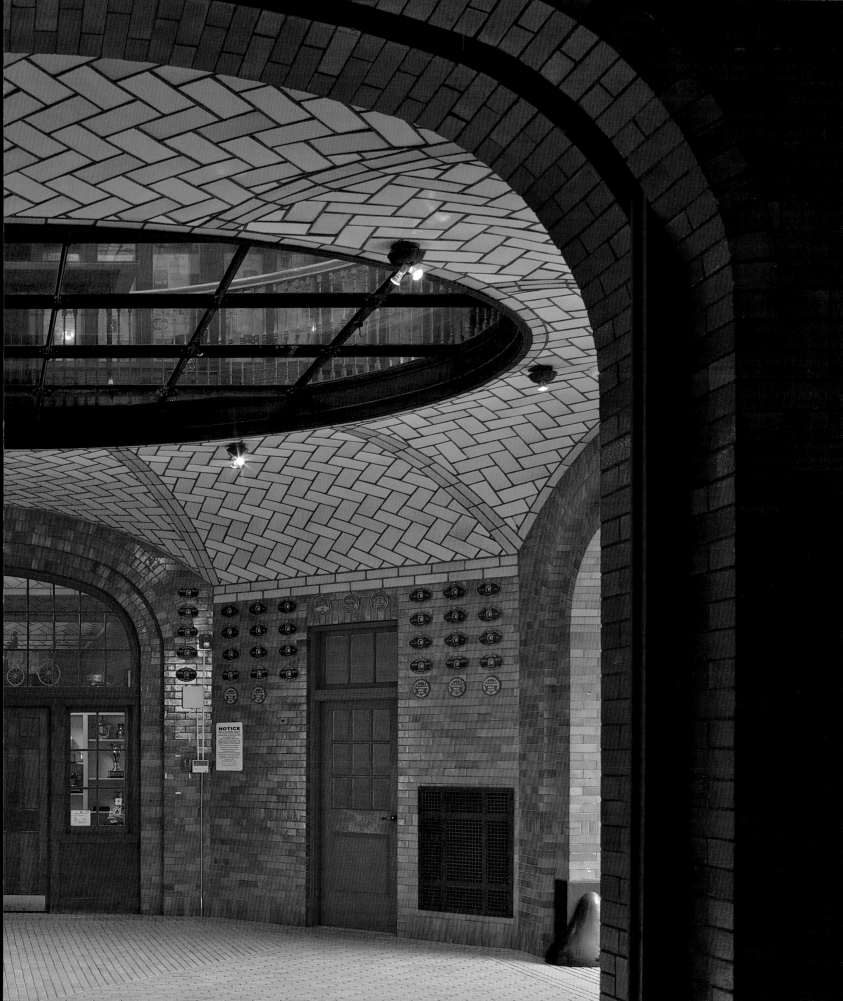

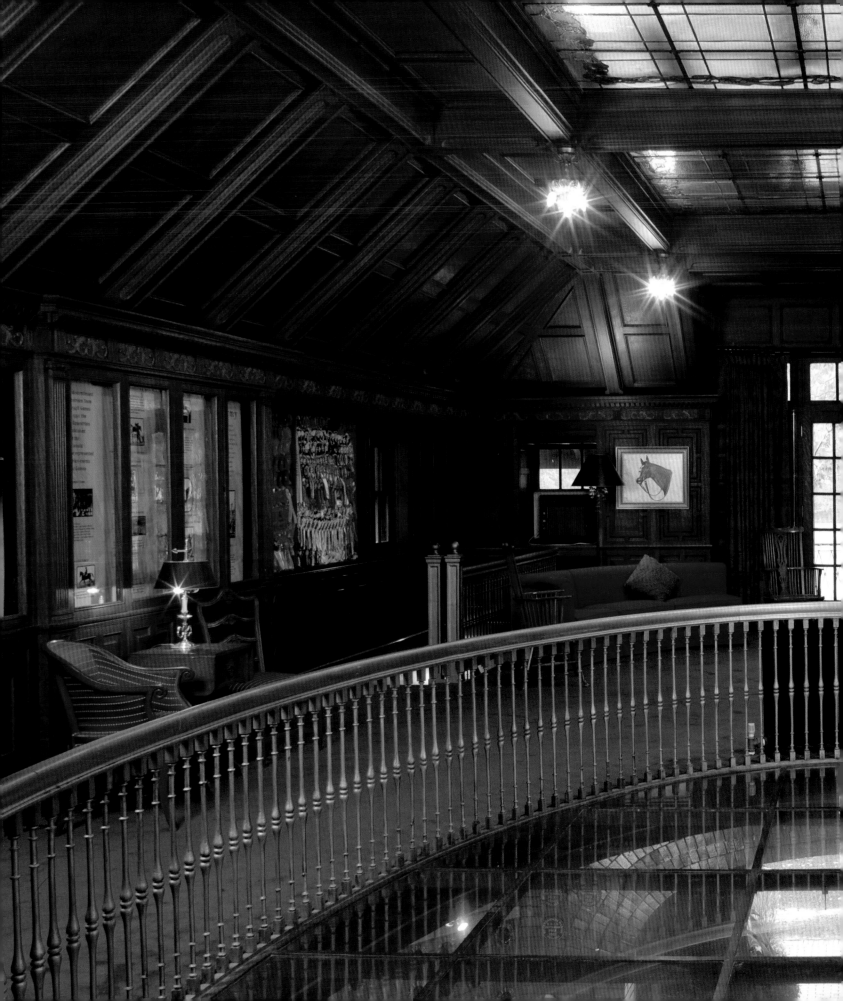

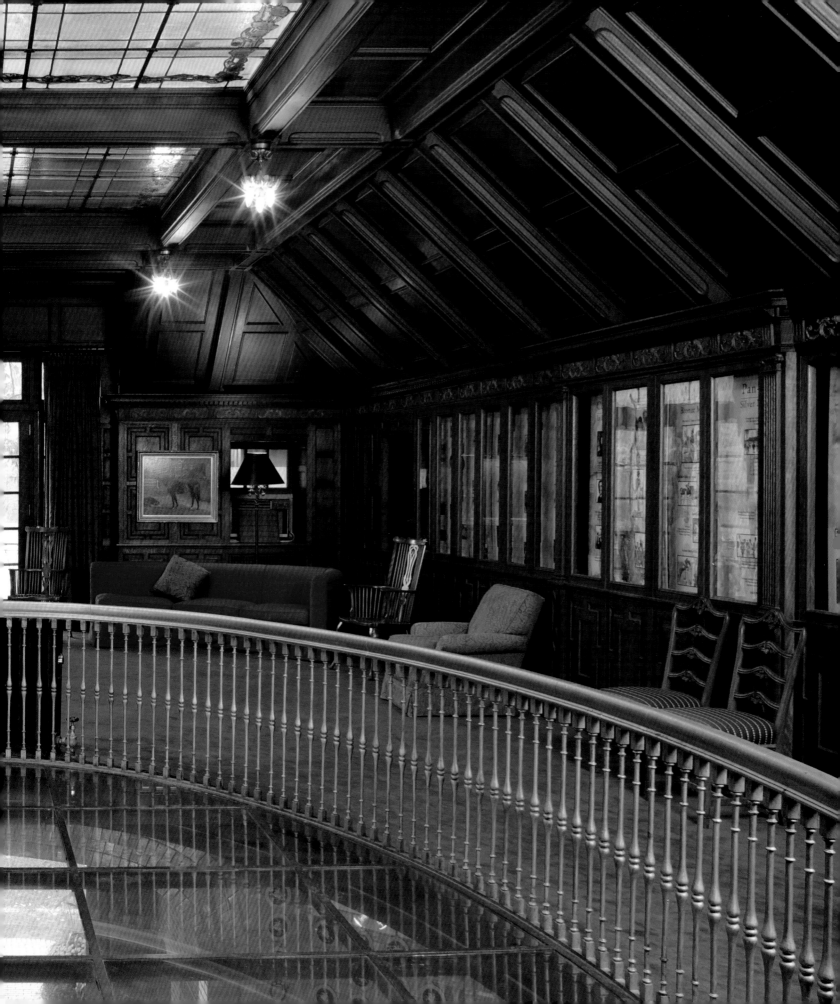

PAGES 94–95 *The entry foyer has an oval-shaped, plate-glass skylight in the rotunda ceiling that allows those in the upper viewing room to see activity on the main floor. Originally Brady used it to view his horses being harnessed or tacked up. It is now a reception area. The double doors lead to the wing of the building that now houses the U.S. Equestrian Team Foundation offices. The wing opposite contains the horse stalls.*

PRECEDING PAGES *The upper level viewing room is used for informal gatherings. Its walls are filled with display cases with historic photographs featuring members of the U.S. Equestrian Team at events that include the Olympic Games and the Pan American Games.*

RIGHT *Fifty-four 12-by-12-foot box stalls are fitted with solid brass hardware and cork footing. Etched brass plates identify some of the stalls as those of benefactors of the U.S. Equestrian Team Foundation. Ceiling, wall, and floor surfaces completely covered in herringbone patterns of glazed or terrazzo tiles create a stunning interior.*

FOLLOWING PAGES *Besides the fifty-four stalls, the stable complex has ample space for offices and storage; twenty-five rooms were originally designed as living quarters for staff, game rooms, storage areas, offices, and a carriage house.*

the Olympics, were comprised of members of the U.S. Cavalry. After the U.S. Equestrian Team was founded in 1950, the equestrian center at Hamilton Farm initially provided a training facility for these athletes, who now train at remote locations. The center has evolved into being the headquarters for the USET Foundation. The Foundation's offices fill one section of the elegant stable while the stalls in the other section are ready for horses participating in equestrian events, including the Essex Horse Trials and the Festival of Champions.

Chronology
1917: Stables at Hamilton Farm
Owned by The United States Equestrian Team Foundation

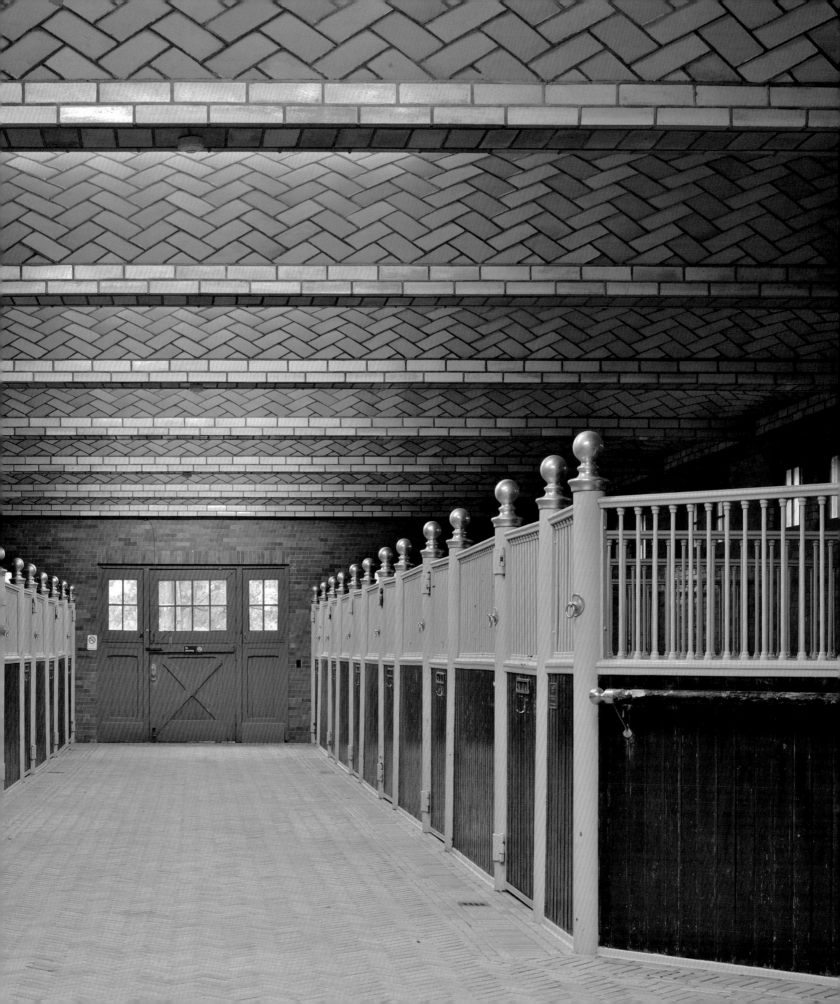

SAGAMORE FARM

GLYNDON, MARYLAND

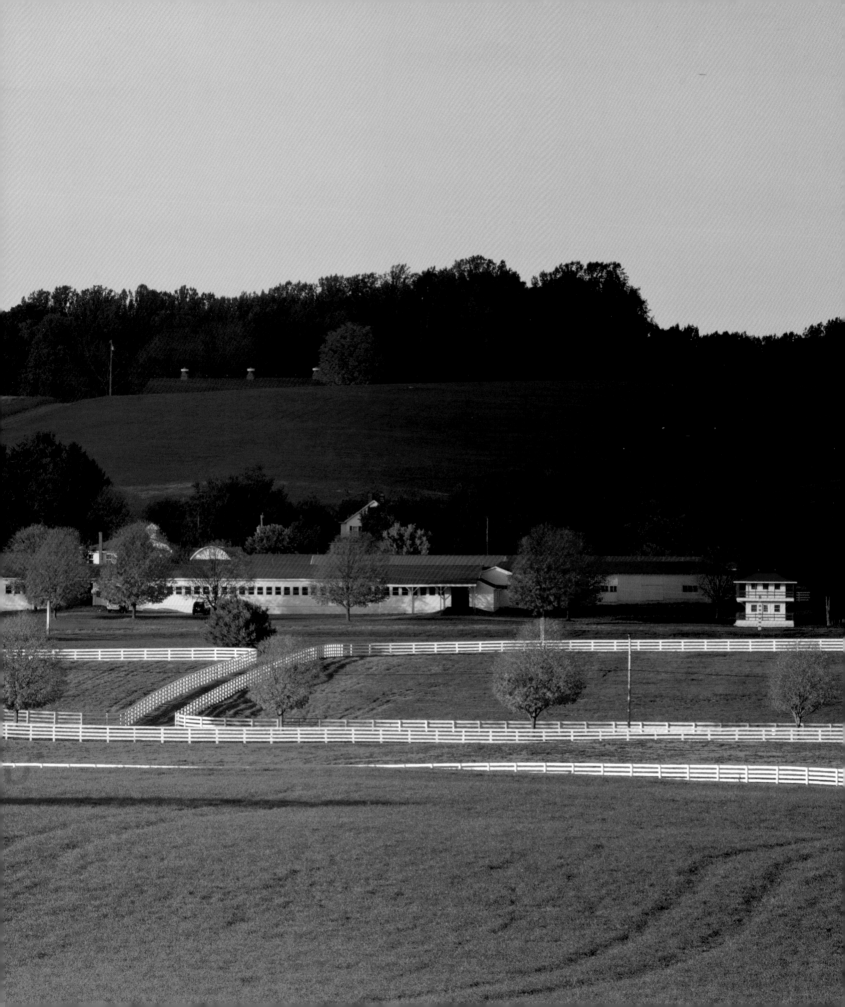

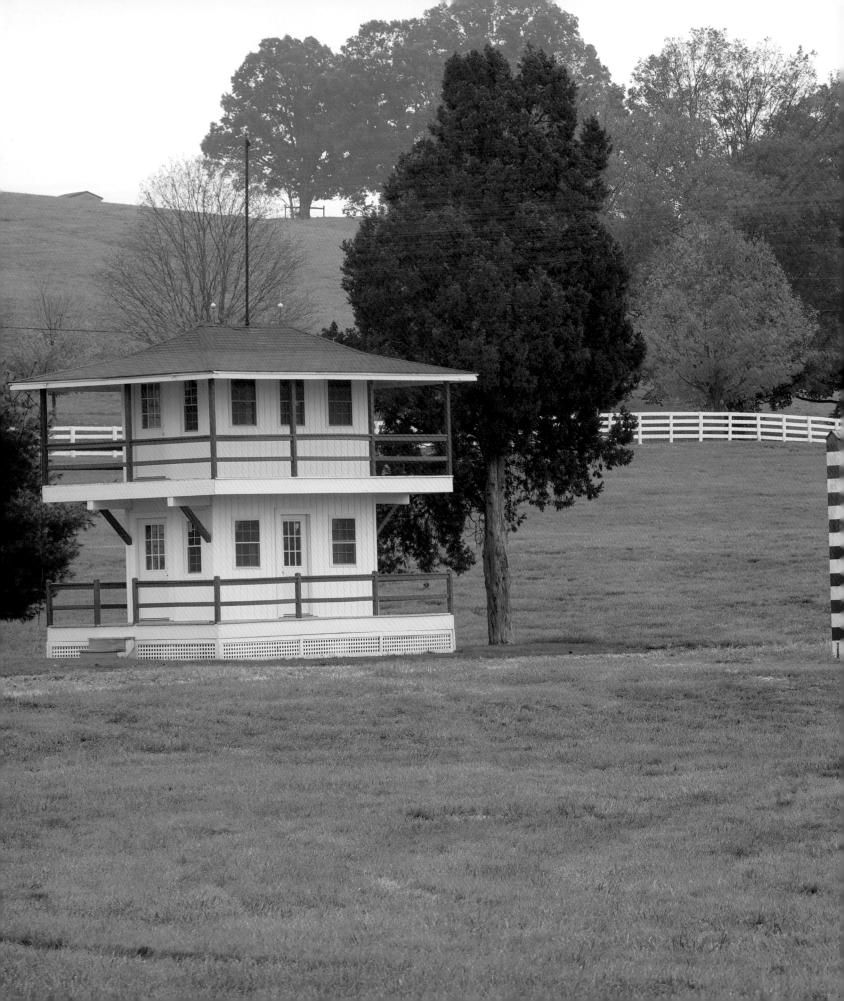

PRECEDING PAGES *New owners Kevin and DJ Plank began a comprehensive twenty-year restoration of the buildings and grounds of historic Sagamore Farm, hiring architect John Blackburn's firm Blackburn Architects, P.C., of Washington, D.C,. for the restoration. Of the project Mr. Blackburn says, "I never pass up an opportunity to 'save' an old barn. In the case of Sagamore, I was especially thrilled to be involved in a project with such a remarkable history."*

LEFT *The outdoor training track was renovated for use by the seven horses currently in training at Sagamore Farm. The pastures of the 530-acre Thoroughbred breeding and training facility are fully revitalized with replanted grasses that set the striking red-roofed white buildings against a backdrop of emerald green.*

When Sagamore Farm, in Glyndon, Maryland, was purchased in 2007, its new owner, Kevin Plank, a Maryland native and founder and CEO of Under Armour, the multi-million dollar-sportswear company, became the second young man in the farm's illustrious history to allow his passion for Thoroughbred racing to guide him to envision this place as a world-renowned leader in the horse industry. Plank's goal for the 530-acre horse farm to become the home of champions was also that of Alfred Gwynne Vanderbilt II, who was given the farm by his mother, Margaret Emerson Vanderbilt, in 1933 for his twenty-first birthday.

In a grand way, Vanderbilt created one of the country's most memorable and significant horse breeding farms from the purchase of his first horse in 1933. Sagamore Farm became successful in the 1940s, but it was during the 1950s and 1960s with Native Dancer, the Vanderbilt-bred foal who was raised, trained, and stood stud there until his death in 1967, that Sagamore's fame soared. The farm's renown grew through the years, with a long succession of stakes winners and Vanderbilt's promotion of Sagamore Farm and Maryland racing.

With a conscientious twenty-year plan, Plank hopes to renew the prestige of the farm and help raise Maryland to its former place as one of the power players in the horse racing world. Plank, like Vanderbilt, has the youth, energy, and determination to make his vision reality. And, like Vanderbilt, anything he does at Sagamore Farm is first-class.

ABOVE, RIGHT, AND FOLLOWING PAGE, LEFT *Sagamore Farm's signature bold red and white racing colors add a graphic vitality to the exteriors and interiors of the various barns. The huge circular training barn with its quarter-mile indoor track and stalls for ninety horses will undergo restoration in the future.*

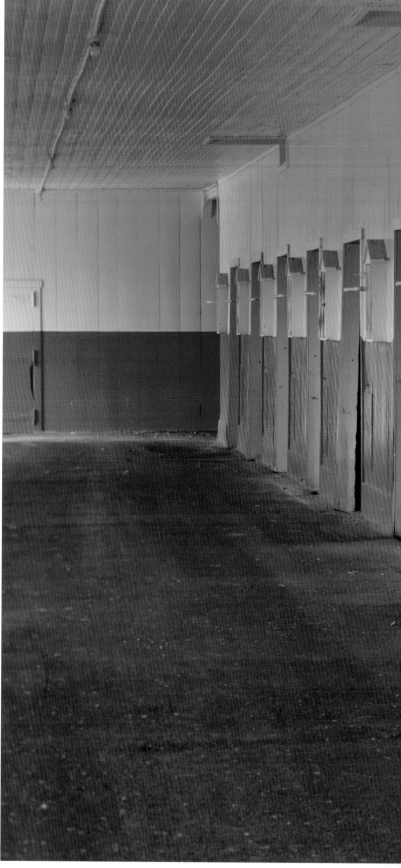

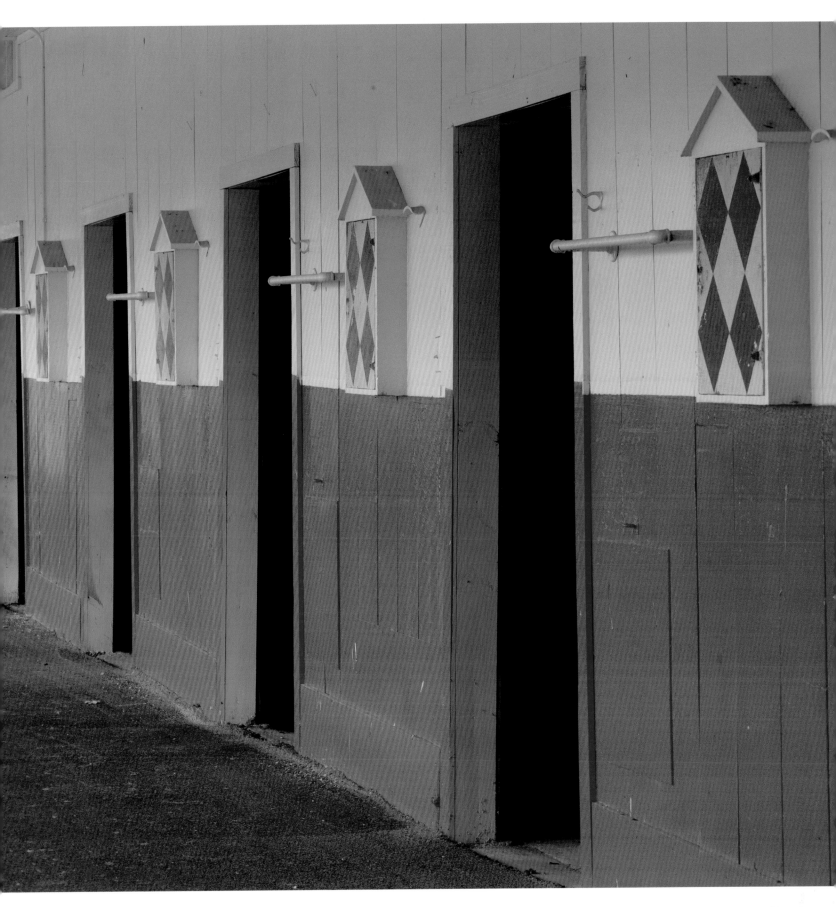

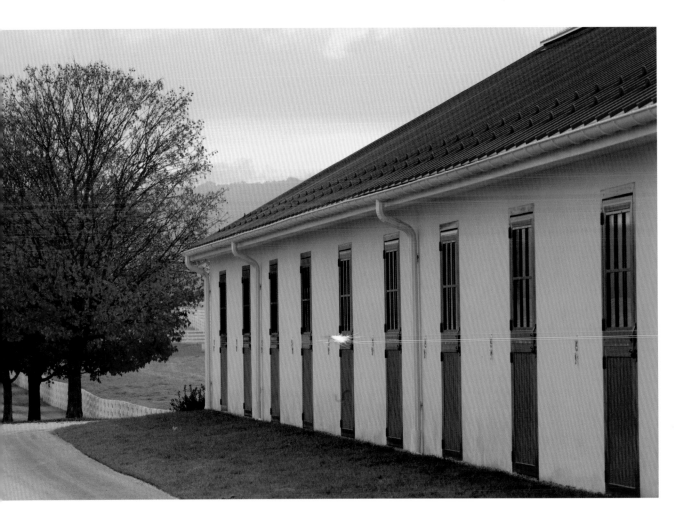

ABOVE AND OPPOSITE *Explaining his work on the broodmare barn, project architect John Blackburn, owner of Blackburn Architects, P.C., states, "The updated broodmare barn facilitates superior natural light and ventilation while preserving the integrity of the historic structure. It was important to incorporate details that define Sagamore Farm, such as the red, black, and white color scheme and the old roof ventilators on each barn. The result is a barn modernized for health and safety. A continuous ridge skylight and recycled rubber brick flooring are new elements that help revive Sagamore's appeal and functionality."*

FOLLOWING PAGES *The Maryland countryside provides a luscious backdrop of fall foliage for Sagamore Farm, one of the most beautiful horse farms in America.*

Plank has assembled a strong team of professionals to bring his vision of a glorious Sagamore Farm to fruition. First, he hired Thomas Mullikin, a longtime friend who moved from Paris, Kentucky, to run the farm and confer with Plank on purchases of breeding stock. Preservation of the iconic farm's scenic beauty and its transformation into a state-of-the-art facility was entrusted to Blackburn Architects, P.C., from Washington, D.C., a firm with a reputation for excellence and more than twenty-five years of expertise in equestrian architectural design, who Plank believed would be sensitive to the significant fabric of the property while renovating the historic barns.

Sagamore Farm's transformation is well under way, and with seven horses currently on the farm, it's en route to making its mark in horse racing once again.

Chronology
1925: Foaling, broodmare, stallion, and training barns
2008: Restoration of foaling and broodmare barn (Blackburn Architects, P.C.)
Owned by Kevin and DJ Plank

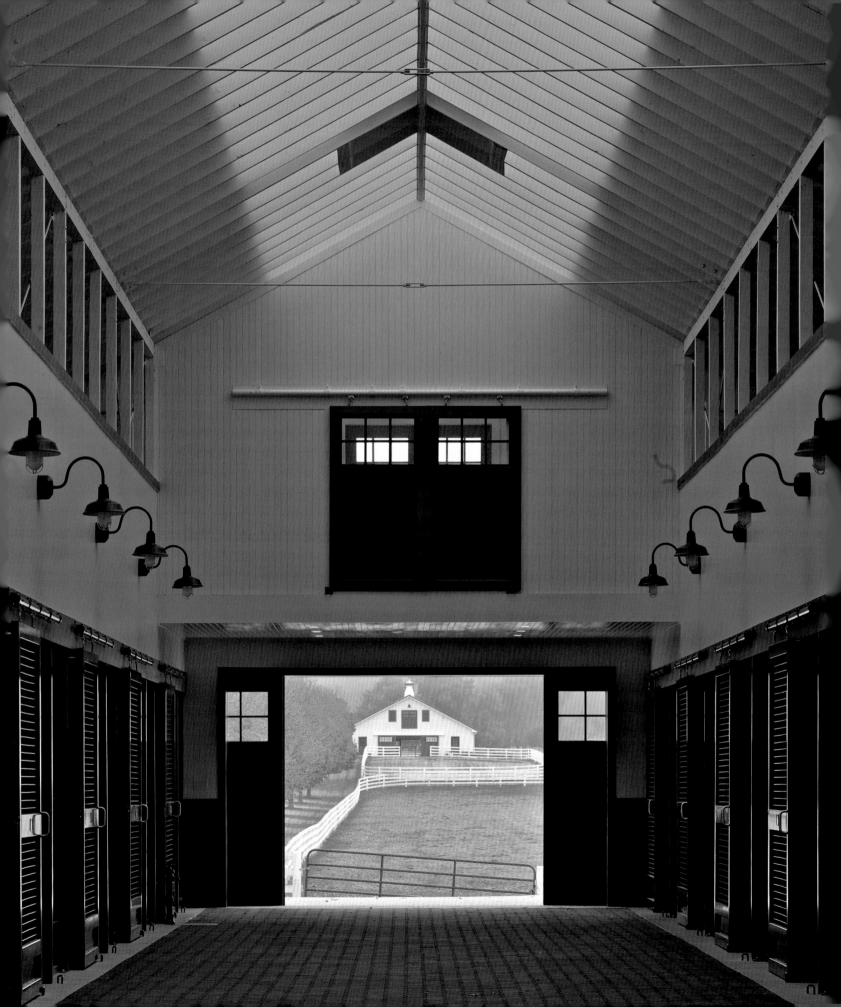

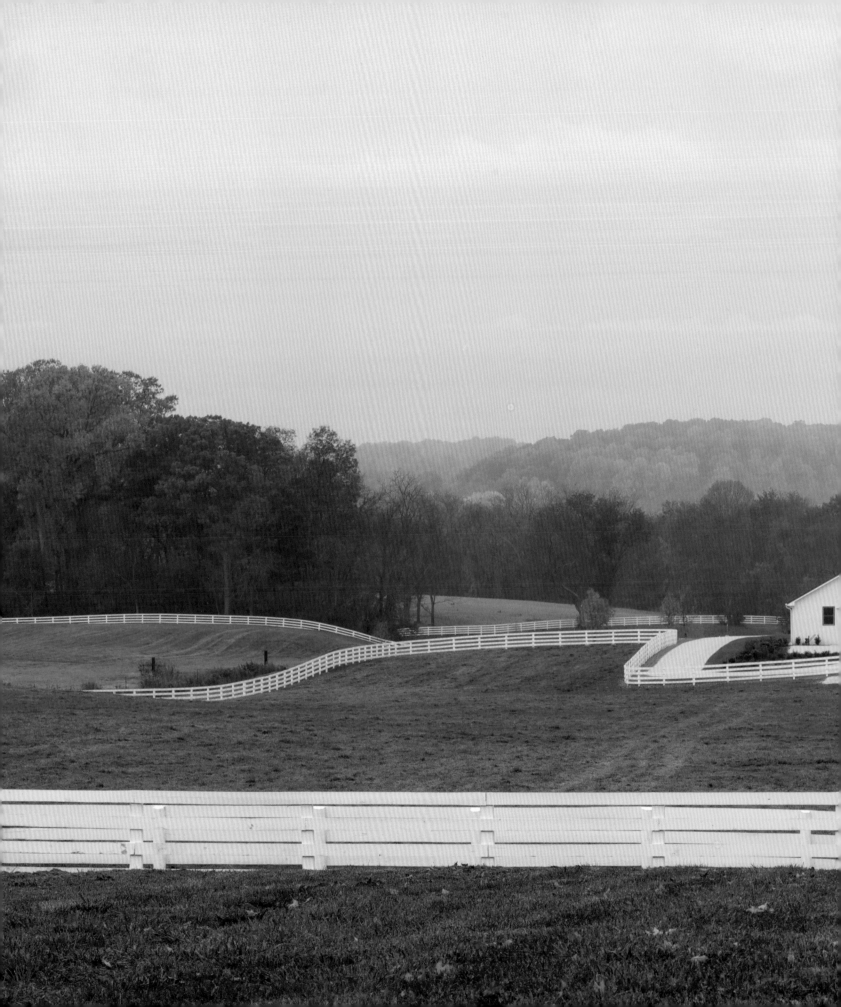

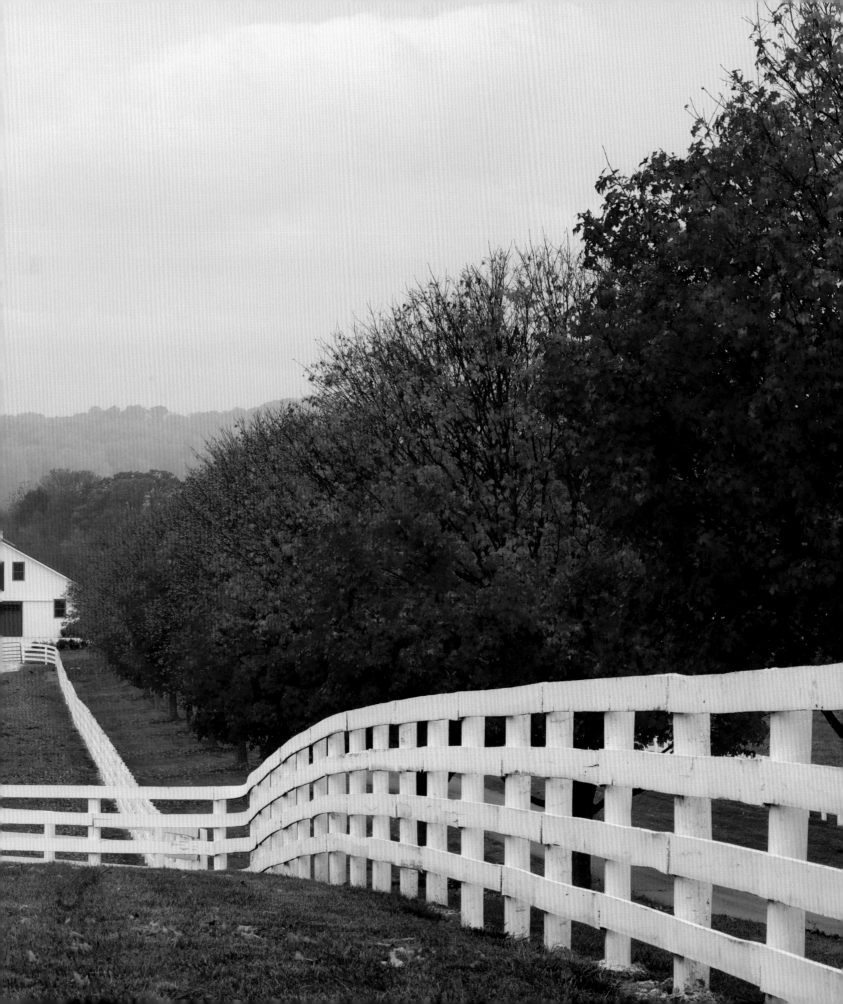

PRECEDING PAGES *The 1928 collaboration between architect James Cameron Mackenzie, who studied at Columbia University and the Ecole des Beaux-Arts and trained at McKim, Mead & White, and owner Richard A. Van Nest Gambrill produced one of the most elegant stable complexes on the East Coast. Its design of Georgian Revival style and simplicity employed traditional materials of brick, wood, and slate, and design elements that included cupolas, fine ironwork, and restrained detailing. Their 1935 book,* Sporting Stables and Kennels, *presented their recommendations for the best design elements for sporting complexes.*

RIGHT *The stable complex in the form of a U surrounds the central courtyard on three sides. At the back are twelve horse stalls with doors that lead out into the back pastures as well as doors that lead out onto a covered loggia. Adjoining buildings that flank the stalls were a carriage house on one side, which held a fine collection of carriages and coaches that Mr. Gambrill drove, and on the other side a sleigh room for his collection of sleighs, a washroom for the horse-drawn vehicles, harnessing areas, a tack room, storage rooms, and grooms' quarters.*

During the Gilded Age, from roughly the 1870s until the Depression, many newly wealthy families built second homes in areas that were reasonably close to the urban centers where they lived and worked, such as New York or Philadelphia, yet afforded a private setting in which a country life could be cultivated. Somerset Hills, the rolling countryside of the Upper Raritan River Valley in New Jersey, appealed to those with new wealth, and extensive building during the 1880s and 1890s transformed the area into one of society's exclusive enclaves.

Blairsden, a magnificent Beaux-Arts residence designed by the prestigious architectural firm of Carrère & Hastings, was built for New York banker Clinton Ledyard Blair, his wife Florence, and four daughters, from 1898 to 1903 with an infusion of millions of dollars through inheritances that made the opulent building and the lifestyle to match possible.

Richard Augustine Van Nest Gambrill, who would become the Blairs' son-in-law in 1917 when he married their third daughter, Edith, was born in 1890 and also grew up among the privileged, wealthy elite. He and his widowed mother, an heiress and the former Anna Van Nest, divided their time between their town house in New York City and Carrère & Hastings–designed Vernon Court, the elegant mansion his mother had built in Newport, Rhode Island. At an early age Gambrill became acquainted with the popular horse sports of the day—coaching and driving, polo, and both flat racing and steeplechasing—for which he became a passionate and lifelong enthusiast and supporter.

By 1928, when the Gambrills built their estate on land adjacent to Blairsden, they had traveled and foxhunted in England for years and visited more than one hundred stables there, in America, and in

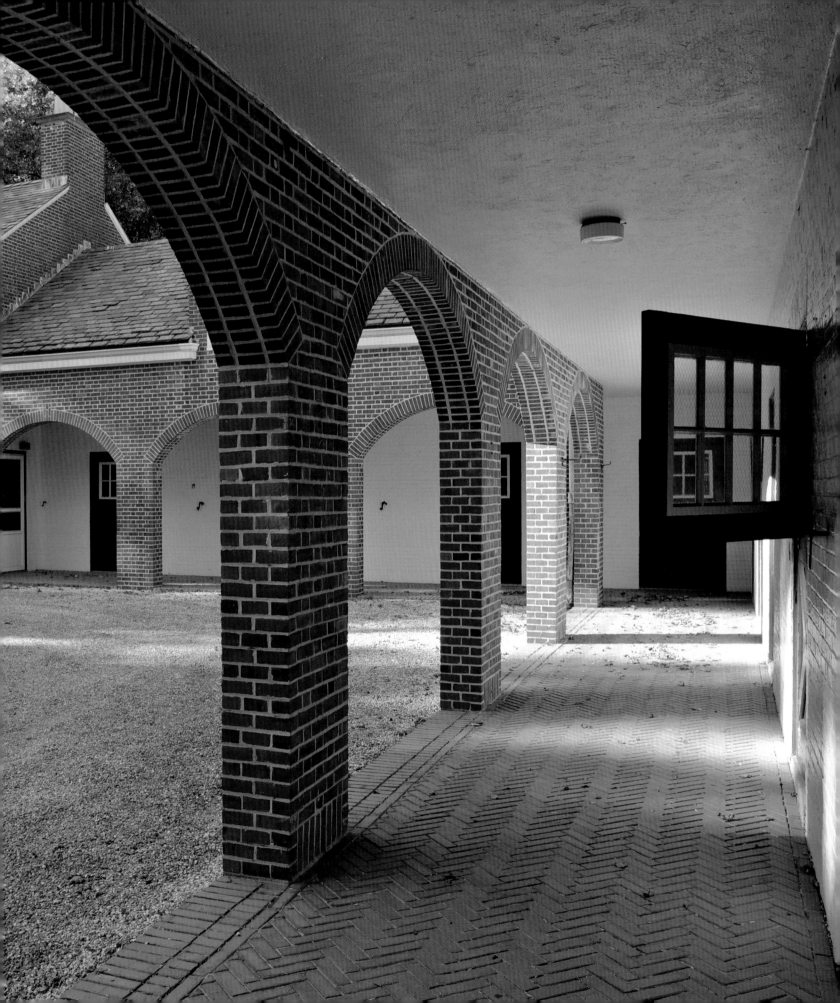

ABOVE AND RIGHT *The refined architecture suited Gambrill's use for the stables. An avid sportsman, he kept many fine hunters that he used for foxhunting, steeplechasing, and pulling his coaches, carriages, and sleighs. The stables were located at the entrance to the estate so that he and his guests might admire the stables and horses before their ascent to the main house. The design, while elegant and constructed with the finest materials, was also efficient and practical, leaving no detail to chance.*

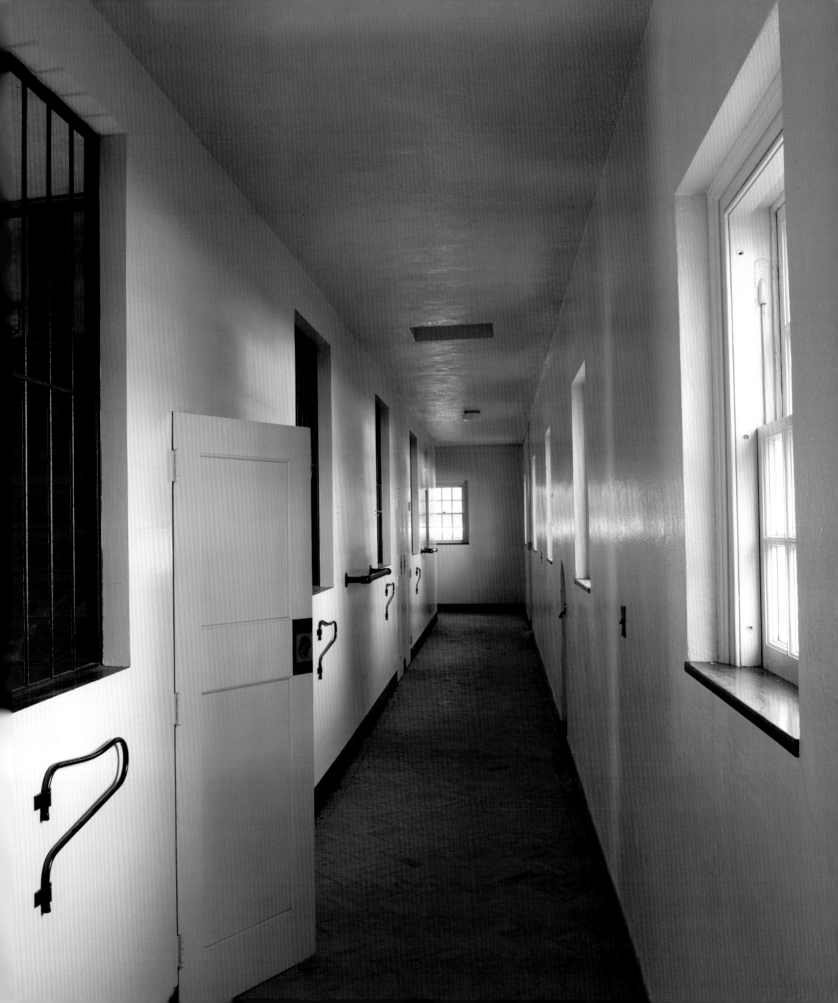

ABOVE AND RIGHT *Elegant details such as the stone horse head sculpture add equestrian flair to the formal simplicity of the stable building complex.*

France. They hired New York architect James Cameron Mackenzie to transform the extant hilltop villa into an elegant Georgian Revival–style country house, and to design new stables, built to Gambrill's specifications, that became the center of activity for the avid horseman, fox hunter, beagler, and coaching enthusiast.

The stables at Vernon Manor were systematically planned with these sporting interests in mind. The complex was arranged around a central courtyard based on the principles that Gambrill and Mackenzie set down in their 1935 book, *Sporting Stables & Kennels*, which said that stables should be practical and efficient, easy to clean, economical to maintain; built with the finest materials available; use the most up-to-date equipment; and have a simple but aesthetically pleasing design.

Chronology
1928: Stables complex (James Cameron Mackenzie, architect)
Richard A. Van Nest Gambrill, original owner/co-designer

NEWSTEAD FARM

UPPERVILLE, VIRGINIA

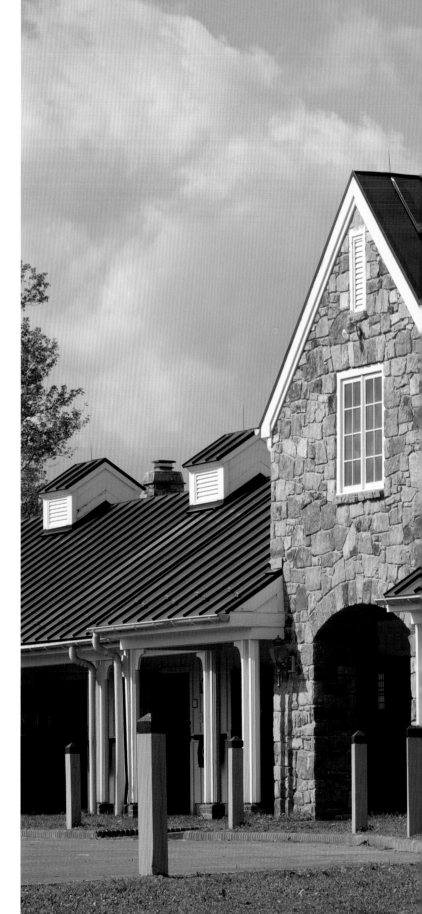

PRECEDING PAGES *Newstead Farm is an award-winning Thoroughbred breeding and training facility in Upperville, Virginia. It was home to Genuine Risk, the filly who won the Kentucky Derby in 1980.*

RIGHT *Bertram and Diana Firestone hired Middleburg architect Tommy Beach to renovate the barns at Newstead Farm, which include the show barn, the broodmare barn, the yearling barn, the quarantine barn, and the clock-tower barn. The show barn's stonework compliments the fieldstone walls of the 400-acre farm.*

Newstead Farm in Upperville, Virginia, came into the limelight after it was purchased in 1936 by Taylor Hardin, a Virginian who had returned to country life after working in publishing in New York City. Newstead Farm became internationally renowned as one of the most successful Thoroughbred breeding and racing enterprises in America. For three decades Hardin and his wife, Katherine, bred and trained an impressive list of champions that were winners of major races in America, France, and England. As well, prized broodmares brought Newstead Farm its reputation as one of the world's top breeding operations.

The Newstead Farm Trust managed the farm and its inventory from 1977 until 1985, when all of its Thoroughbred holdings were put up for sale and eventually purchased by a Mr. Treptow. Bertram and Diana Firestone purchased Newstead Farm and its surrounding 400 acres in 1991, and they have continued the tradition of the high-profile farm with a successful Thoroughbred breeding and training operation. The Firestones gained worldwide recognition in 1980, when their Thoroughbred Genuine Risk became the second filly in history to win the Kentucky Derby. Genuine Risk also came in second in the Preakness and the Belmont that year, becoming the only filly in history to place in each of the Triple Crown races. Genuine Risk was inducted into the National Museum of Racing and Hall of Fame in 1986. She was officially pensioned in 2000. Always beloved by the Firestones and well cared for at Newstead Farm to her last day, the magnificent Genuine Risk died there peacefully on August 18, 2008, at the age of thirty-one.

The Firestones have won seven Eclipse awards for their champion Thoroughbreds and were inducted into the Virginia Thoroughbred Association Hall of Fame in 1982. The Firestone Thoroughbreds are multiple champions of the most prestigious races in the world. They have won, in addition to the 1980 Kentucky Derby, such G1 Stakes races as the Kentucky Oaks in 1976, the Epsom Oaks in 1981, the Hollywood Derby in 1992, and the Secretariat Stakes in 2008, among many others.

The Firestones' daughter, Alison Robitaille, is an accomplished International Grand Prix show jumping rider whose successful career has included representing the United States Equestrian Team on numerous occasions, as well as 41 Grand Prix wins and competing on 24 Nations Cup teams and in five World Cup finals.

The Firestones hired architect Tommy Beach, who has done much work in the surrounding hunt country, to renovate the stable complexes, the training barn, stallion barn, and broodmare barn, which

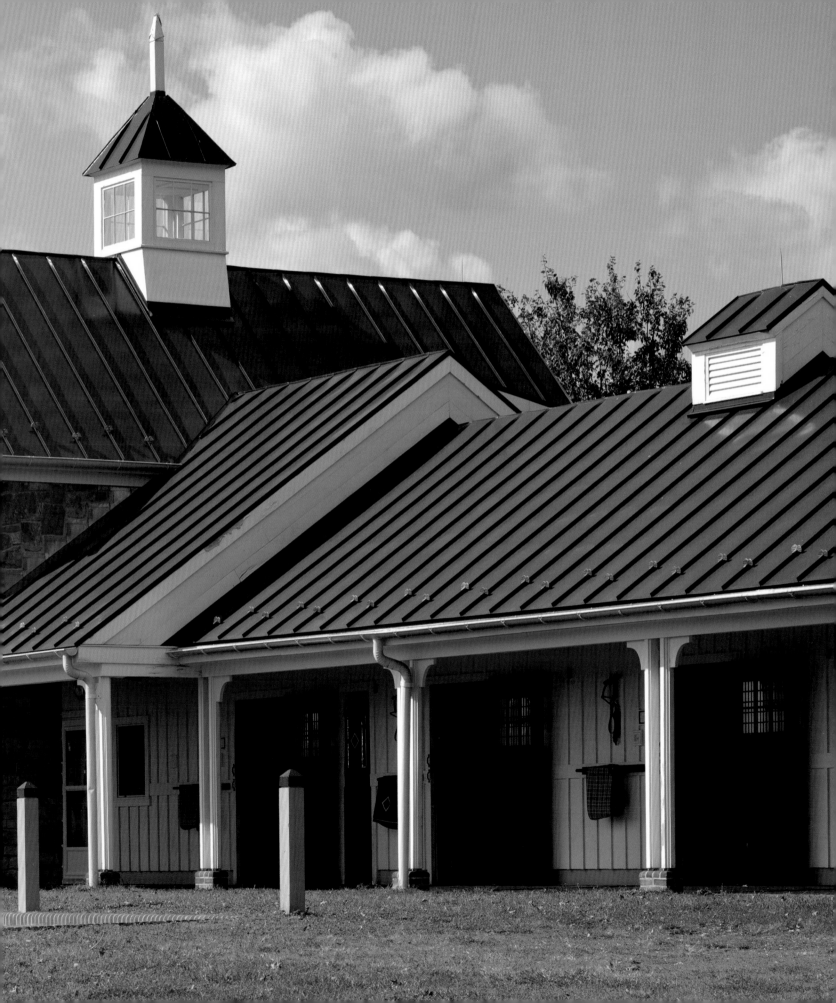

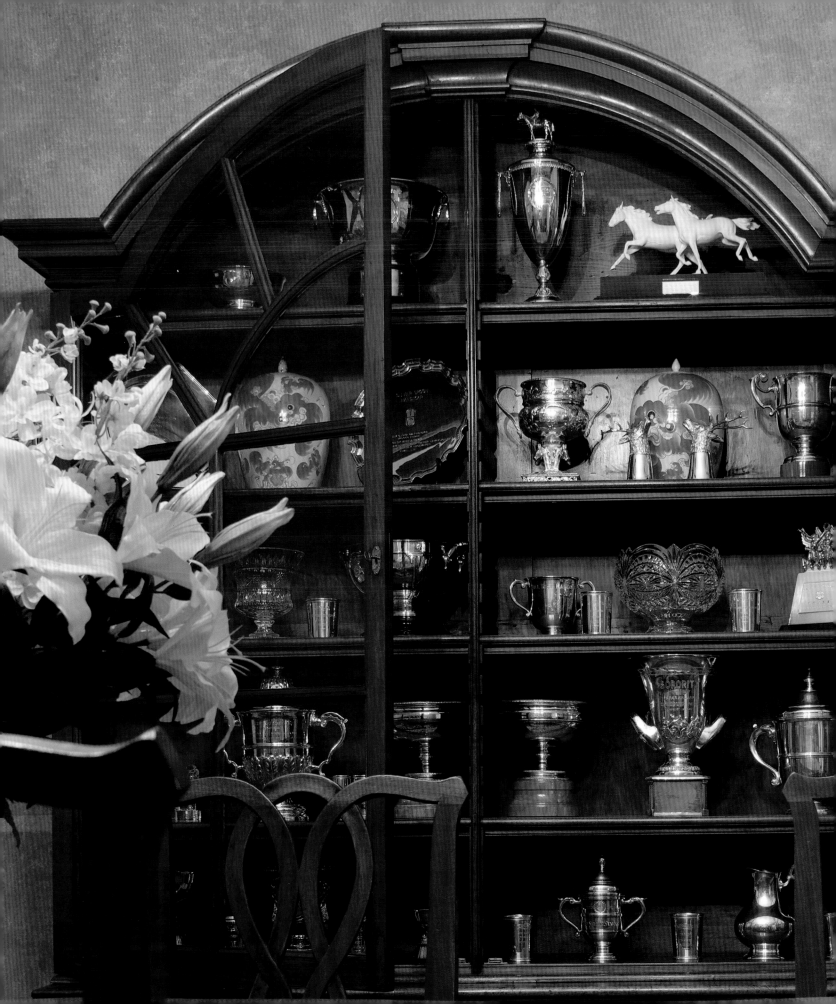

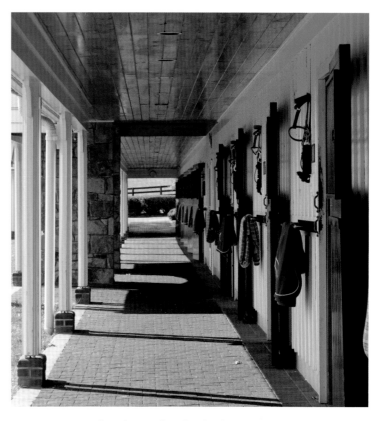

LEFT AND ABOVE *Over the past three decades the Firestones have won every prestigious horse race in the world. A sampling of their large collection of trophies is displayed in an antique hutch. Some of the Grade I Stakes races and horses who won them include:*
1976 Kentucky Oaks—Optimistic Gal
1979 Travers Stakes—General Assembly
1980 Kentucky Derby—Genuine Risk
1981 Epsom Oaks—Blue Wind
1982 The Japan Cup—Half Iced
1992 Hollywood Derby—Paradise Creek
2008 The Secretariat Stakes—Winchester

now provide seventy stalls. Completed in 2000, Beach's redesign was in keeping with the area's architecture. The historic horse farm took on a more appropriate and traditional look with additional dormers on metal roofs, copper weather vanes with verdigris patinas, hunter-green shutters, wood trim, and a sheathing of crisp, cream-painted wood. With the addition of a world-class grass Grand Prix course and the transformation of the cement utilitarian structures, one of Virginia's preeminent horse farms has become an exquisite, picturesque presence in the equally idyllic countryside.

Chronology
1936: Established; three barn complexes
2000: Restoration and renovation; show barn, broodmare barn, yearling barn, clock-tower barn, quarantine barn (Tommy Beach, architect)
Owned by Bertram and Diana Firestone

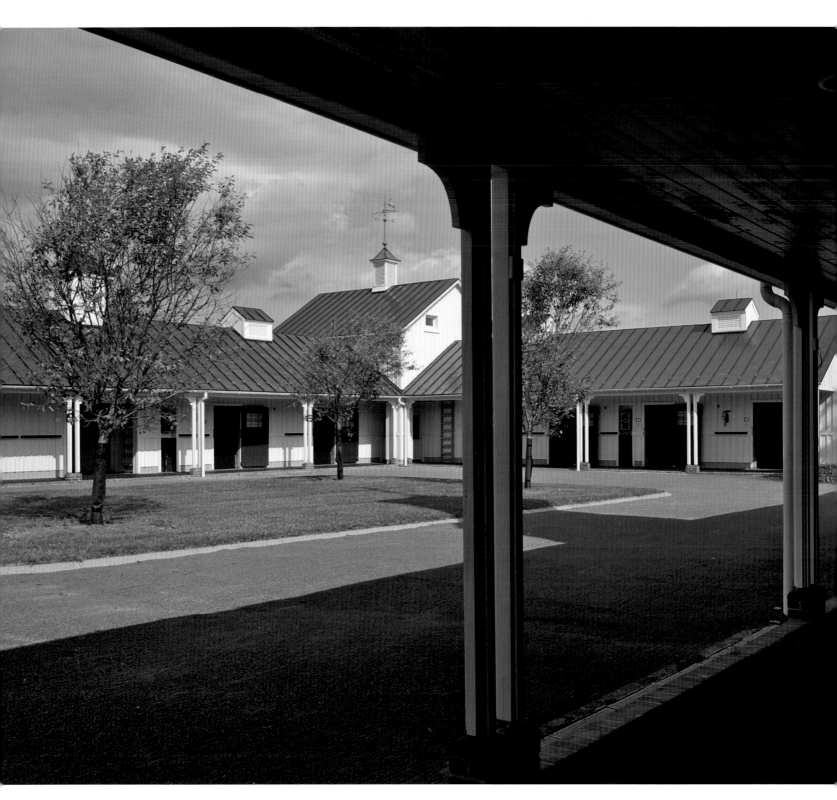

ABOVE AND OPPOSITE *The clock-tower barn has stalls for eleven horses and an apartment on the second floor. It is a U-shape of stalls that surrounds a central courtyard. Newstead Farm's stables are finished in a traditional color scheme of cream and hunter green, perfect in the Virginia countryside.*

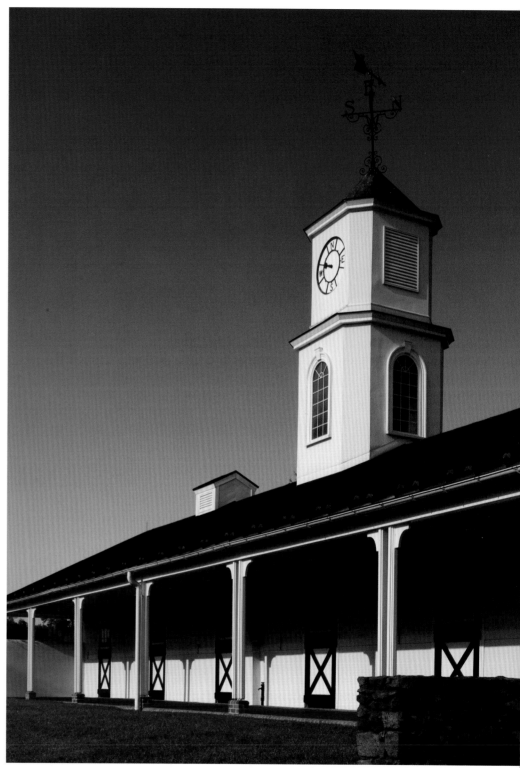

FOLLOWING PAGES *Of his renovation of Newstead Farm for the Firestones, architect Tommy Beach says, "They trust you to know the best, they expect the best, and then they let you do it. The concept was to enhance the existing barns aesthetically and functionally and to do justice to the incredible property."*

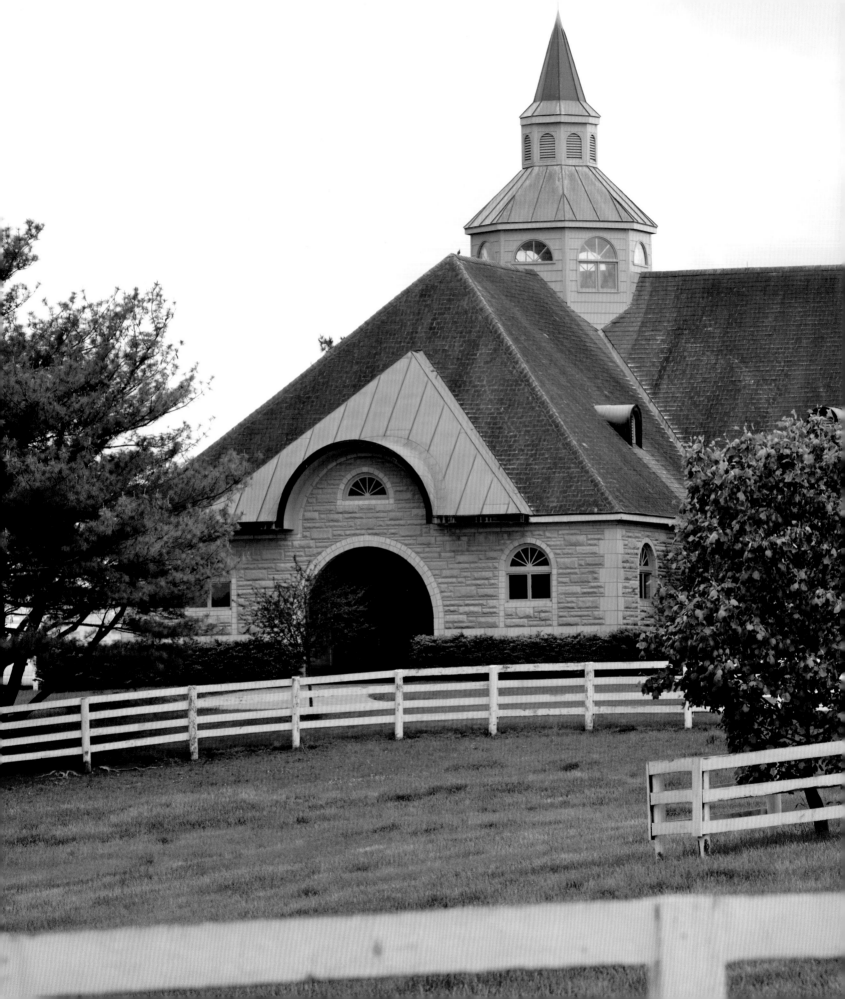

PRECEDNG PAGES *Donamire Farm is one of the most gorgeous Thoroughbred breeding and training farms in the bluegrass of Lexington, Kentucky. The royal stables in Chantilly, France, inspired owners Don and Mira Ball for the design of their four barns. Collaboration with architect Thomas Lett led to a landscape that resembles an eighteenth-century village set in the French countryside. Mr. Ball reinforced the sense of that pleasing environment by intentionally designing the layout of fencing with no straight lines. The fifteen miles of fencing have only curves.*

LEFT *All of the architecture, including the broodmare barn shown here, is constructed of Indiana limestone. The immense roofs are clad in slate shingles with standing-seam copper "eye-brows" over the entrances.*

Mr. Don Ball is the quintessential born-and-bred Kentucky gentleman. He and his wife, Mira, established Donamire Farm, now a 650-acre Thoroughbred breeding and training farm in Lexington, in the mid-1970s because of their love of horses and horse racing. Donamire Farm is paradise and perfection in the bluegrass.

A trip to France inspired the Balls to envision a farm based on the royal architecture in Chantilly, where in 1735, Louis-Henri, Duke of Bourbon, 7th Prince of Condé, built grand stone horse barns (now the Musée Vivant du Cheval), in part because of his belief that he would be reincarnated as a horse. Donamire Farm reflects this early French architecture and, with the siting of the barns in the landscape, it resembles a village in the French countryside. The Balls worked with architect Thomas Lett to give the farm its evocative setting and style. The muted gray stone of French vernacular structures was replicated in fine Indiana limestone for the appropriately massed and scaled buildings. Ball's design of the farm layout used no straight lines or hard angles, only curves, to emphasize a design based in nature and to reinforce the pastoral effect of the picturesque setting.

The resultant Normandy-style stone barns and offices are magnificent, and their situation in verdant green pastures bordered by more than fifteen miles of pristine white fencing makes the site one of the most beautiful horse farms in the country.

RIGHT *The training barn is used for the twelve racehorses now in training with the Balls' daughter-in-law, Katherine Ball. The largest of Donamire Farm's barns, it sits on a rise overlooking the 600 acre spread.*

Both Mr. and Mrs. Ball are community leaders and actively participate in many charitable and civic organizations. Each year the Balls graciously host the Lexington Derby Ball, held on Kentucky Derby eve, under a massive white tent overlooking the gently rolling hills, grass racetrack, and pond of the bucolic farm. They also host the Summer Celebration, to support Kentucky Educational Television, and numerous other events throughout the year.

Committed to promoting Kentucky's top agribusiness, the horse industry, the Balls have made Donamire Farm available to the public during regular hours and through various horse farm tour companies. The Kentucky horse industry was also given a boost by Hollywood filmmakers when they featured various picturesque horse farms, including Donamire Farm, in the major motion pictures *Dreamer* and *Simpatico*.

Don and Mira Ball's generosity and influence are expansive; their life's work has been a true blending of the love of horses, a gracious hospitality, and an uncommon commitment to public service.

Chronology
c. 1970s: Training, Stallion, Broodmare, Yearling barns and farm office
Owned by Don and Mira Ball

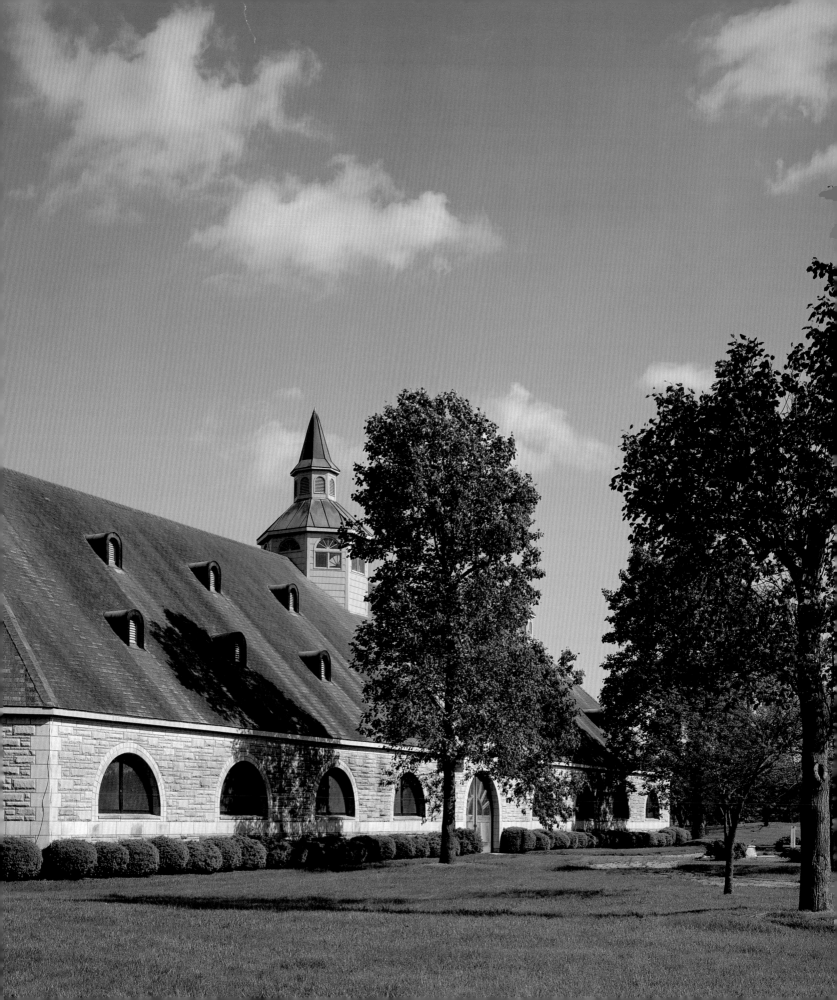

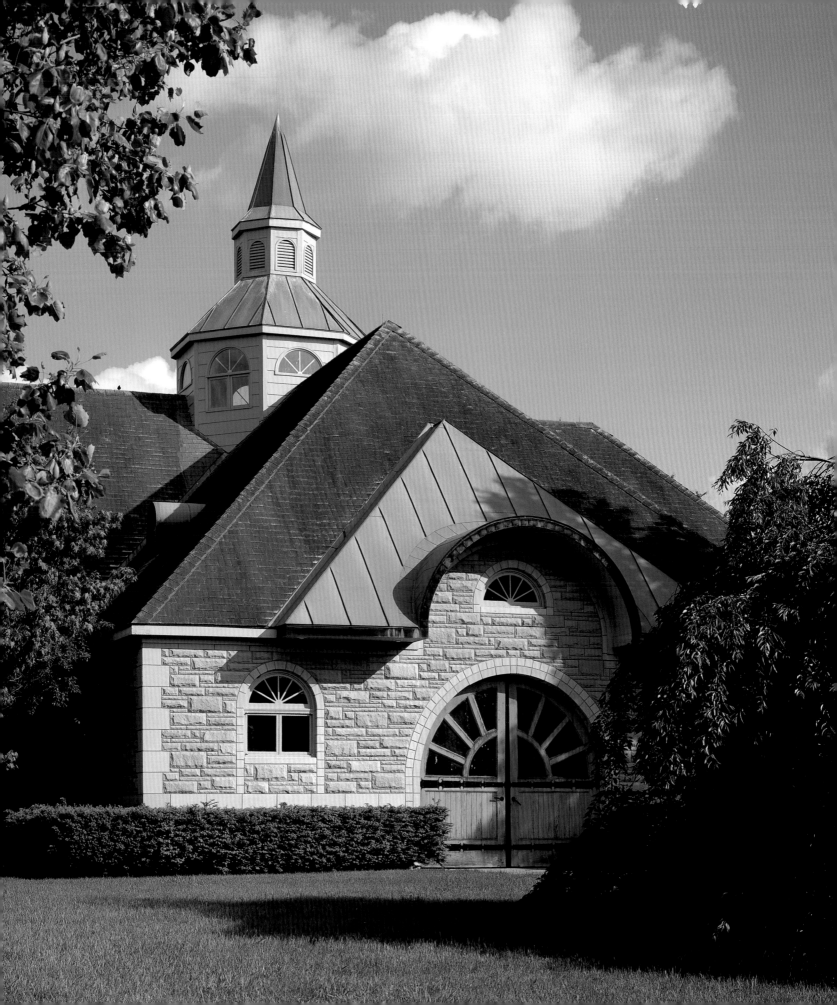

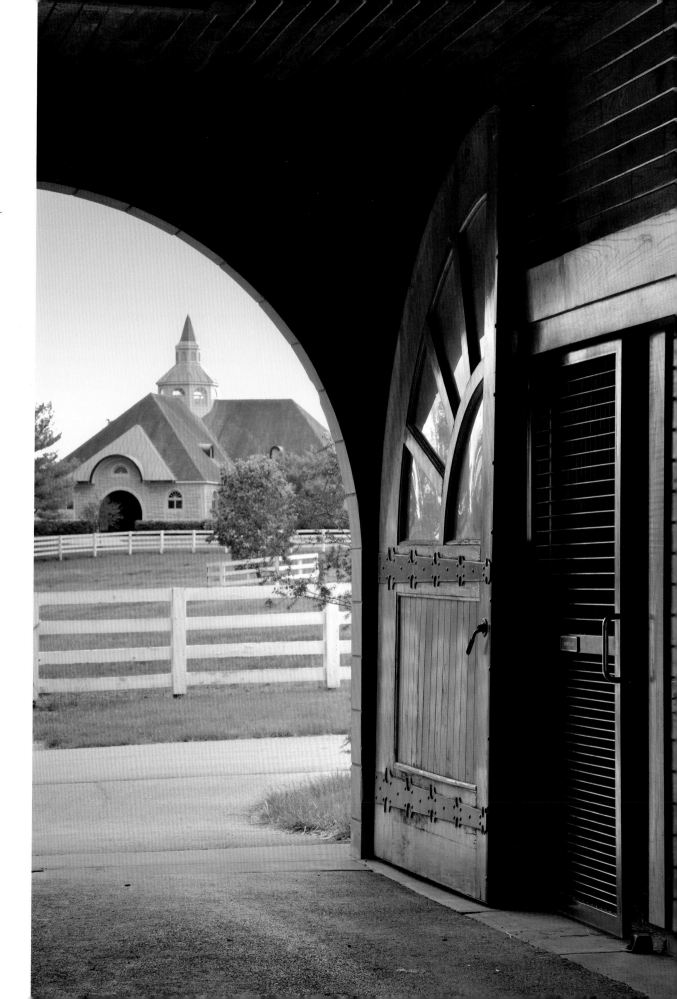

OPPOSITE *The beautiful stallion barn is set within a perfectly manicured landscape.*

RIGHT *As with the other barns, the yearling barn has finely shellacked wood throughout. The heavy arched doors swing on well-set hinges whose decorative extensions of handwrought iron embellish the faces of the doors. Here the stallion barn is seen in the distance.*

FOLLOWING PAGES *The training barn has twenty-four stalls and an indoor track that encircles them.*

PAGES 140–41 *Horses and trainers move easily within each of the voluminous barns because of the generous dimensions of the stalls and aisles. The barns are located conveniently near the pastures.*

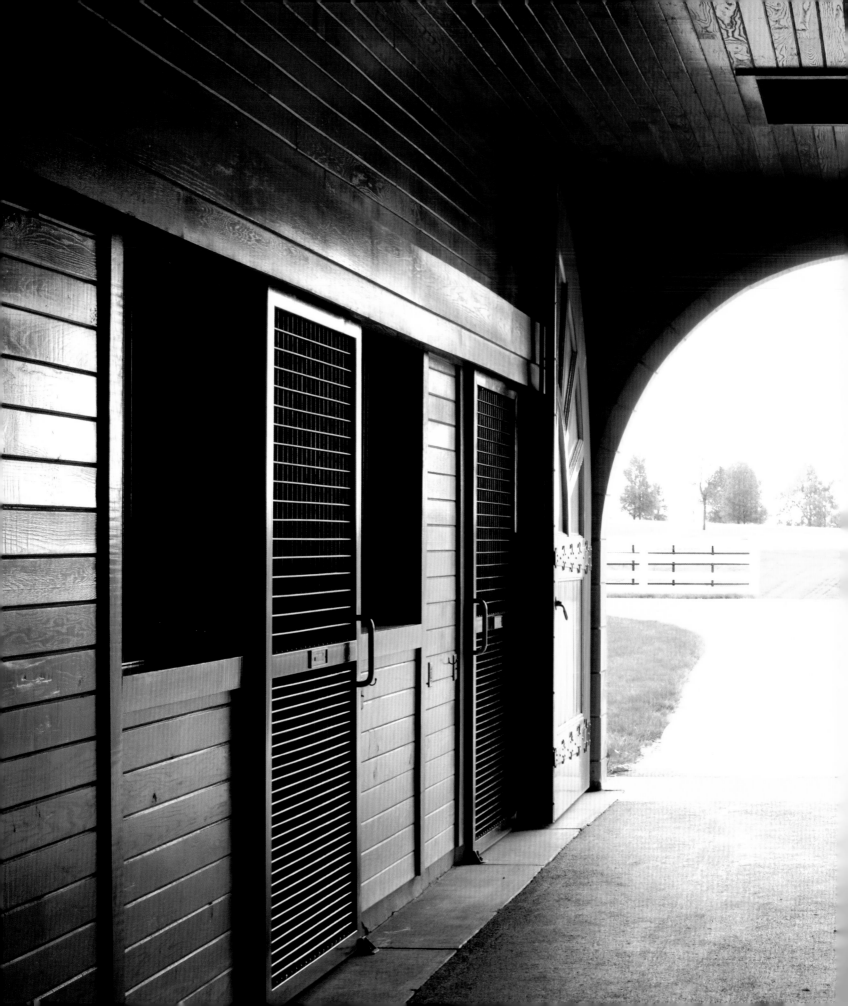

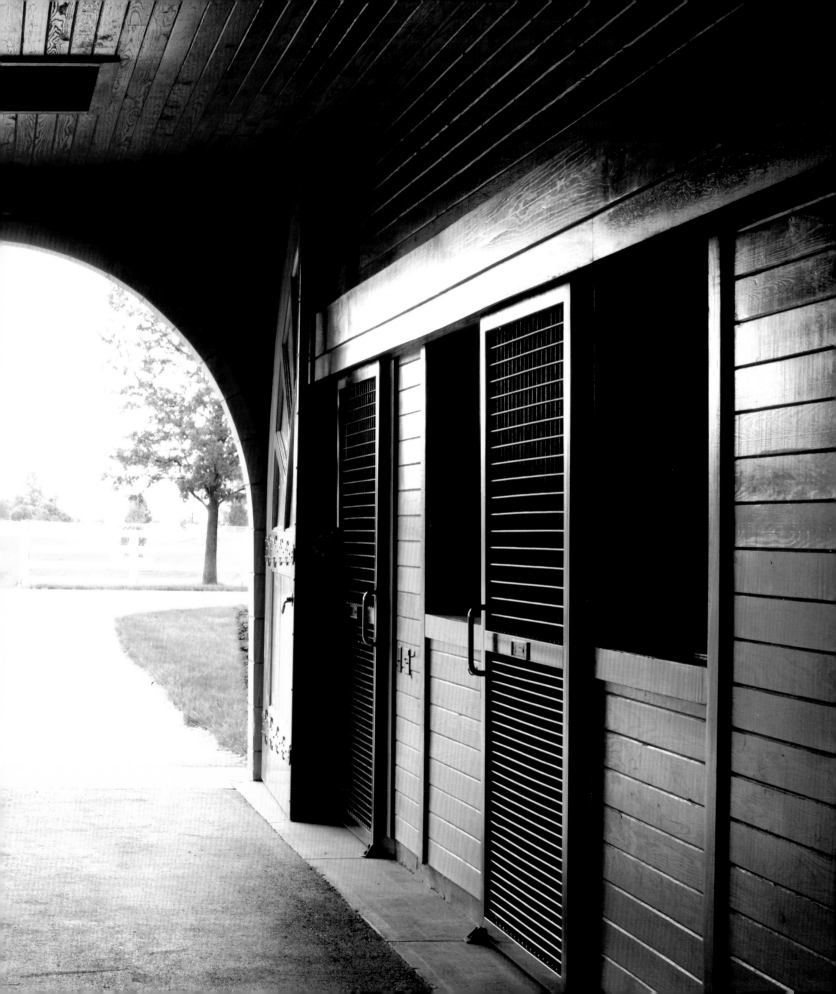

LEFT *A gazebo and conservatory (not seen here) set in the midst of a flower garden provide the best view of the grass training track in the lower pasture. The Balls host various events throughout the year, such as the Lexington Ball, held the day before the Kentucky Derby, and Summer Celebration, a fund-raiser to support the programs of Kentucky Educational Television. A huge white tent is set up on the hill opposite the gazebo and guests are treated to the special view of the track and the rest of the scenic beauty of Donamire Farm.*

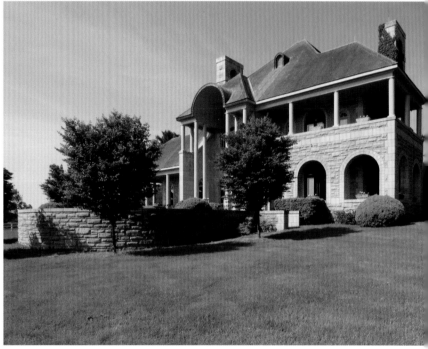

ABOVE *Donamire Farm's inviting and well-appointed offices are located in a notable two-story structure whose impression is more residential than commercial.*

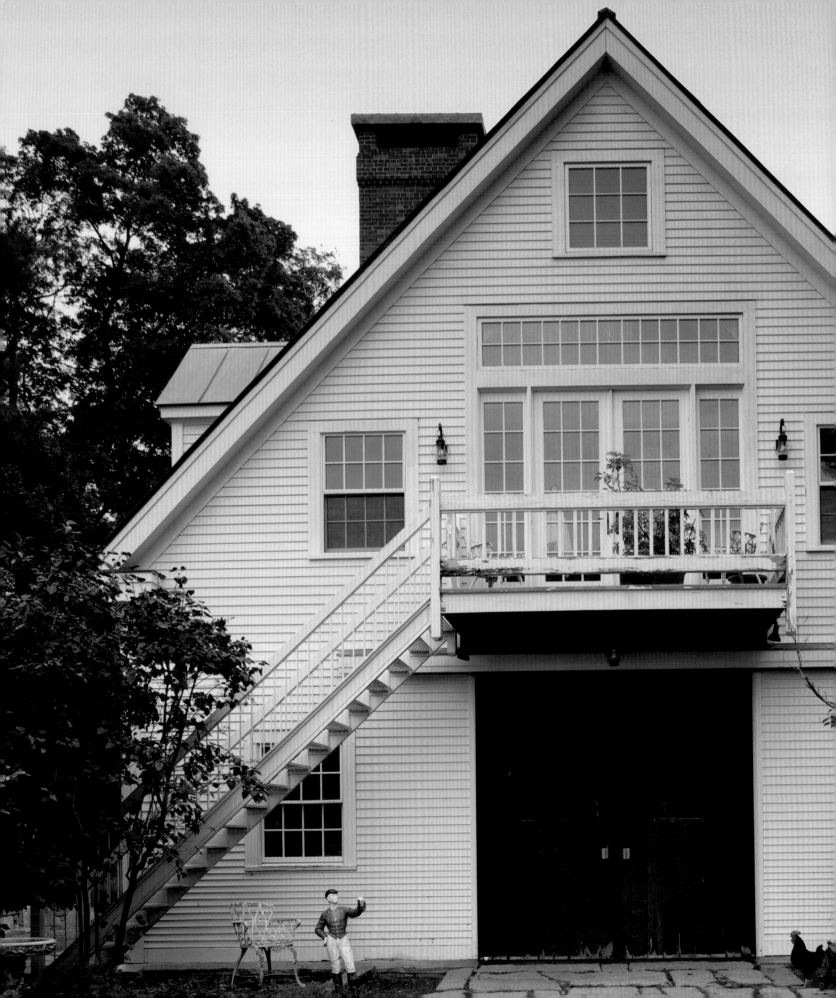

DEVON GLEN FARM

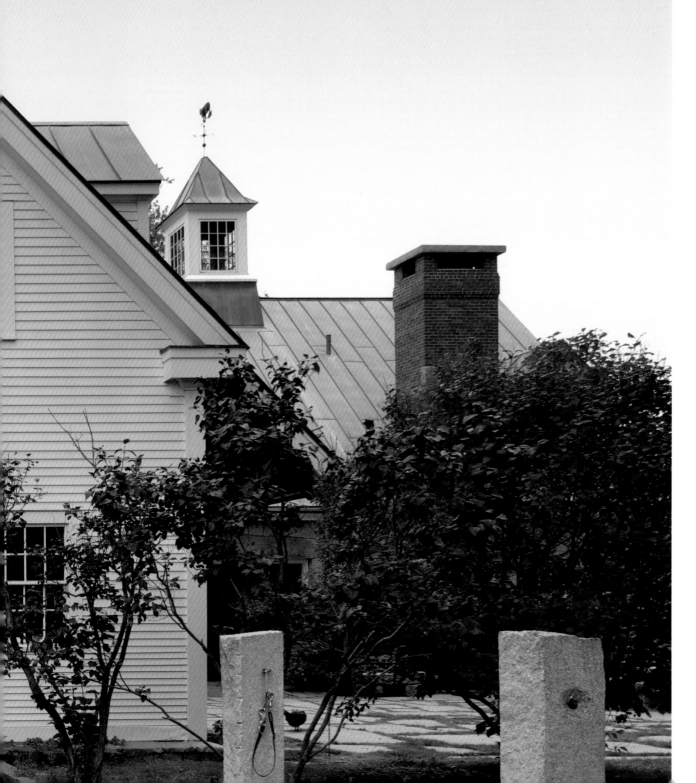

The many small picturesque villages that dot the country's eastern seaboard look today much like they did when they were founded more than two hundred years ago. If a community is fortunate, both its landscape and traditions have been preserved. The community in Essex County, Massachusetts, in which the owners of Devon Glen Farm reside, is one so fortunate. It is home to one of the oldest foxhunts and one of the oldest polo clubs in America, and it has been, therefore, mindful of the preservation of these sports as well as of the open land. The owners of Devon Glen Farm appreciate their unique heritage and devote much of their time and resources to upholding it.

The owners were as conscientious in their design and construction of the stables and barn as they are in their stewardship of the historic farm. They worked with an expert team of builders for nearly six years to complete the historically authentic oak post-and-beam barn. The huge barn, which has hay and equipment storage, a tack room, a chicken coop, and a collection of antique carriages, is also used for large gatherings.

Devon Glen Farm's owners are incredibly generous with their time, expertise, and resources. The husband, who acquired more than 1,000 acres of nearby land over the last forty years, is particularly dedicated to land conservation and wise stewardship. The wife is well-respected for her enthusiastic support and promotion of open land for riding and the local trail network. Other land not part of Devon Glen Farm was wrestled from the hands of developers at the eleventh hour, and now its streams, ponds, and natural vistas are protected in perpetuity by its placement in a conservation easement.

The wife rides with a local hunt and has been instrumental in educating the public about the camaraderie fostered by the traditional sport of foxhunting and the generational community it builds.

The couple also frequently opens its stables and barn to charitable events that include dinners for more than two hundred guests and, in 2008, a young riders' clinic, where the fields were filled with fifty ponies matched with novice riders and ten instructors. It is through this kind of welcome, and because of their love of horses and horse sports, that the owners of Devon Glen Farm have influenced their cherished community in so many ways.

Chronology

c. late 1700s: Farm established
1999: Stable and barn

PRECEDING PAGES *The stable complex at Devon Glen Farm has a large newly constructed post-and-beam barn linked to the two-story stable with four stalls, a tack room, a wash area, and an office on the ground level and groom's quarters above.*

Landscaping that includes rhododendrons, lilacs, and crab apple trees is historically appropriate for the New England farm. A courtyard in front of the new barn is used for social gatherings and special events, with an outdoor fireplace that makes the space warm and inviting.

RIGHT *Four sturdy stalls in the stable are built with oak and pine from the property. Every vertical post is set on top of a metal shoe, creating structural reinforcement and a fine design detail. Another unusual feature in the interior space is a chimney of handmade bricks using the seventeenth- and eighteenth-century construction method of laying the bricks with a space of no more than ⅛ inch between them.*

FOLLOWING PAGES *The historically authentic barn built by the owner and a dedicated team of builders over a period of six years is post-and-beam construction that includes such eighteenth-century features as uncut pegs that stick out beyond the sides of the beams. The owner designed the main-level area to include a tack room, chicken coop, space for a collection of nineteenth-century carriages and a sleigh, storage space for hay and farm equipment, and a hayloft. The barn was designed to host charity events, held two or three times each year, in the large main space, which is fully insulated and heated.*

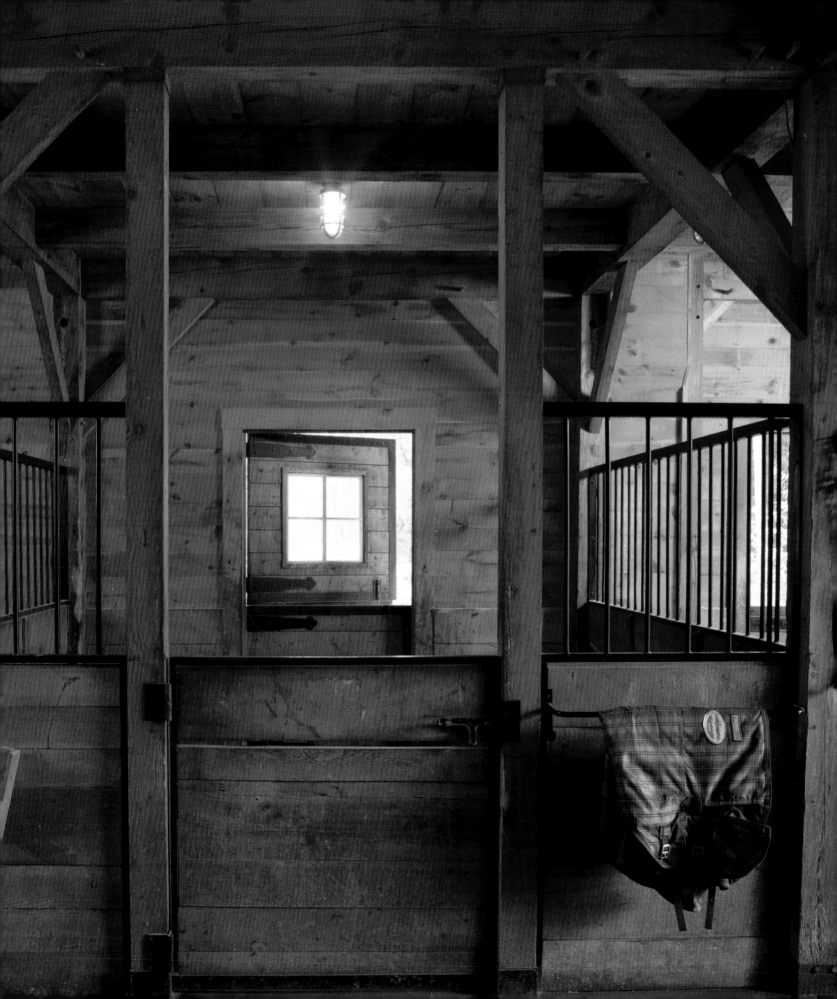

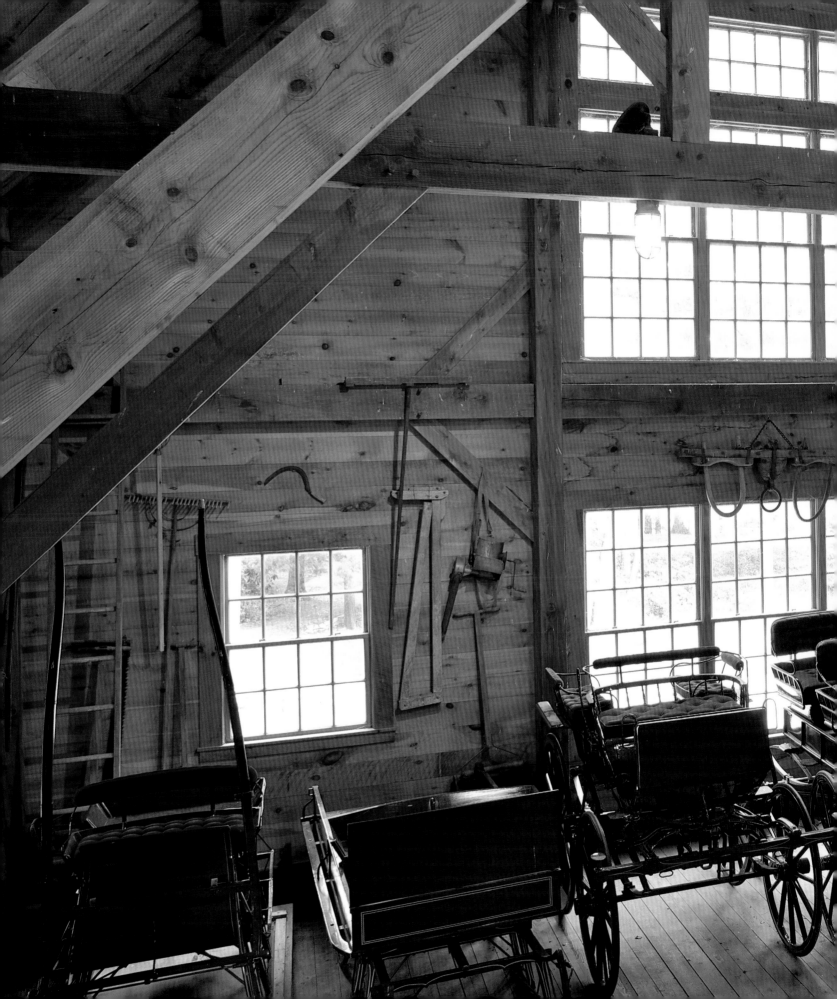

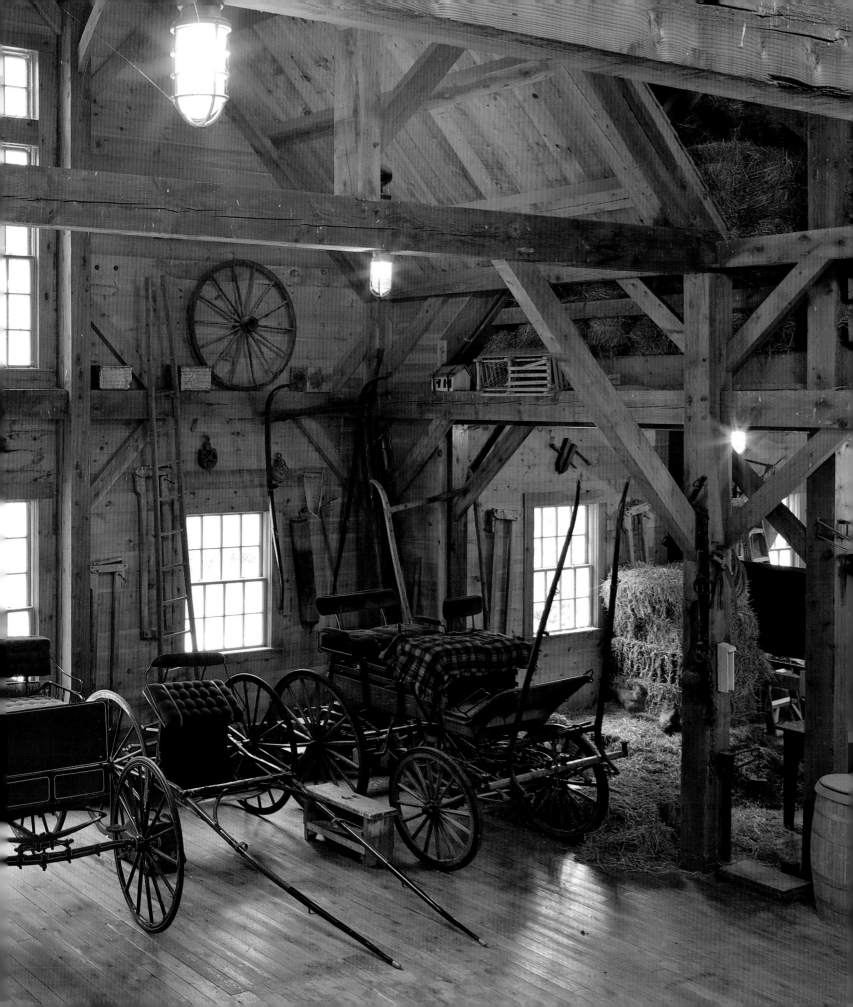

ABOVE *A cupola features windows that open for ventilation, a standing-seam metal roof, and an antique weather vane.*

RIGHT *The three-story barn has a basement level built with huge granite stones, quarried in Rockport, Massachusetts, that give the structure a centuries-old, pleasing aesthetic. The massing of the building elements, the sharp angle of each roofline, the size, distribution, and placement of the upper windows set with eight-over-eight glass panes, tightly overlapping clapboards, standing-seam metal roofs, and antique weather vanes all add to the positive visual impact of the magnificent barn.*

FOLLOWING PAGES *To enhance the courtyard the owners included an outdoor fireplace whose brick and stone chimney and the monolithic slab of granite provide rustic detailing for the new barn.*

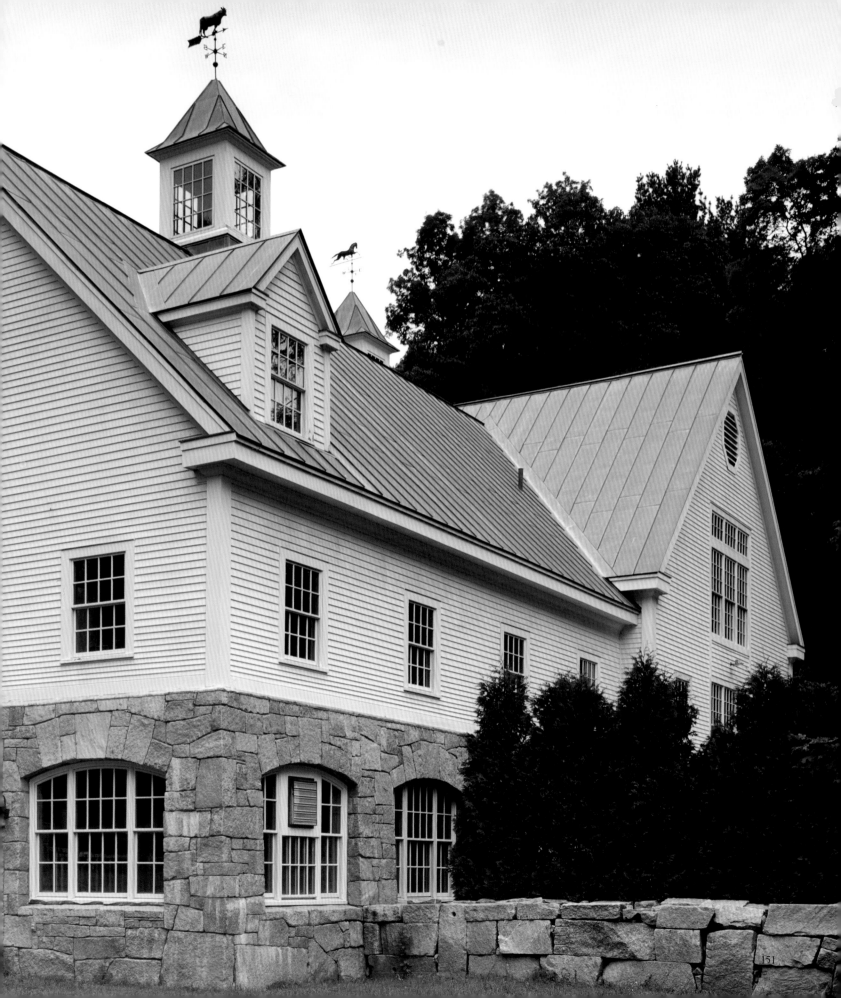

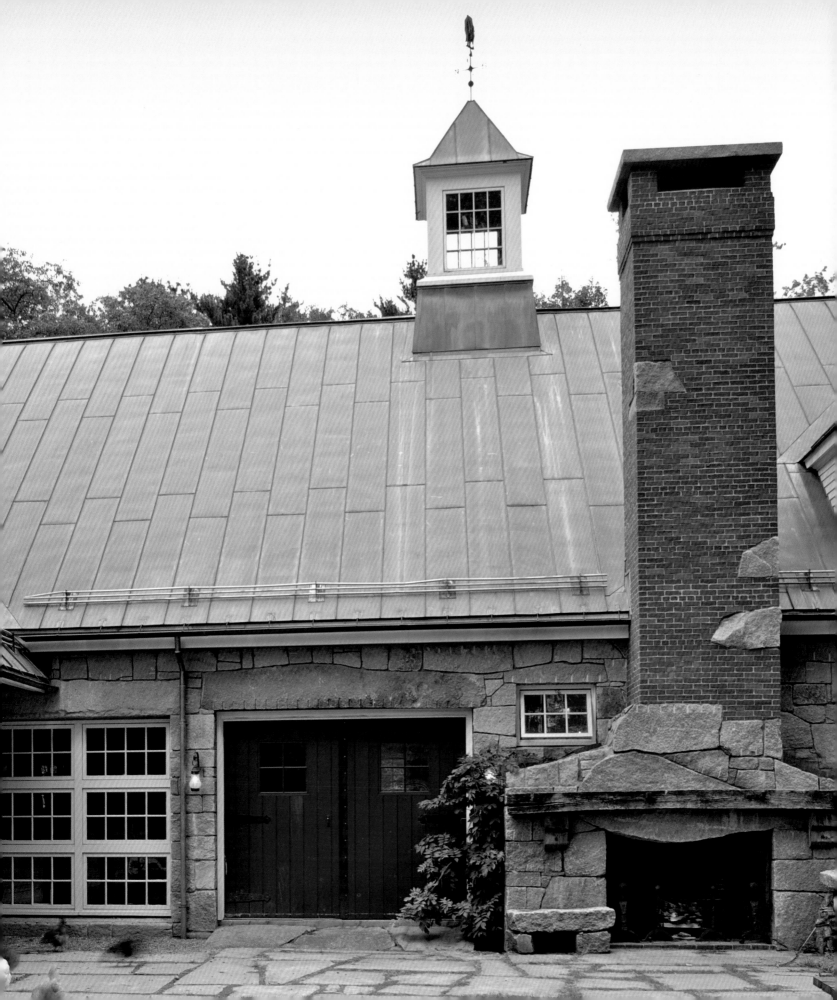

RALLYWOOD FARM

MIDDLEBURG, VIRGINIA

PRECEDING PAGES *When he first saw the site, architect Tommy Beach knew right away what to do and where to position the residence and stables for his clients. Once covered in brambles, the 360 acres of gently rolling hills provided a perfect place for Rallywood Farm, an equine sporting complex that includes a residence, stables, office, indoor arena, equipment barn with grooms' quarters, a large outdoor ring, and employees' houses.*

ABOVE AND RIGHT *The U-shaped complex has a design of Palladian symmetry. Roof heights are matched on opposing building wings, one of which is a two-story residence and the other a voluminous indoor arena.*

When the current owners of Rallywood Farm were looking for land on which to build their ideal horse farm, they were told about a site with rolling hills in northern Virginia's hunt country that was partially wooded and traversed by a tributary of Goose Creek. At the time the open fields were covered in thick brambles, but the pleasantly undulating landscape as well as its location within the territory of the Orange County Hunt appealed to the couple. To carry out a specific concept and design the stable and sports complex properly, the couple hired Tommy Beach, a well-respected architect known throughout the region as an expert in hunt country architecture, who has since become their good friend. The complex is a successful combination of form and material—there is a subtle play between the two architectural elements. Beach achieves balance and visual focus in a Palladian-inspired design of simple and elegant symmetry. A central courtyard is surrounded on three sides

PRECEDING PAGES *The living quarters that are a contiguous part of the stable complex were conceived as guest quarters and a meeting space, but have become the couple's home. Rows of horse stalls extend in either direction from a spacious foyer which, when used together with the residence's main floor, creates a perfect space for entertaining and special occasions such as hunt breakfasts.*

ABOVE *On either side of the wide entrance hall are a long walnut farm table, c. 1594, Pyrenees, and an eighteenth-century French table that hold cherished displays and beautiful antiques. Eighteenth-, nineteenth-, and twentieth-century animal-themed paintings turn the space into a fine art gallery and include works by British artist John Gifford (1860–1900), Danish listed artist Reinhold Nielsen (1891–1984), and listed American artist Larry Wheeler (born 1942).*

OPPOSITE *Rock Star, the owners' favorite champion Trakehner, who was imported from Germany and lives a few doors down, is often invited into the dining room to visit with guests after dinner.*

with well-scaled, connecting wooden structures whose opposing wings coincide in form and detailing. The roof height of the two-story living quarters in one of these wings matches the height of the opposing wing by the structuring of its voluminous indoor arena. The architect's firm grasp of the historic regional styles guided his design toward an appropriate updated interpretation of vernacular Virginia architecture.

The wife is a self-taught equestrian whose love and fascination for horses has lasted for as long as she can remember. She has kept horses most of her life, and for ten years she was a serious competitor on the national circuit of the American Quarter Horse Association, which she followed with two six-horse trailers on the move 365 days a year. Ranked as an Amateur High Point All-Around Rider, she competed in both English- and Western-style divisions. After she and her husband relocated in the late 1980s to the Capital area, a later move to northern Virginia's hunt country would inspire the avid horsewoman to become a foxhunter, and within a year she was foxhunting seven days a week. Today she rides much less. She is vitally interested in higher education and the challenges it faces in the United States today, and as an appointed director on the Board of Visitors for Virginia Tech she now has the opportunity to use her energy, time, and resources to further the university's important work.

Chronology

1999: Stable residential sports complex
(Tommy Beach, architect)

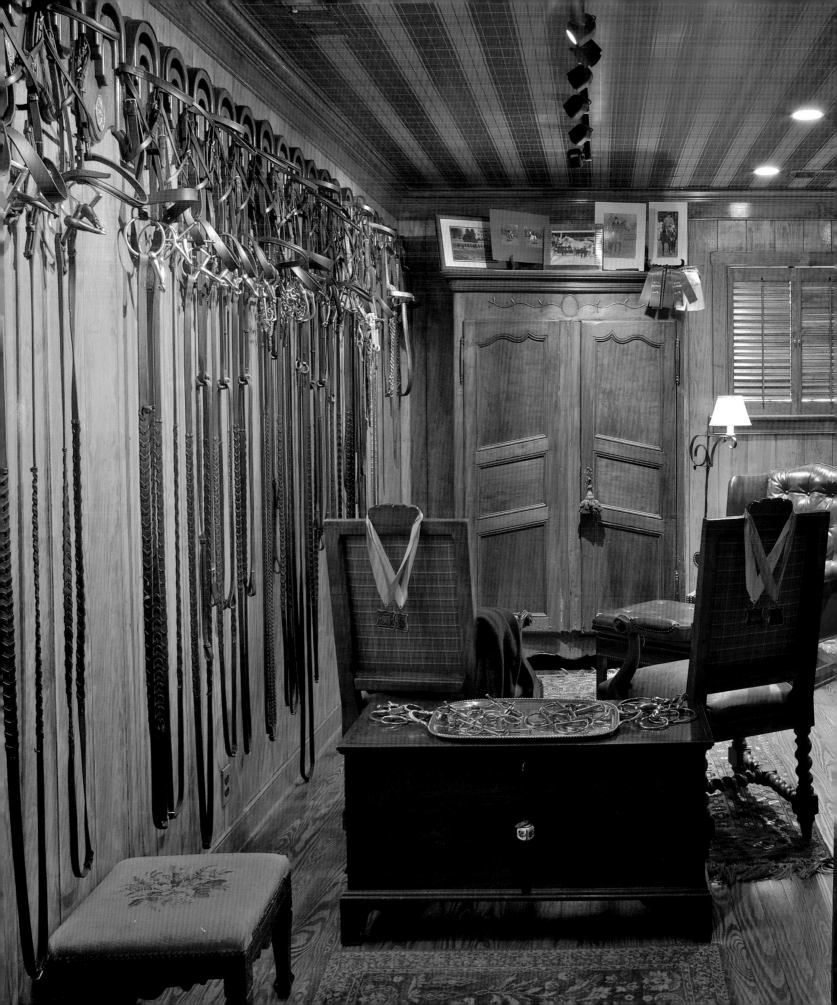

LEFT AND ABOVE *The well-appointed tack room that holds collections of trophies, bridles, saddles, velvet riding helmets, whips, and well-used boots, is also a place to kick back and relax in a cozy, luxurious atmosphere.*

The West

TEXAS HILL COUNTRY

A SAMPLING OF HORSE BARNS

FREDERICKSBURG, GILLESPIE COUNTY, TEXAS

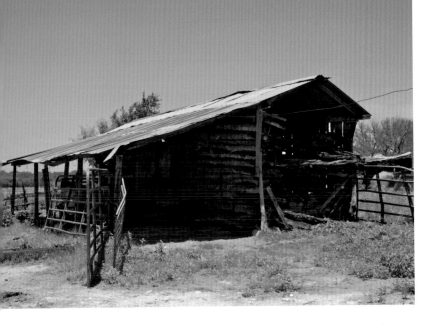

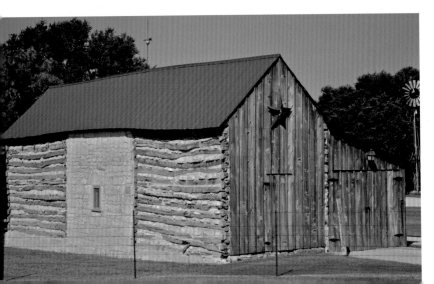

PAGES 164–65 *A view of the Grand Tetons in Wyoming.*

PRECEDING PAGES *Native Americans who occupied the Texas Hill Country believed that the lands, abundant with game and fresh water, held good medicine. Medicine Spirit Ranch was named to honor this belief. Although the picturesque horse and hay barn at Medicine Spirit Ranch is new, it blends in perfectly with the historic architecture found in Gillespie County with its traditional design and construction materials. Its interior is well-lit by ground floor as well as clerestory windows.*

LEFT TOP AND MIDDLE *Although chinking and daubing were used to seal many of the nineteenth- and early-twentieth-century structures in the area, the primitive c. 1900 Neffendorf homestead log animal shelter/stable in Gillespie County is not sealed so that the shelter will be well ventilated.*

LEFT BOTTOM *The sturdy construction of a simple mid-nineteenth- century barn in the Texas Hill Country incorporates hand-adzed logs, local fieldstone, and wood siding.*

OPPOSITE TOP *The 1871 Ferdinand Hoehenberger homestead includes a farmhouse and a white washed stone stable.*

OPPOSITE BOTTOM *A new barn uses recycled wood to give it the perfect weathered, historic look. The barn, set in a 1,200-acre game preserve, is an innovative design that has five sets of double sliding doors.*

The region of central Texas known as the Hill Country is well known for its pleasant hilly terrain, mild winters, and abundance of wildflowers in the spring. The 10,000-square-mile Edwards Plateau has a porous limestone base that soaks up rainfall and releases it at its eastern and southern edges at the Balcones Fault, creating springs where a string of major Texas cities, such as San Antonio and Austin, grew up.

The surface of the plateau is, therefore, drier than its rainfall would dictate, consisting of exposed rock and caliche, which is poorly adapted to agriculture. Exceptions occur in fertile strips of alluvial soil on the banks of the many clear streams and rivers that flow through the area, including the Colorado River. These were the places best suited for agriculture. People have made a living in the Hill Country with livestock, to some extent horses and cattle, but more commonly goats, which survive by browsing on the shrubby vegetation. Workhorses were also required that were most likely the progeny of horses of the Native Americans of the region, bred from those imported to the New World during the sixteenth century by Spanish colonists.

Before Mexico gained its independence from Spain in 1821, the territory that would become the Republic of Texas, and in 1845 a state,

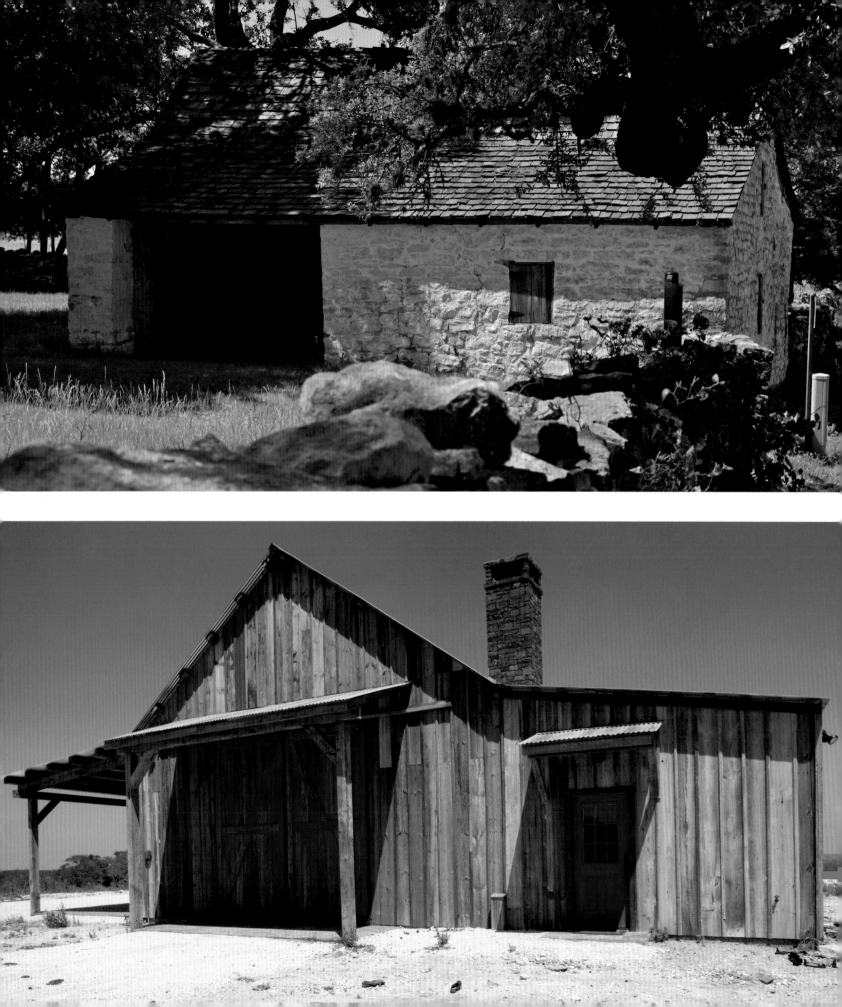

ABOVE *At Medicine Spirit Ranch, a small complex of buildings was designed to look like a nineteenth-century Western town. A stall for a favorite horse is constructed with sheet metal and wood have a rustic appearance.*

OPPOSITE *The Western-style barn at Medicine Spirit Ranch holds tools and equipment, hay, stalls, a tack room, and a spacious central area for entertaining decorated to show Texas pride.*

was dominated by Mexican settlers and various groups and bands of Native Americans. By 1740 the plateau of central Texas was dominated by the Comanche, for whom the horse became a cultural icon. Known for their superb horsemanship, the Comanche hunted deer, buffalo, and small game. Mexican and Comanche dominance in the Hill Country began to change in the 1820s, with the immigration of Anglo-Americans from Tennessee, Arkansas, and Missouri.

In the mid-1830s scouts from Germany looking for land on which collectives of immigrants might settle decided that the Hill Country would be their destination. During the 1840s, groups of Germans landed at Indianola, a major port that was destroyed by hurricanes in 1875 and 1886. The settlers traveled west through the already cultivated coastal plain to the Hill Country, where they established self-sufficient farms on their allotted 100 acres per person and laid out towns within easy distances for travel as centers of commerce and culture. Towns such as New Braunfels, Comfort, and Boerne, and hamlets such as Luckenbach, were established in this way.

Fredericksburg was one of the largest of the towns dominated by German culture. The surrounding farms' stables and barns, which were built by the early settlers, have almost all been replaced with metal buildings or newer wooden horse barns. There are, however, a few scattered remnants of relatively small, roughly adzed or hewn whole, round-log structures with stalls and smaller areas for animals. More prevalent but not common are the barns built of hand-adzed wood, limestone, and stucco. Contemporary horse barns built for pleasure horses are stick-built structures whose designs are typical of those found in the West in the latter part of the nineteenth century and today.

Chronology

c. mid- to late 1800s: Stone and hand-adzed log stable
1871: Stone stable
c. 1900: Homestead log animal shelter/stable
2007: Recycled wood stable
2007: Wood hay barn and stable: Medicine Spirit Ranch, Owned by Tom and Trudy Hutton

STANFORD EQUESTRIAN CENTER

STANFORD, CALIFORNIA

PRECEDING PAGES *The Eastlake-style Victorian Red Barn was built in 1878 as the main training stable for Leland Stanford's trotting horses on his world-renowned Palo Alto Stock Farm. Stanford became arguably the most successful trotting horse breeder in the world. Electioneer, the top stallion in America, stood as stud at the farm for many years, always siring quality progeny. He is honored with a life-size bronze statue at the entrance to the historic barn.*

ABOVE *The multimillion-dollar restoration of the massive Red Barn included repainting it with original colors.*

RIGHT *The restoration of the Red Barn included the large second-floor hayloft where open hay chutes provide ventilation by allowing warm air from below to rise to the clerestory louvers just below the roof ridgeline.*

The Red Barn is the centerpiece of the Stanford Equestrian Center, a facility on 13 acres in the heart of the California campus of Stanford University. In 2008 the huge barn was returned to prime condition when a complete restoration and the remodel of the equestrian complex was made possible by the generosity and professional expertise of Stanford University alumnus John Arrillaga, a real estate developer and basketball player who is dedicated to the university's athletic programs and a major upgrading of its various athletic facilities. Well-known equestrian designer Laurel Roberts of Laurel Roberts Equine Design in Salinas, California, helped with the multimillion-dollar project that created a state-of-the-art equestrian complex on the university's historic grounds.

RIGHT *The interior of the main Red Barn was completely renovated with thoughtful stall door designs that allow plenty of ventilation. Large tack boxes are conveniently located beside each stall. The structure was reinforced with new wood where needed, and the whole interior was given a fresh coat of white paint.*

FOLLOWING PAGES *A well-kept tack room has racks and pegs that make saddles and bridles easily accessible. Trunks hold other items used at horse shows.*

PAGES 180–81 *The thirty-seven stalls in the student barn are beautifully appointed with brass-trimmed solid iron rails and slatted Brazilian hardwood doors whose historic design adds artistic beauty to the utilitarian space.*

The Eastlake-style Victorian Red Barn was built in 1878 as the main training stable for Leland Stanford Sr.'s trotting horses on his world-renowned Palo Alto Stock Farm, the 550-horse breeding and training facility that existed from 1876 to 1903. What is left of the farm is now on the campus of Stanford University, created by the Stanfords to honor their son Leland Jr., who died in 1884. Leland Stanford Sr. was intensely dedicated to his horses—he owned the top stud in America, Electioneer, and became arguably the most successful trotting horse breeder in the world, bringing prestige and renown to his California farm.

The Red Barn, the center of the university's riding program and boarding facility for students' horses, underwent a first restoration in 1984 and a second in 2008. Work from 2005 to 2008 also included renovation of the existing student stable and construction of new riding rings. For the large new riding ring that was added in front of the Red Barn, a European drainage system was installed to maintain the state-of-the-art footing. Major groundwork on the five existing rings, which included an indoor arena, involved raising portions of the rings by as much as seven feet where they had settled before the draining was put in place.

The equestrian center was also improved with a new European-style free walker and twenty-eight turnouts, among other facilities. With pastures, stables, and six riding rings, the redesigned 13-acre horse facility is not only in beautiful condition, but its functionality has also increased substantially, easily accommodating the full schedules of the Stanford Equestrian Team, regular riding clinics and horse shows, and Stanford student riders.

Chronology
1878: Red Barn (main barn)
1984: Restoration of Red Barn (Esherick Homsey Dodge and Davis, architects, San Francisco)
1987: One-story student stable
2008: Main riding ring, European-style free walker, covered round pen, various outdoor facilities and buildings; restoration of Red Barn; renovation of student stable, indoor riding arena, four riding rings

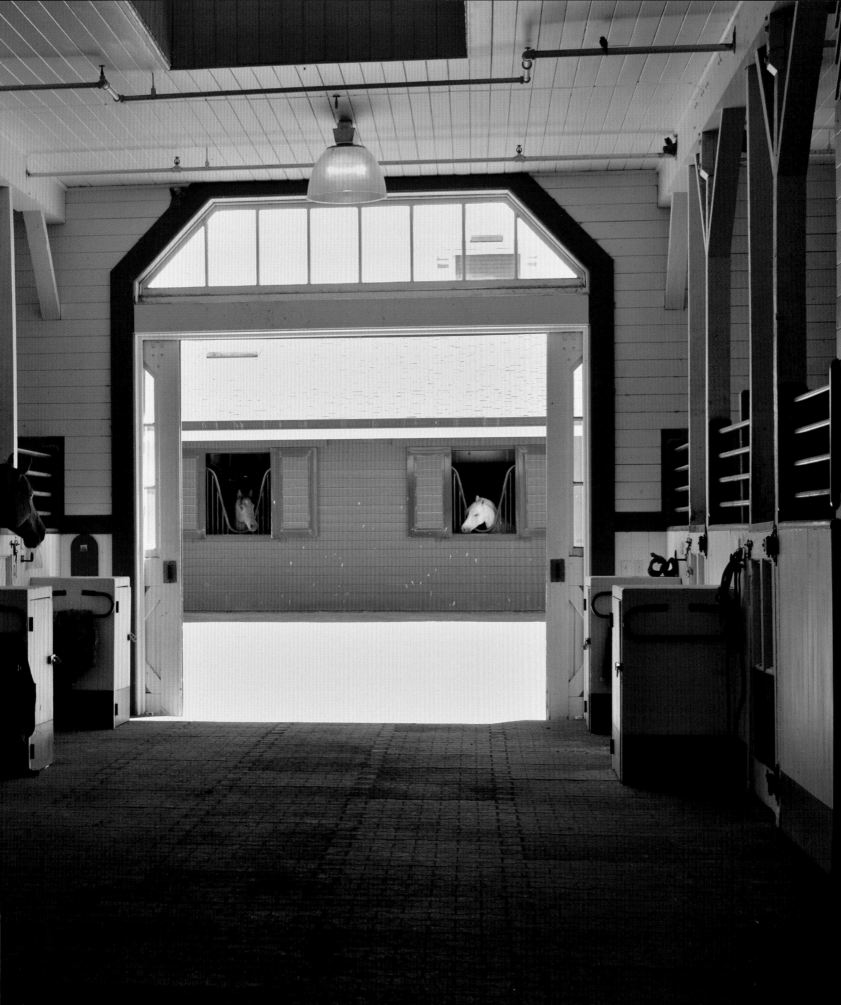

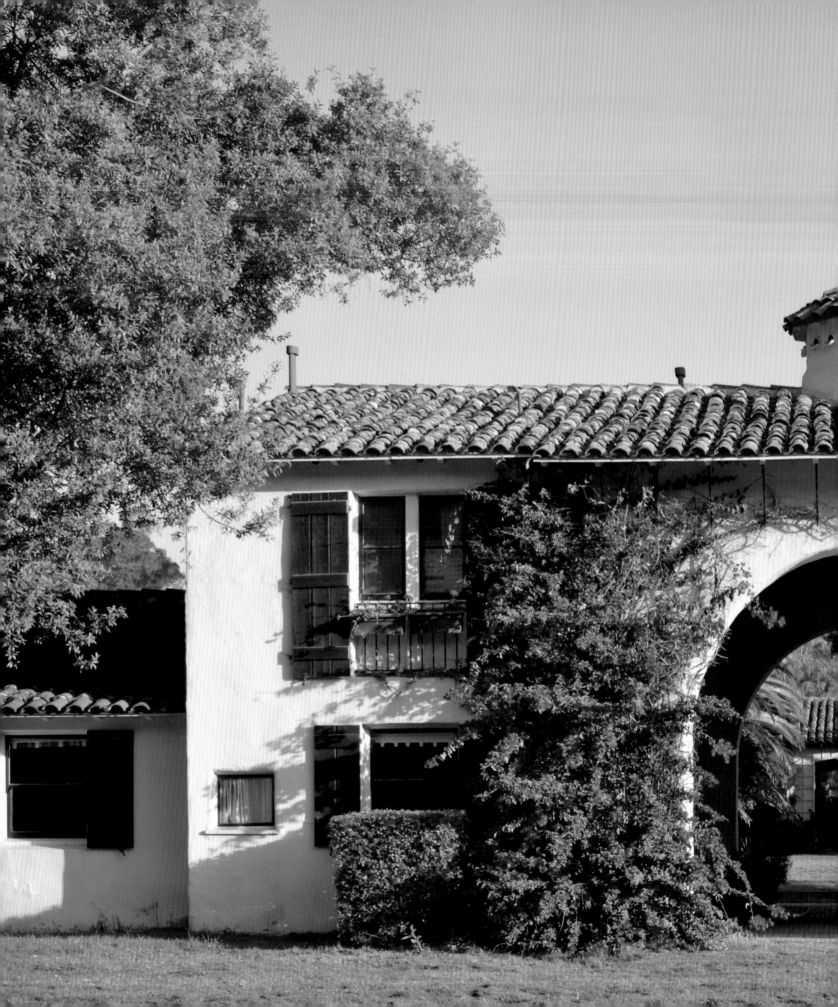

HOPE RANCH RIDING & HUNT CLUB

SANTA BARBARA, CALIFORNIA

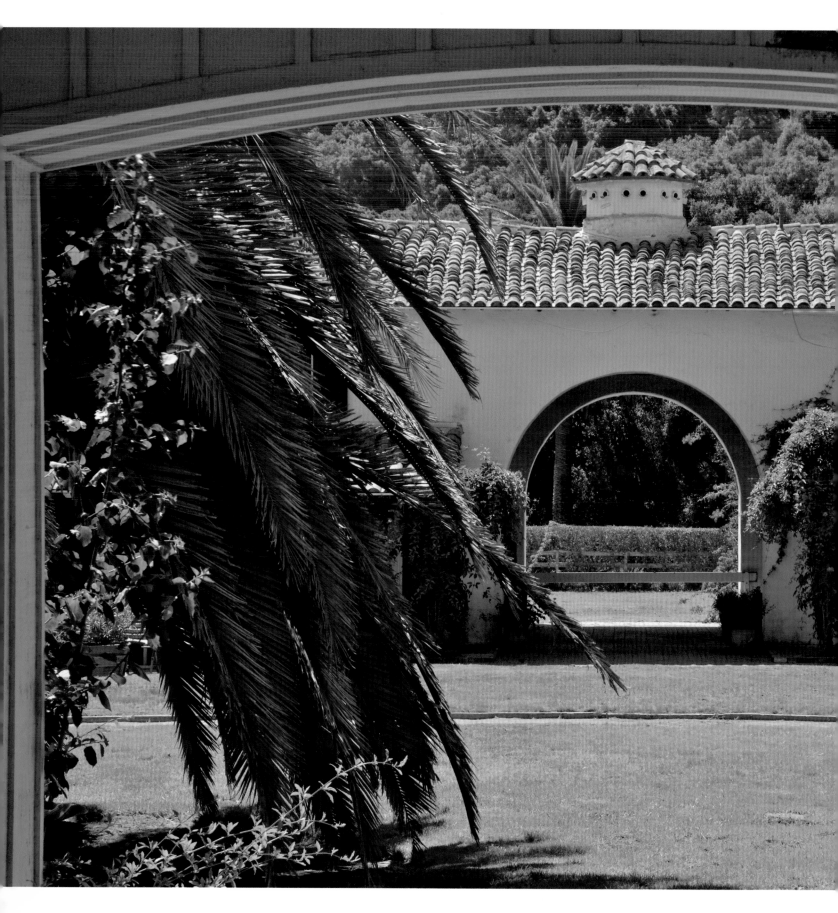

PRECEDING PAGES *Los Angeles architect Reginald D. Johnson designed the Hope Ranch Riding & Hunt Club complex in 1929. The exterior of the historic architecture remains unaltered, but the interiors of the main clubhouse have been remodeled into residences.*

LEFT *Reginald D. Johnson was one of the leading architects of his day. He was a master at site planning and creating exquisite yet simple Spanish Colonial Revival–style residences that were built throughout Southern California.*

Hope Ranch has always been a particularly beautiful place to catch the breezes of the nearby Pacific Ocean. Originally it was the site of one of the larger Chumash villages in the Santa Barbara, California, area. As early as 1829 horse-drawn carriages brought groups to picnic on the hilly land. In 1870 the 3,000-acre Rancho de las Posadas y la Calera (which included the Hope Ranch lands) was granted to Thomas Hope, an Irish immigrant and sheep and cattle rancher.

In 1888 Hope's widow sold 2,100 acres to the Pacific Improvement Company, owned by California's Big Four—Charles Crocker, Mark Hopkins, Collis Huntington, and Leland Stanford—who made plans for development that were begun but never completed. By 1909 a clubhouse, golf course, tennis courts, polo field, and a steeplechase racecourse around Laguna Blanca were ready for seasonal residents of the famous waterfront Potter Hotel and the Santa Barbara community. Some roads had been built, palm trees had been planted, lines for a water distribution system had been laid, and a two-million-gallon reservoir was completed.

In 1914 Harold S. Chase, a Santa Barbara realtor and brother of the dynamic civic leader Pearl Chase, organized the La Cumbre Golf & Country Club for which a new clubhouse was built in 1918. Harold Chase formed syndicates in 1924 and 1925 that bought 825 acres in the easterly part of Hope Ranch and later 1,200 acres to the west. The new owners offered a few large building sites and an updated variety of recreational facilities.

Within this area the Hope Ranch Riding & Hunt Club was designed by architect Reginald D. Johnson, who also created such buildings in Santa Barbara as the Biltmore Hotel. The original layout of the riding club included a one-and-a-half-mile steeplechase track that ran directly in front of the clubhouse, enclosing that building, the stables, a hillside for racing spectators, a riding ring, and a polo field.

Since its heyday, the riding club has come under private ownership. The Thieser and Humbel families, who purchased the property in 1994, have remodeled large living quarters in the former clubhouse. To respect the legacy of the club and its importance to Santa Barbara's architectural history, the exteriors, constructed in 1929, were left as they had been designed by Johnson. The stables of the Hope Ranch Riding & Hunt Club are again filled with horses and riders and the community can once more enjoy the historic property.

Chronology
1929: Clubhouse and stables (Reginald D. Johnson, architect)
Owned by the Thieser and Humbel families

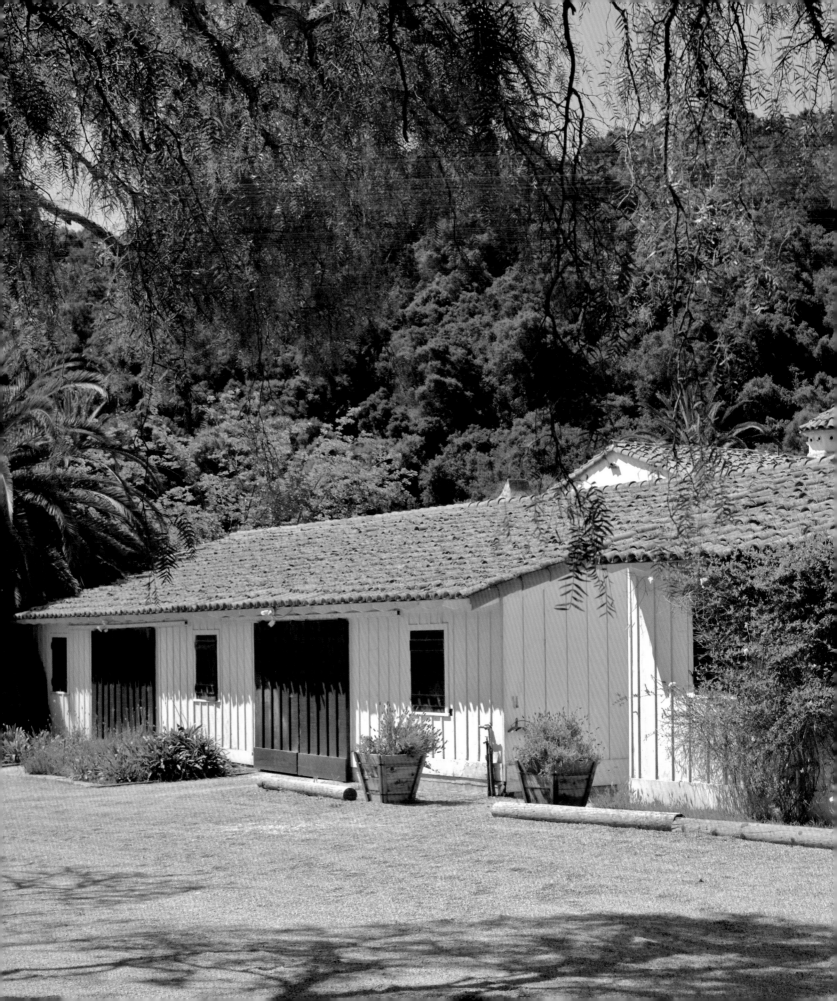

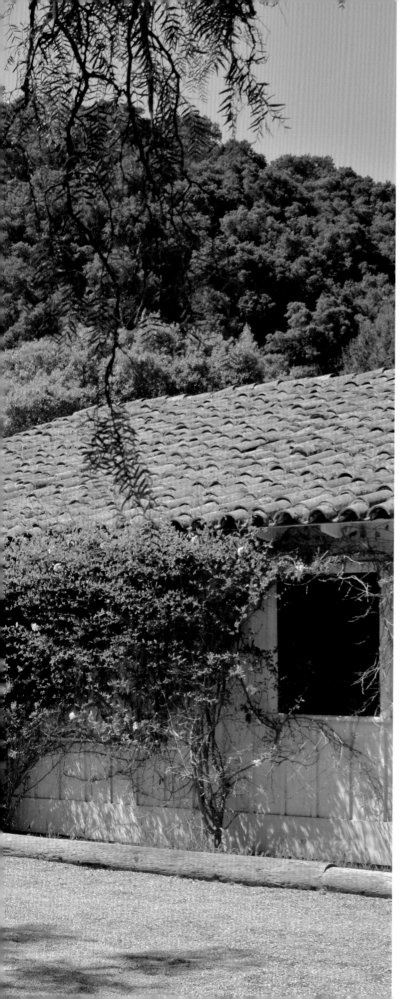

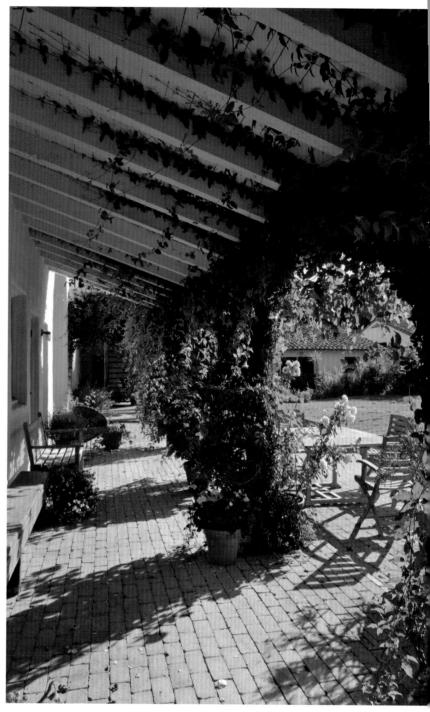

LEFT *The stables at the Hope Ranch Riding & Hunt Club were wood with heavy, handmade, full-barrel-arched terra-cotta roof tiles.*

ABOVE *Brick pathways and a covered patio near the clubhouse-turned-living quarters give the inner courtyard a residential feeling.*

Hope Ranch
Riding & Hunt Club

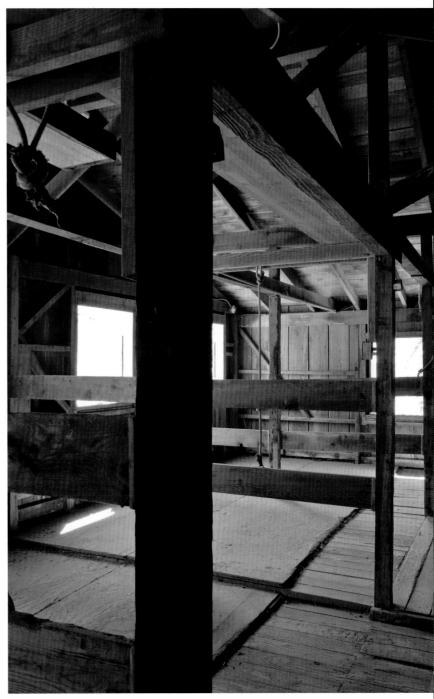

LEFT *The stables are the center of an active riding facility where students participate in classes held by the property owner and riding clinics with visiting experts. Hope Ranch's established equestrian tradition, its many resident horse owners, and thirty miles of cut trails also added great appeal to the property.*

ABOVE *The simple interior of the stable where elegant ladies and gentlemen had their horses tacked up remains unchanged from its 1929 condition.*

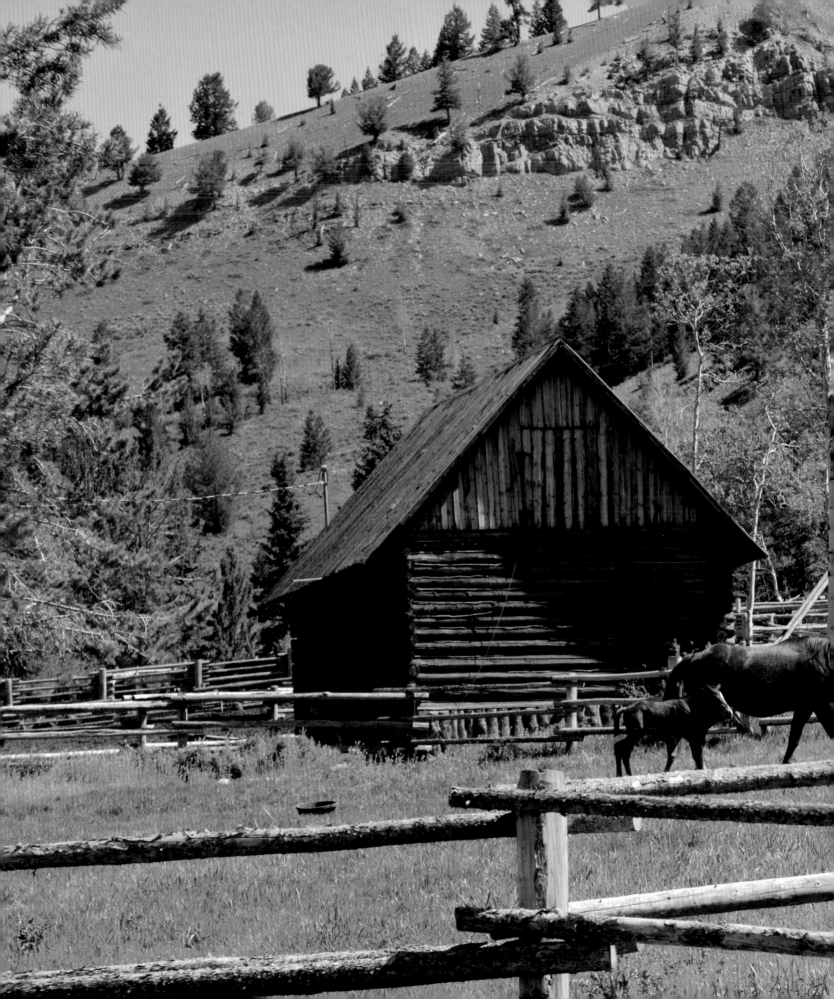

GROS VENTRE RIVER RANCH

MOOSE, WYOMING

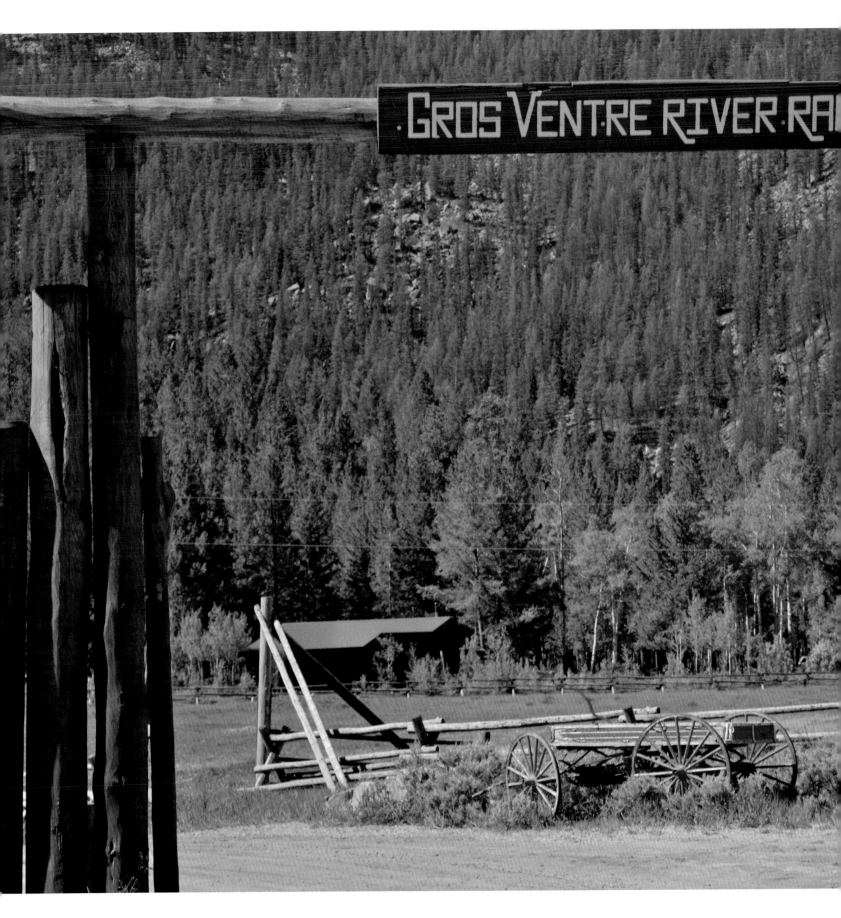

PRECEDING PAGES *Gros Ventre River Ranch was a property homesteaded in the late 1800s in the heart of Wyoming's Jackson Hole Valley. It was converted into a dude ranch in the 1950s and resold in 1987 to the current owners who have added new buildings all designed in the Western tradition.*

LEFT *The 160-acre ranch is located on the Gros Ventre River near protected lands of the 300,000-acre Gros Ventre Wilderness and the Grand Teton and Yellowstone national parks. It is now one of the top ranches chosen by the National Dude Ranchers' Association.*

The beauty of Wyoming lies not only in its magnificent landscape but also in its honored Western traditions. Rushing streams and rivers created from abundant snowfall cut through canyons and flower-covered fields each spring, the rugged majestic Tetons serve as a backdrop for the vast sage-filled plateau that is the valley, and the seasons paint the landscape with brilliant emerald green, dazzling gold, or soft, peaceful white.

Here, primeval rugged wilderness meets twenty-first-century man. The protected landscape remains little changed, historic buildings give the small towns their authenticity, and current architectural trends nod to the historic traditions of the timber-built West. Yet the ambiance created with state-of-the-art technology, luxurious facilities, gourmet offerings, and an abundance of artisan talent remains true to the area's Western heritage. The horse, the Native American, and the American cowboy are revered here.

Jackson Hole was originally seasonal hunting grounds for the Gros Ventre, Shoshone, Blackfoot, and Crow tribes. From 1808 until 1845 American trappers and fur traders used animal trails and those of the Native Americans to traverse the valley and hold annual summer fur-trading rendezvous. It was not until 1883 that the first homestead was claimed, but by the late 1890s, settlers were discovering the valley. During the 1880s and 1890s the American West became a destination for wealthy adventurous Easterners who traveled there to hunt the abundant wildlife. Ranchers accommodated the travelers with rooms and meals in their houses and provided guided hunting tours. Soon they began to charge fees to help offset the costs, and the dude ranch was born.

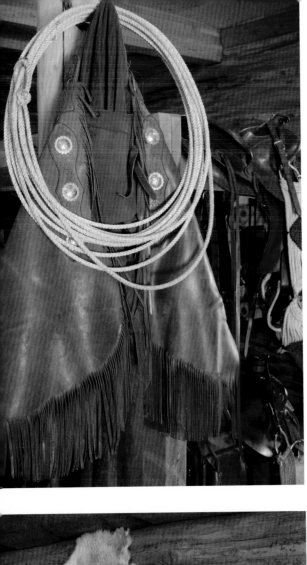

Gros Ventre River Ranch holds all of the rugged beauty of a nineteenth-century homestead with all of the comforts and amenities of the twenty-first century. The Webers opened the 160-acre dude ranch in the late 1980s with four historic log cabins, four new cabins, a timber main lodge, and facilities for more than one hundred horses. Located on the Gros Ventre River near the protected lands of the 300,000-acre Gros Ventre Wilderness and the Grand Teton and Yellowstone national parks, it is now one of the top ranches chosen by the National Dude Ranchers' Association. Nearby mountain trails, streams abundant with native cutthroat trout, and a plethora of native wildlife that includes elk, deer, bison, moose, mountain goat, bighorn sheep, wolf, and black and grizzly bears makes the area unequaled in natural resources.

Chronology

Late 1800s: Homestead

c. 1920s: Murie barn (moved onto Gros Ventre RR in the late 1980s)

1950s: Conversion to dude ranch

1987: Tack barn; outbuildings for staff living quarters; restoration of Murie barn

1990: Hay shed

Owned by Karl and Tina Weber

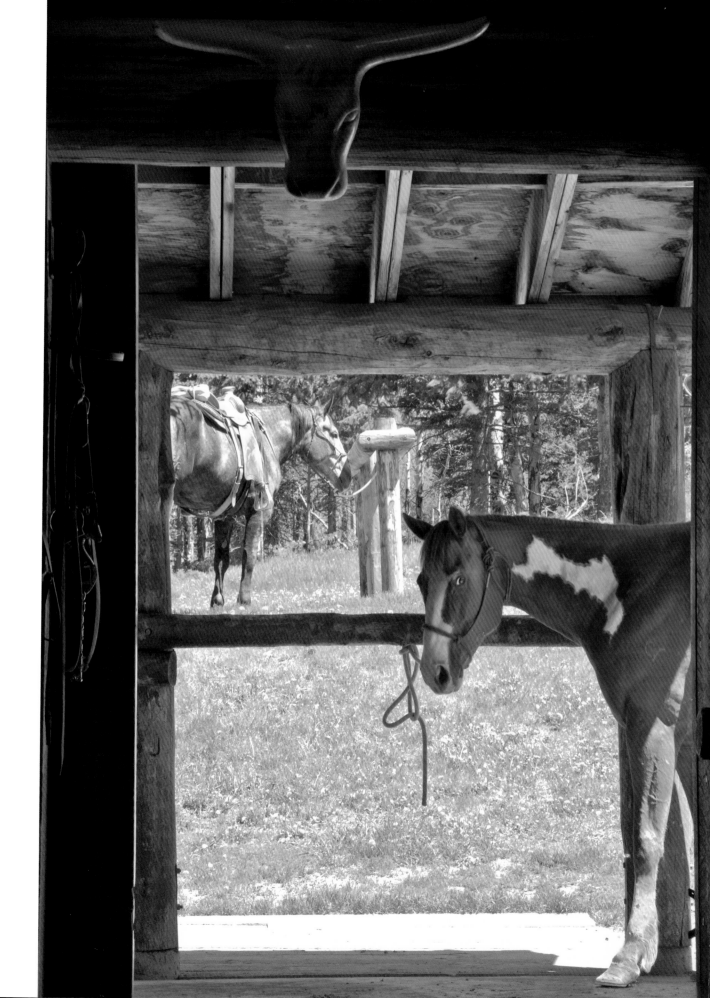

LEFT *New buildings across the dirt driveway from the lodge and cabins include a two-story log structure near the corrals that contains a tack room, offices, and living quarters for the ranch staff.*

ABOVE *The 1920s Murie Barn was relocated onto Gros Ventre River Ranch in the late 1980s, adding to the ambiance of the log-built barn and stable complex.*

FOLLOWING PAGES *Horse facilities at the ranch include corrals and stables for one hundred horses. The crisp air at an elevation of 7,000 feet enlivens the majestic setting of Jackson Hole's natural beauty, central to which are the spectacular Grand Teton Mountains.*

197

FLAG IS UP FARMS

SOLVANG, CALIFORNIA

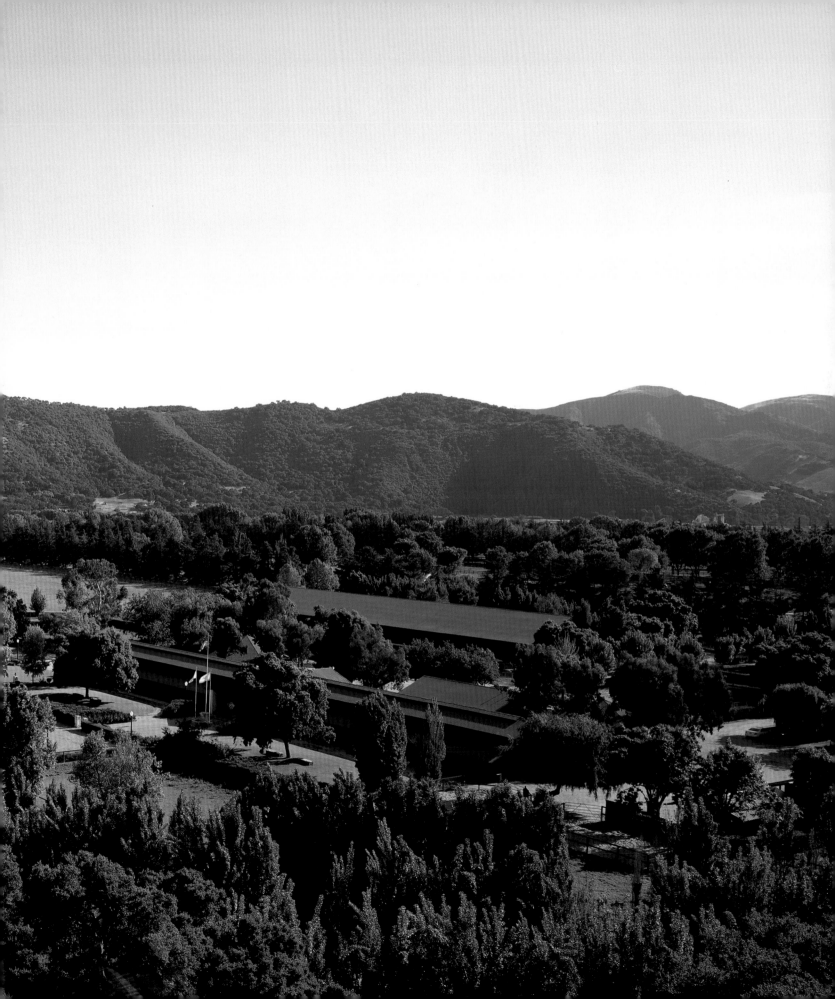

PRECEDING PAGES *Flag Is Up Farms is a state-of-the-art horse training facility established in 1966 by Monty and Pat Roberts. The 100-acre farm is set in the bucolic Santa Ynez Valley, just over the foothills from Santa Barbara.*

LEFT *Outside his office where he writes his best-selling books, teaching manuals, and quarterly magazine, when he is not demonstrating internationally, Monty spends a moment with Shy Boy, the wild Mustang that chose to Join-Up® with him and whose story in DVD and book form has inspired horse lovers throughout the world.*

OPPOSITE *Among the numerous bronzes displayed at their farm is Pat's sculpture of Shy Boy. Pat is an internationally recognized artist specializing in equine-themed classic bronzes.*

Monty and Pat Roberts established Flag Is Up Farms, a complete horse training and breeding facility in the Santa Ynez Valley just over the foothills from Santa Barbara, in 1966. Since then the dynamic couple has trained thousands of horses and helped millions of horse owners on a global basis with Join-Up®, the nonviolent communication technique developed by Monty, while raising their two daughters and a son and serving as foster parents for forty-seven other children. From its beginnings as a horse farm operated by a world-champion cowboy and an accomplished horsewoman, the farm and its owners have become renowned for their impact on the worldwide horse community.

In the 1970s, Flag Is Up Farms was famous for successes in Thoroughbred racing: for eighteen years Monty and Pat were the leading consigners of two-year-olds-in-training at Hollywood Park and trained Thoroughbred champions who won the Prix de l'Arc de Triomphe, the Santa Anita Derby, and numerous other Grade 1 Stakes races. Since that time Monty and Pat and their three grown children have spread the word that there is an alternative to violence in starting and training horses by advocating the Join-Up® technique Monty developed from his years of studying equine behavior. This method focuses on creating a partnership of trust and respect as the basis of communication using body language that the horse understands.

Monty has been a best-selling author since 1996, and today his work includes several television series, a quarterly magazine, and a multi-faceted presence on the Internet. The Roberts also conduct corporate seminars that enable business leaders to translate the lessons of communication from the Join-Up® method to their workplaces and homes.

Though much of Monty's time is spent speaking and teaching in Europe, he and his family are dedicated to their training work at Flag Is Up Farms. Pat, daughter Debbie, and Debbie's husband, Tom Loucks, are

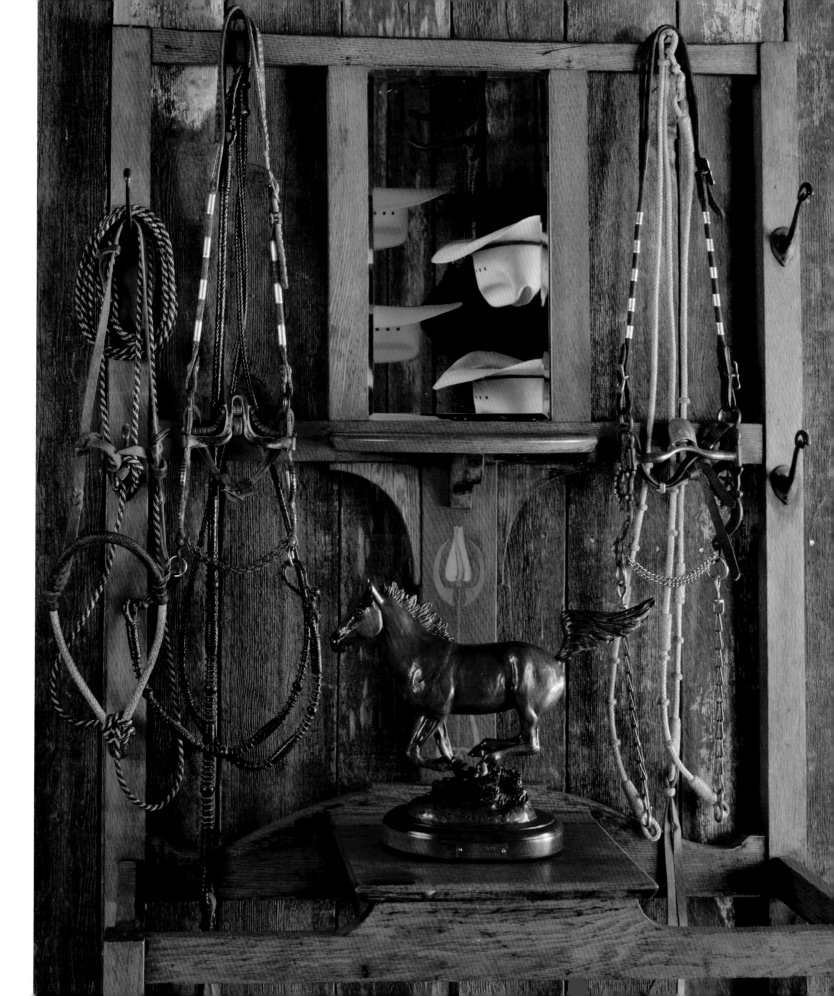

PRECEDING PAGES *Monty Roberts is a champion horseman whose career on the Western circuit spans six decades. Spectacular displays hold a selection from hundreds of beautiful cast, solid silver prize buckles commemorating championships in cutting, reining, working cow horses, team roping, team penning, steer wrestling, bull riding, and horsemanship.*

ABOVE AND OPPOSITE *Monty demonstrates his championship form in working a young calf and stopping his horse, galloping at 35 mph, at the exact spot where he had planned.*

FOLLOWING PAGES *The Monty Roberts International Learning Center is located at Flag Is Up Farms. Monty and Pat also conduct corporate seminars here that enable business leaders to translate the lessons of communication from the Join-Up® method to their workplaces and homes.*

an active influence in running the state-of-the-art training facility that includes the Monty Roberts International Learning Center. Daughter Laurel Roberts travels internationally designing equestrian centers and is a leading authority on footing for racetracks and riding rings. Pat is also an internationally recognized sculptress specializing in equine-themed classic bronzes.

The Roberts family and the undying passion and endless energy of Monty Roberts have surely made the world a better place, both for horses and for people, through their commitment to respectful, gentle, nonviolent communication. These horse lovers are an amazingly compassionate, focused, and energetic team.

Chronology
1966: Farm established
1972, 1976, 1980, 2001, 2003: Facility additions
Owned by Monty and Pat Roberts, Inc.

TOYON FARM

NAPA, CALIFORNIA

PRECEDING PAGES *The entrance courtyard to the stables and indoor arena complex at Toyon Farm was designed by the owners' friend, the internationally renowned Mexican architect Ricardo Legorreta.*

ABOVE AND RIGHT *The golden earth tone chosen for the training complex compliments the California landscape. Besides the stable and indoor arena the riding facility has two outdoor rings for dressage riders set against a backdrop of oak-studded hills.*

In 1993, when Ed and Camille Penhoet heard of a house and stables that had become available in Napa, they jumped at the chance to have a house and dressage facility close to their residence in Berkeley where Camille, who grew up riding in Pebble Beach, could be near her horses.

During her many years of eventing, she had always been challenged by the discipline of dressage and had always desired a well-equipped property of her own. Eighty acres was more than the couple needed, but the former Morgan breeding and training facility was a perfect starting point for what they wanted to create. They soon realized that they owned some of the most prime vineyard land in the Napa and Carneros appellations, and they planted 38 acres, half in Pinot Noir and half in Chardonnay grapes, the varietals most suited to the area's soil and climate. Now, with seasonal sales to Ancien, Stag's Leap Wine Cellars, and Saintsbury, Toyon Farm is the ultimate in California living, a hilltop view of acres of vineyard and a stable complex near the house.

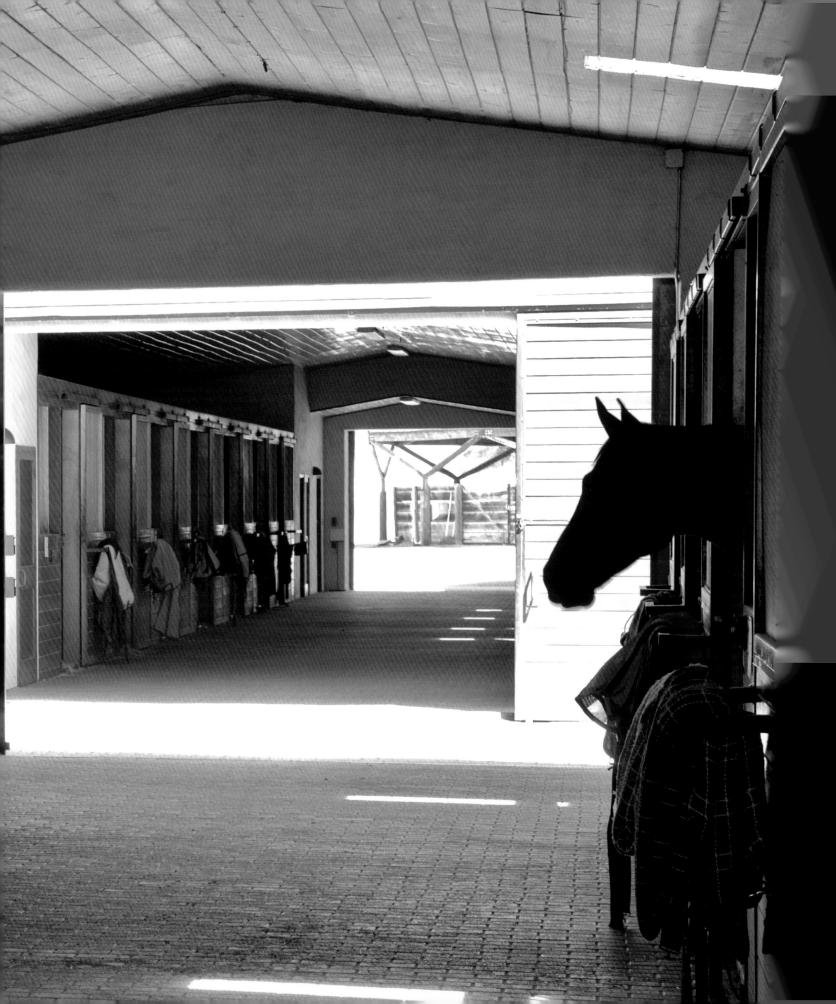

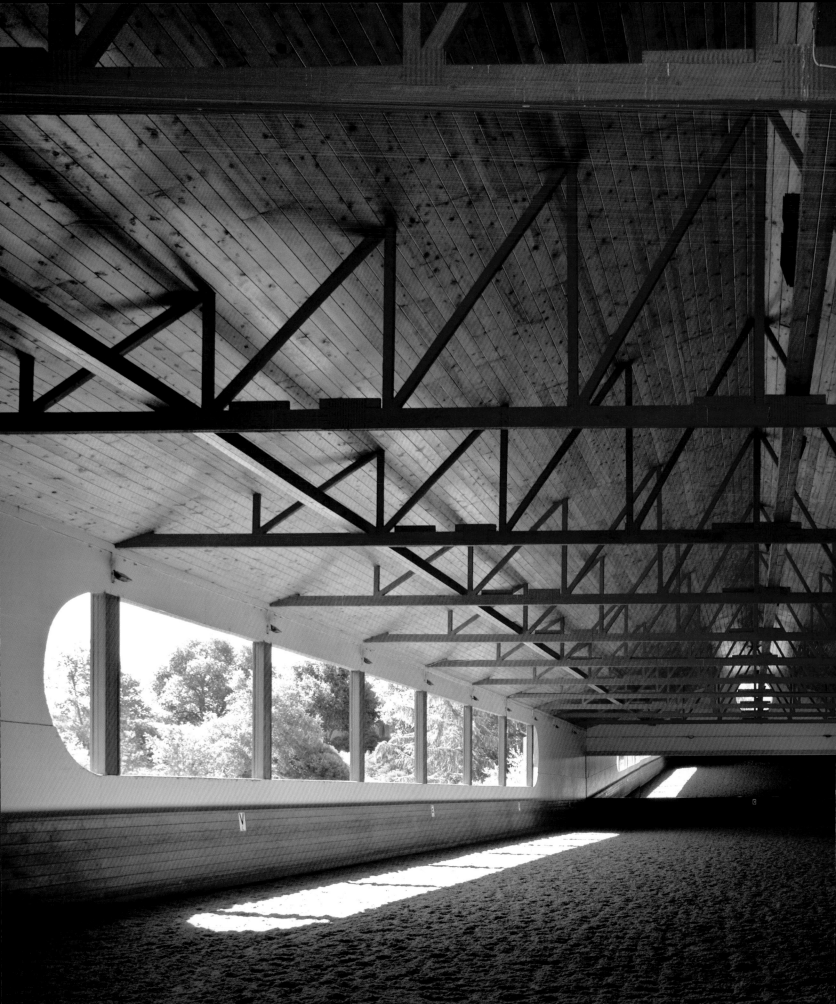

PRECEDING PAGES *Originally built in 1984, the former Morgan training and breeding facility was completely remodeled in 1995. Thirty-six stalls under two roofs were finished in a warm knotty pine.*

LEFT AND ABOVE *The huge indoor arena was given slanted kickboards, full-length mirrors, and Pinnacle composite footing, creating a state-of-the-art dressage ring. Clinics are given regularly by Olympic-level judge Axel Steiner at Toyon Farm.*

The remodel of the 1984 design was a collaboration between the owners and Northern California architect Marcel Sedletzky. Using the existing buildings, convenient wash stations, offices, a viewing room overlooking the dressage ring, three wide barn aisles with ten to twelve stalls each, and individual lockers, were rebuilt under two roofs and finished inside in a warm knotty pine. The indoor arena was given slanted kickboards, full-length mirrors, and Pinnacle composite footing, creating a state-of-the-art dressage ring.

When the Penhoets' friend, the internationally renowned architect Ricardo Legorreta, stopped by for dinner one night, he ended up sketching some ideas for a new stable entrance. Later, formal plans arrived with a design for an entry courtyard that included a seating area, shade trees, and a tiled fountain or drinking trough, emulating the peace and relaxation reminiscent of Legorreta's native Mexico.

Today the stables are filled with horses, some owned by Camille, others owned by trainers and students who enjoy the community that Camille has created with her boarders and who often enjoy rides through the vineyards. The training facility's scheduled events include

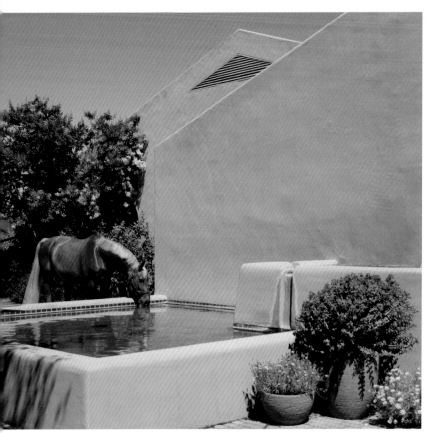

ABOVE *The horses use an elegant drinking trough designed with decorative glazed tiles and a fountain.*

RIGHT *Toyon Farm is comprised of 80 acres, thirty-eight of which are planted in grapes. The vineyards provide an incomparable setting for frequent trail rides.*

clinics given regularly by Olympic-level judge Axel Steiner and training with local instructors. Besides the indoor arena, two outdoor rings create the perfect facility for dressage riders, some of whom compete in shows throughout California, including Camille, who has earned her gold medal from the United States Dressage Federation. With acres of vineyard and a state-of-the-art horse training facility overlooking the valley, the Penhoets' hilltop estate is unsurpassed in California ambiance.

Chronology
1984: House, stables (Robert Keenan, architect)
1995: Remodel, stable complex (Marcel Sedletzky, architect)
1995: Remodel, stable complex entry court (Ricardo Legorreta, architect)
Owned by Ed and Camille Penhoet

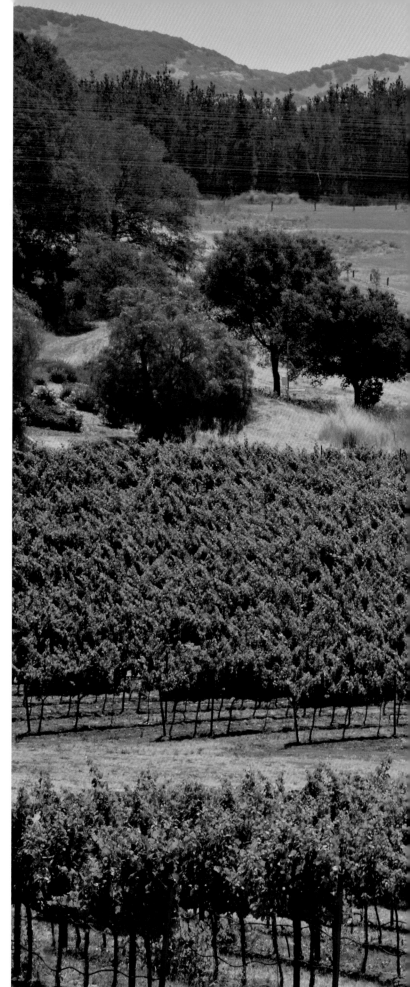

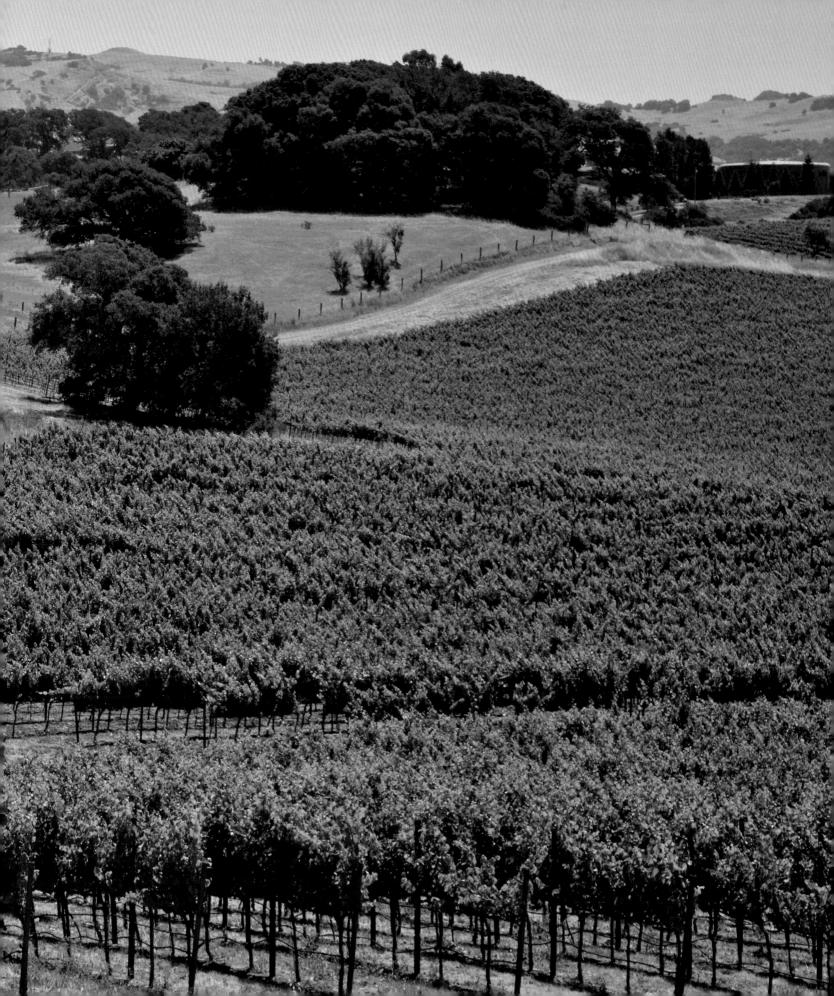

OM EL ARAB INTERNATIONAL

SANTA YNEZ, CALIFORNIA

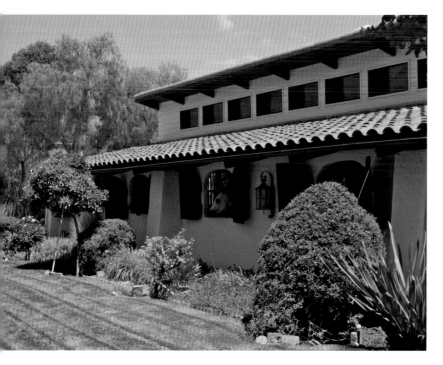

PRECEDING PAGES *Om El Arab International is one of the top Arabian breeding operations in the world. Its setting among the low hills of the Santa Ynez Valley and stables built in the traditional Mediterranean style prevalent in California give the horse farm an unusual elegance. The main complex includes the stallion and mare barns, a show ring with an observation room, and the farm office.*

ABOVE AND RIGHT *The front of the stallion stable has windows opening from the stalls to greet visitors as they enter the complex. At the back of the main horse barns/show ring complex a stone fountain gives the stables a Mediterranean feeling.*

Om El Arab International is a world-renowned Arabian horse-breeding farm in California's Santa Ynez Valley. The complex resembles a spa and country club with Mediterranean-style architecture traditionally landscaped with palm trees, pampas grass, and bright-flowering bougainvillea; in the stable courtyard stands a stone fountain reminiscent of the ubiquitous waterworks in Moorish palaces.

The Om El Arab Arabian horse-breeding operation that is home to multiple world champions is one of the most successful private horse breeding programs in the world. With its impressive credentials in mind, kings and sheikhs and the wealthy and powerful travel from the far corners of the world to inspect and purchase Om El Arab bloodstock.

Owner pride is evident as prospective clients in the viewing room watch as a champion stallion is led into the mare barn. Anyone who has been treated to the experience of seeing an alpha-male stallion strutting into the mare barn to boldly proclaim, in a primal, strange, shocking, wonder-filled spectacle of graceful, powerful horse language, that he is the star—the king—will never forget the visceral moment.

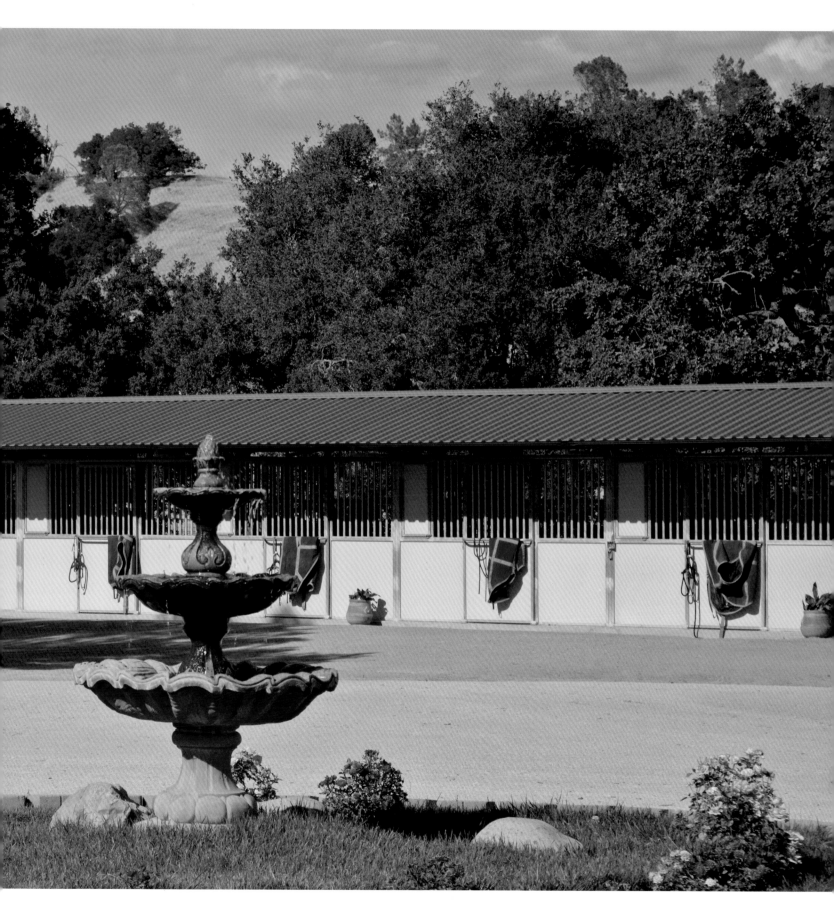

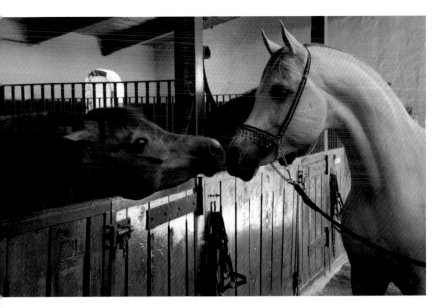

ABOVE *A mare greets the number-one stud Om El Shahmaan, the most magnificent Arabian at the farm.*

RIGHT *The mare barn has box stalls that face the center aisle and other stalls, a high roof and clerestory windows that add light and provide ventilation to the spacious interior. Om El Arab was the Breeder of the Year in the U.S. in 2004.*

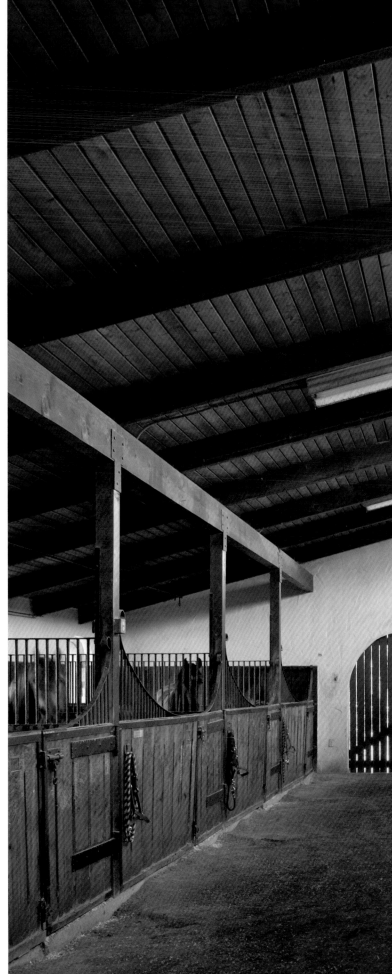

The riding ring, foaling stalls, vetting stalls, stallion and mare barns, and numerous open-air stalls are full, and Sigi Constanti, the owner, and her daughter, Janina Merz, who is the farm manager, together with an excellent staff, run the business that has made Om El Arab's bloodlines some of the most prized and valuable in the world. As a breeding operation that began in Germany more than forty years ago, Om El Arab now has the distinction of having its bloodlines represented in every country where Arabian horses are bred today.

Om El Arab International has consistently garnered top prizes at major shows throughout the world. They were recognized as Breeders of the Year for the United States in 2004, and their leading sire, Sanadik El Shaklan, who passed away in August 2008, was regarded by the international community of horse breeders as one of the world's most influential sires. Many considered the affectionate, tall, exotic, elegant, and finely made stallion to be the most perfect Arabian of his type. "His sire, El Shaklan," explains Constanti, "is believed to have shaped the modern look of the Arabian. Sanadik El Shaklan's progeny, Om El Shahmaan, whose pedigree is also an equal blend of Egyptian and Spanish bloodlines—the Golden Cross—is now our leading sire, the pride and hope of Om El Arab."

Chronology

1984: Broodmare and stallion barns with show ring
and observation room complex, stables, outdoor arena
Sigi Constanti, owner/designer and Steve Shawl, designer
Owned by Om El Arab International, LLC

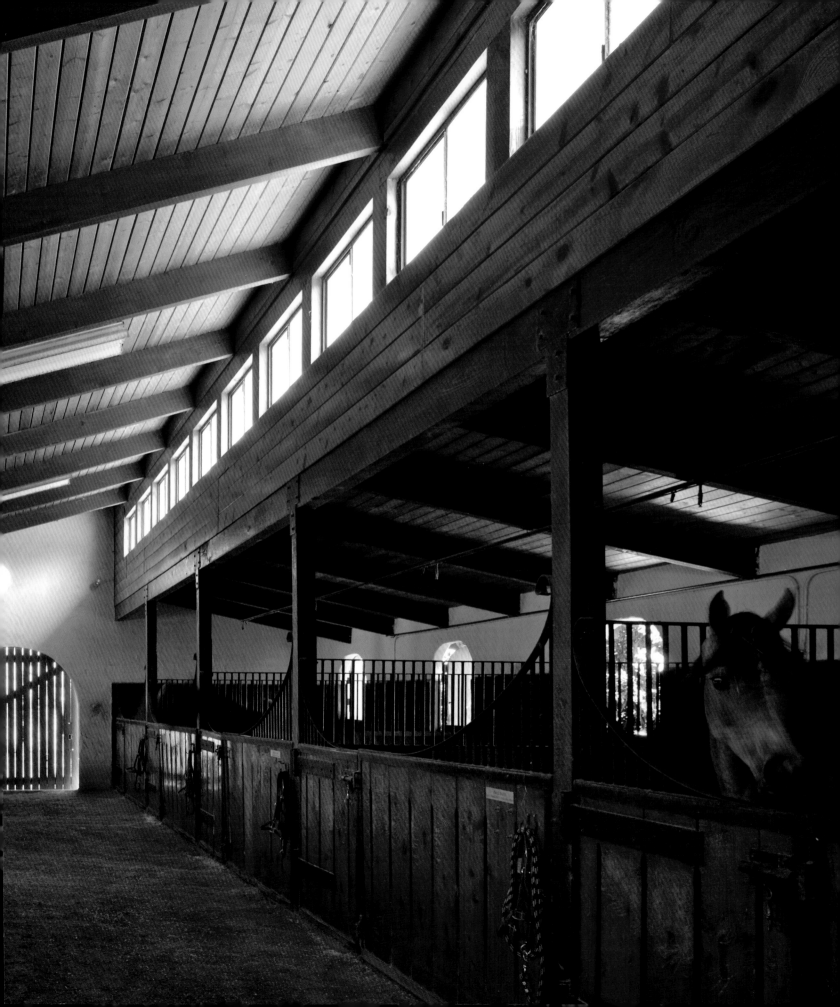

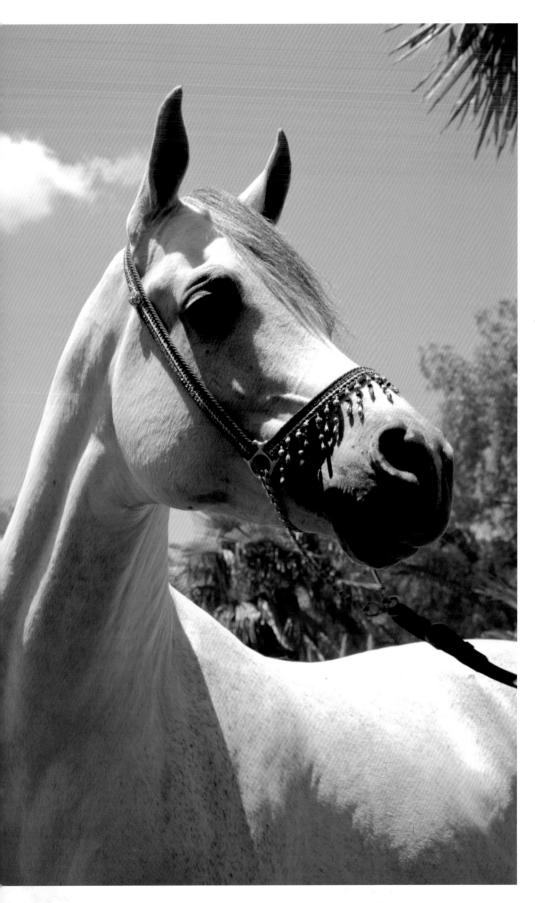

LEFT *Sanadik El Shaklan's progeny, Om El Shahmaan, is an equal blend of Egyptian and Spanish bloodlines and the leading sire. The pride and hope of Om El Arab, he is wearing a show halter.*

OPPOSITE TOP *The patio outside the stallion and mare barns complex is a refreshing place where prospective buyers and other visitors may relax.*

OPPOSITE BOTTOM *An ornate gold and silk artisan saddle was a 2003 gift from the representative of the King of Morocco, inscribed with "In honor of your Breeding Program and long-term friendship." Om El Arab bloodlines are in every country in the world where Arabians are bred.*

FOLLOWING PAGES *Besides selling breeding stock and participating in a rigorous international travel schedule, the owners of Om El Arab maintain it as a 62-acre working farm. Oats, barley and wheat forage are grown successfully on 42 acres of dry, nonirrigated land, creating hillsides that turn from tawny salmon to Irish green to dusky beige between the seasons.*

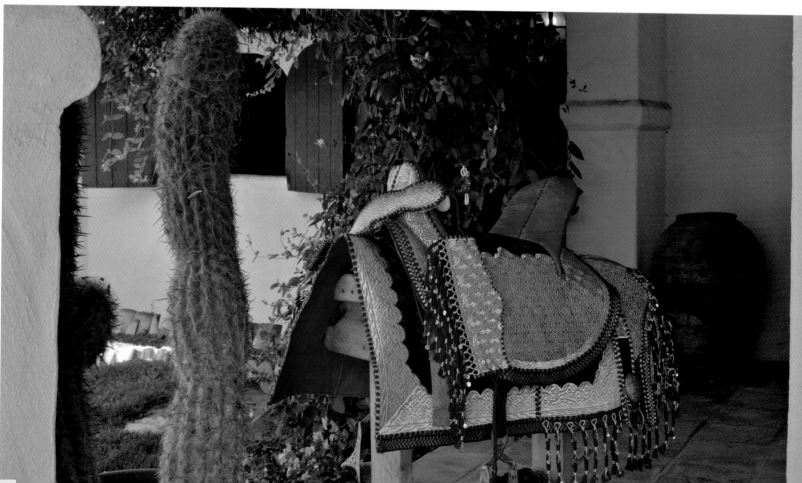

RANCHO ESPERANZA

SANTA BARBARA, CALIFORNIA

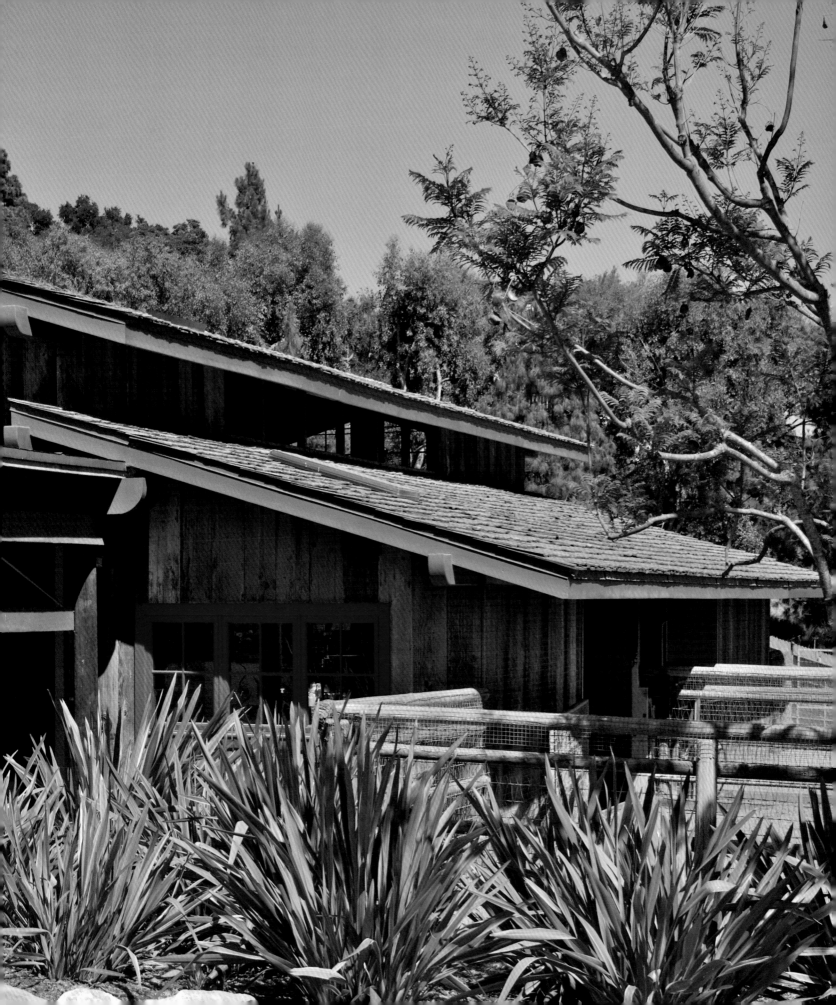

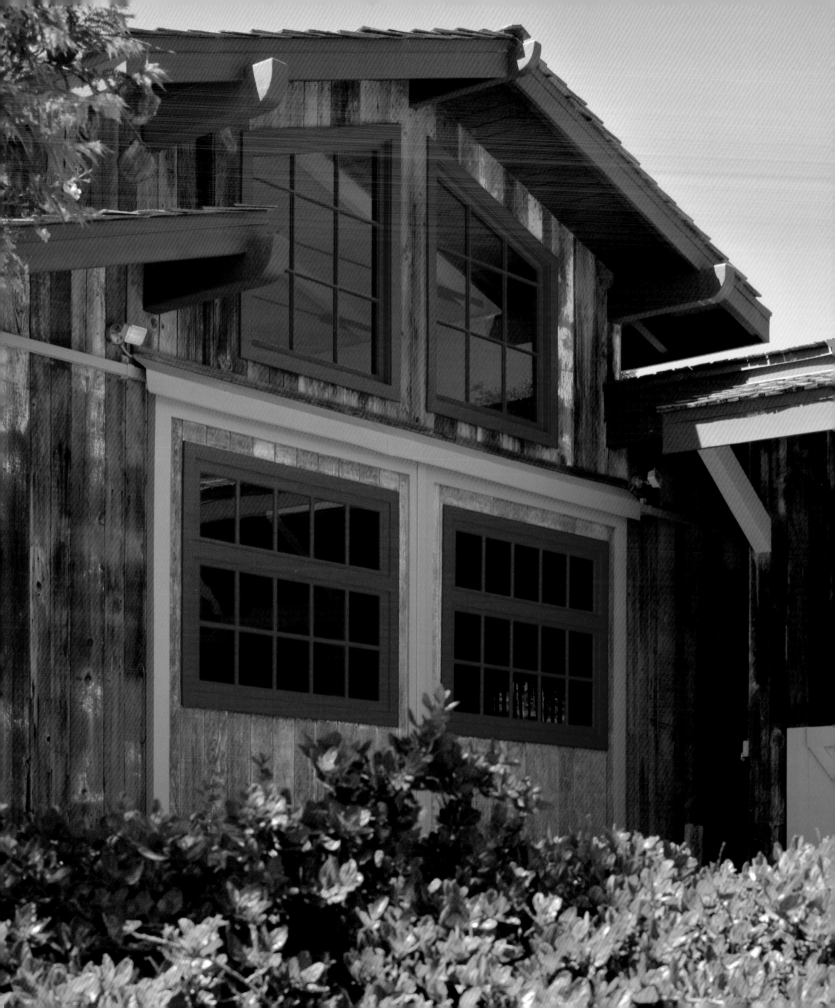

PRECEDING PAGES *The stable at Rancho Esperanza in Santa Barbara's Hope Ranch suburb was designed with a Western aesthetic by Natalie Hodges using weathered wood salvaged from the dismantled buildings of old stables. The barn's design is rustic on the exterior with state-of-the-art innovations on the interior.*

LEFT AND ABOVE *Natalie, a former fashion designer and artist, consciously chose the paint colors for the barn to match the flaxen and red-chocolate mane and body colors of the Rocky Mountain horses. The barn's design gives the horses a lifestyle that is as natural as possible with minimal confinement. All of the three wooden 12-by-14-foot stalls are fully open on the fourth side to individual sand paddocks.*

When Natalie Hodges conceived the new horse barn and corral design for Rancho Esperanza, the 7-acre spread that she and husband Brett own in Santa Barbara's Hope Ranch suburb, she did so with specific goals in mind. Not only did she want the stable to reflect a fine design aesthetic, but it had to be utilitarian and innovative. The Hodges transformed steep slopes covered with the remnants of an avocado orchard into a viable horse ranch with a new riding ring and stables constructed with wood and iron hardware salvaged from the dilapidated buildings of the Vandevere stables, which a neighbor was dismantling a few miles away.

TOP LEFT *The owners' collection of Bolivian* frasadas *and* awayos *are most unusual and colorful.*

BOTTOM LEFT *To give the horse barn interior and the horses as much light as possible, the upper halves of the large stall doors each open to the ranch and the doors facing the wide center aisle are designed using solid wood for the bottom and ironwork above. The design is copied from the one found in eighteenth-century European stables.*

OPPOSITE *Hodges often rides in pieces from her fine collection of silver vaquero tack that she has been collecting for years.*

FOLLOWING PAGES *Long with an open design for the front entrance to the stable, extra-wide double doors at the far end of the stable and glassless clerestory windows allow pleasant ocean breezes to enter the barn. After the hay stored for the year is used up, the empty bays at the back of the barn create a larger area where the Hodges have held barn dances and sit-down dinners for a hundred guests from various trail clubs and nonprofit organizations.*

PAGES 238–239 *Horses frolic in the riding ring surrounded by beautiful blooming jacaranda trees. The ranch has three large irrigated kikuyu grass pastures where the horses are turned out in groups during the day and brought into their open-ended stalls at night.*

Hodges designed her barn with an authentic Western look to use the old materials and yet reflect the latest innovations in stable design. The large center-aisle barn also houses tack- and saddle-making rooms and a wash area, and it is illuminated by a series of glassless clerestory window openings that let in California breezes from the Pacific Ocean. The flaxen and red-chocolate colors of the Hodgeses' Rocky Mountain horses provided the inspiration as Natalie painted the interior of the barn, contrasting the texture of the old wood with high-gloss paint. Color chips were held up to match the horses, and paint was mixed on the spot.

Hodges began riding as a young adult and has evolved from competing in dressage with a Lipizzaner to trail riding with the smooth four-beat gait and easy dispositions of her Rocky Mountain horses. In addition to weekly trail rides with her husband, a tradition that their daughter, Lillie, grew up with, Hodges often rides on the large cattle ranches of Santa Barbara and San Luis Obispo counties and participates in horse-camping as a member of the Sage Hens. But her riding ring and the thirty miles of maintained historic equestrian trails in Hope Ranch provide a good ride at a moment's notice.

Chronology
1986: Riding ring
1987: Stables (Natalie Hodges, designer)
Owned by Natalie and Brett Hodges

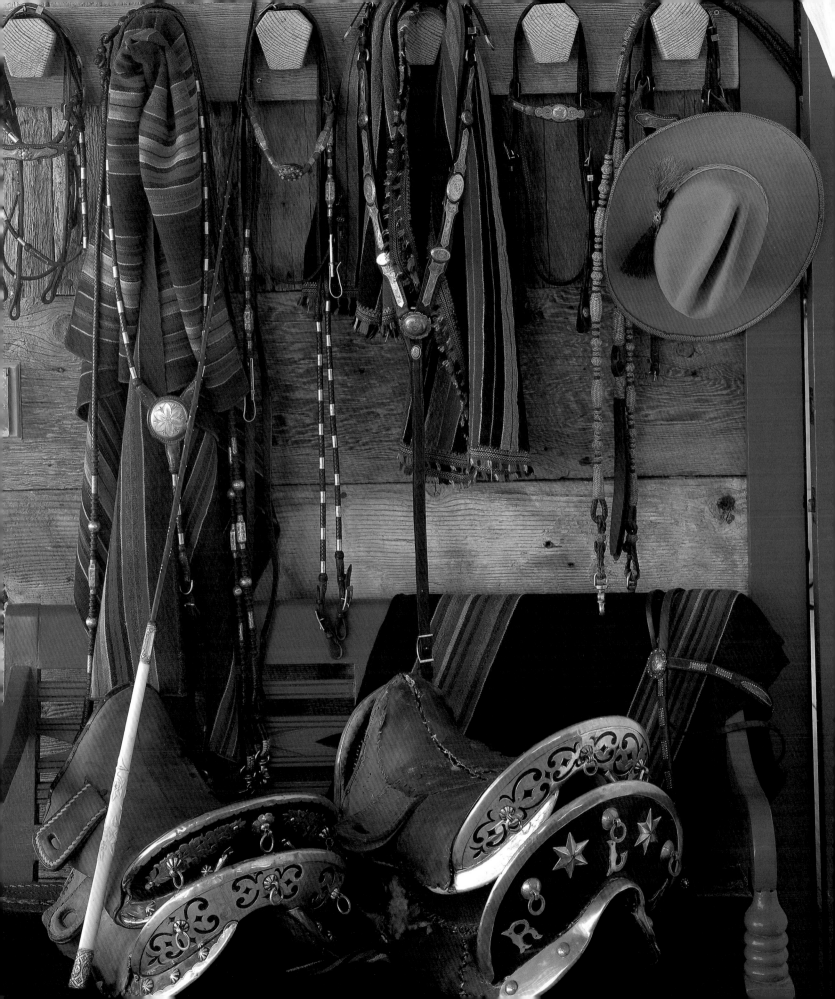

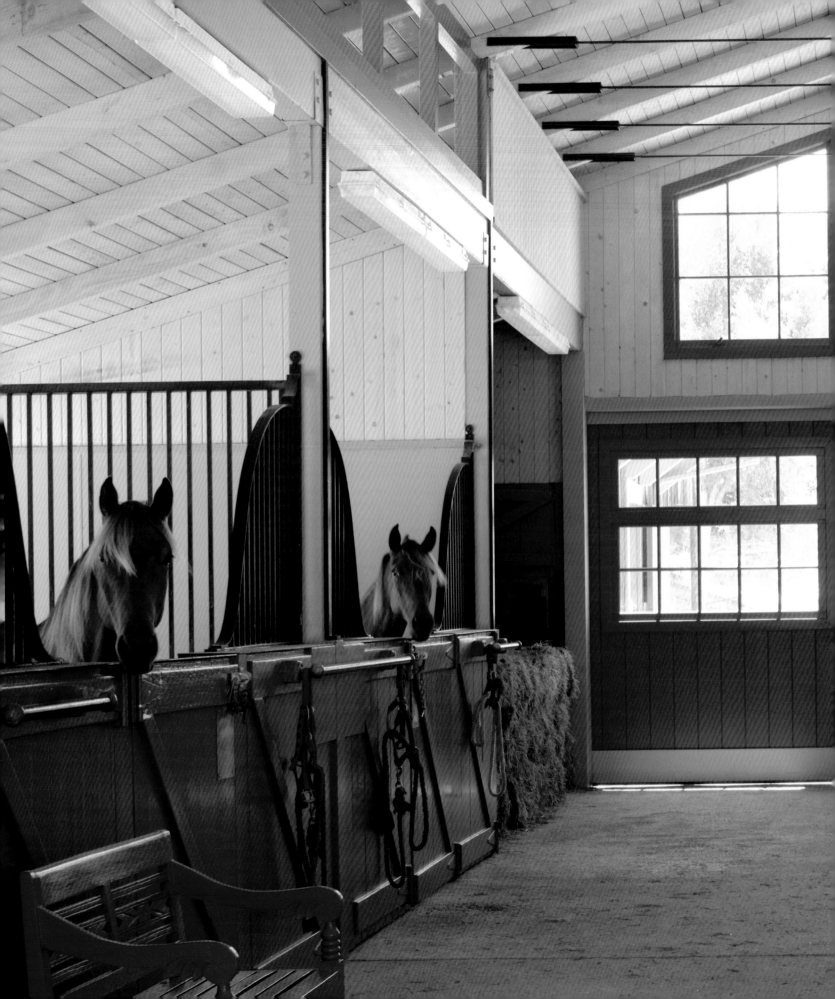

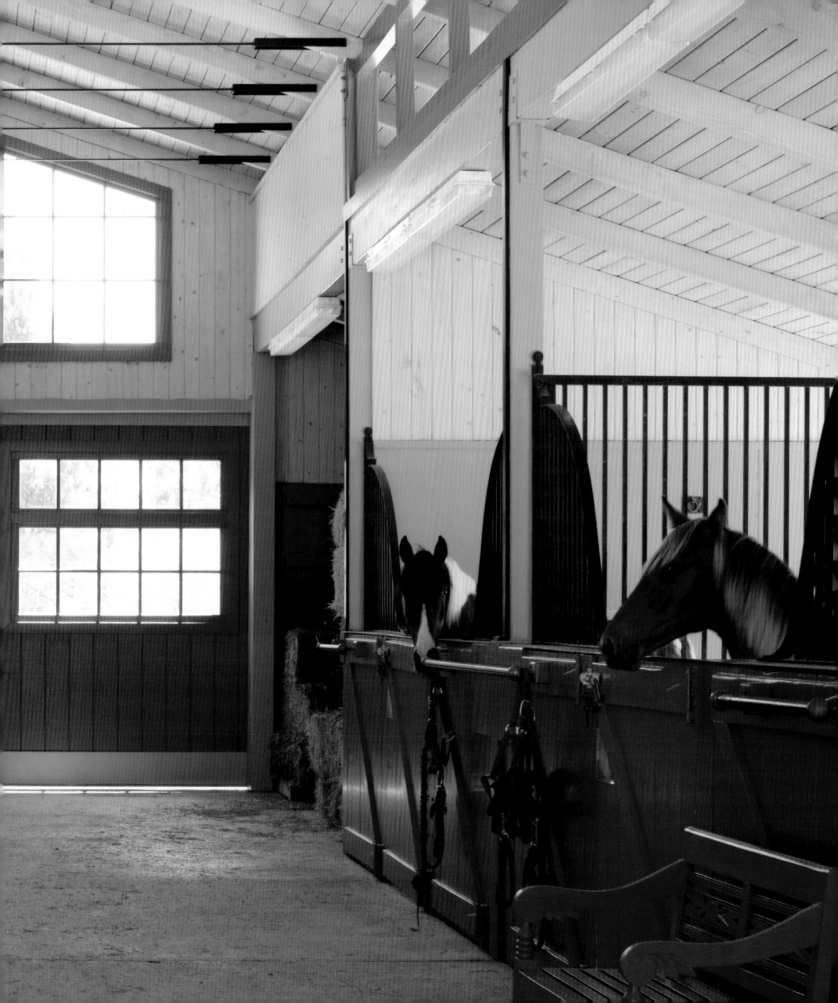

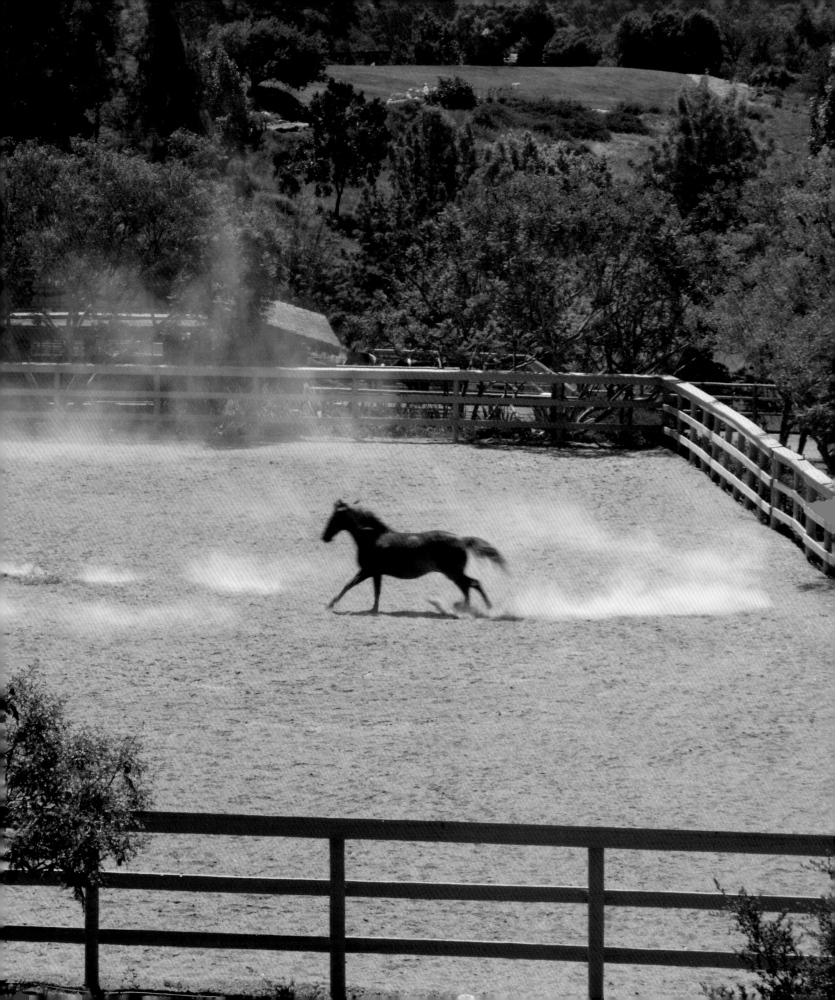

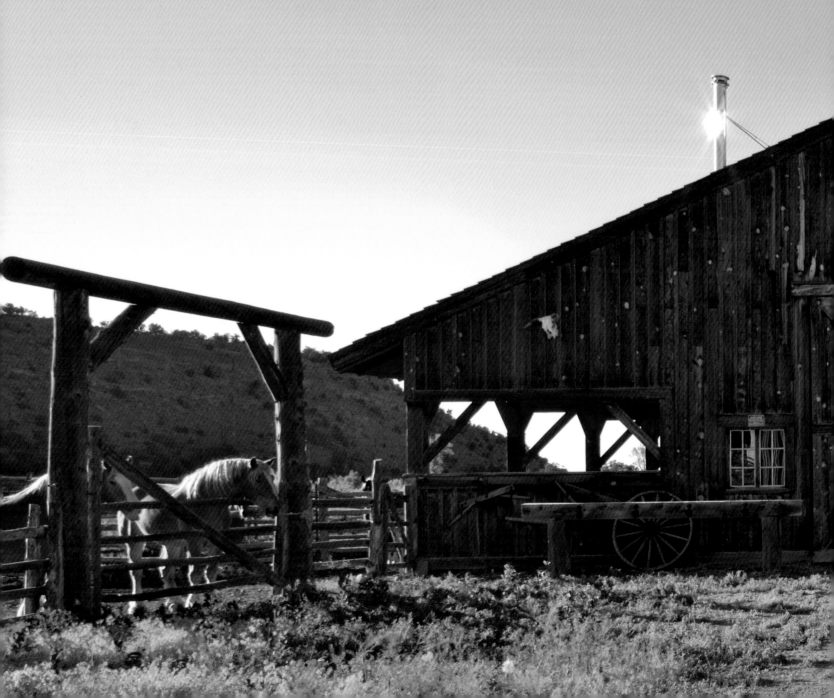

CENTENNIAL RANCH

RIDGWAY, COLORADO

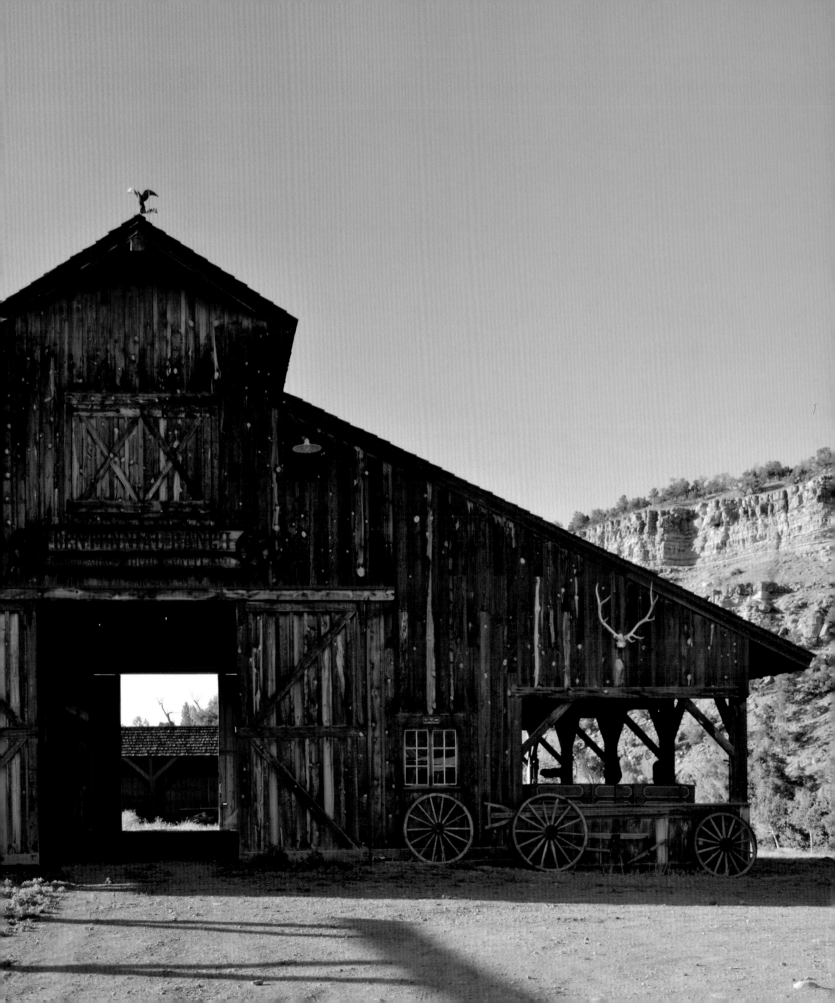

PRECEDING PAGES *This barn is made of timber-frame construction utilizing recycled timber and hand-forged hardware throughout. It is a classic historic design to accommodate working saddle and draft horses.*

RIGHT *Clerestory windows provide light to the barn interior. A covered loafing shed for horses and a shed to protect antique horse-drawn equipment are located on either side of the structure.*

The "Old West" conjures powerful images for us today of broad, pristine landscapes of rolling hills and forested mountains with wildlife, crisp blue skies, and clean rushing rivers. This landscape is completed by the iconic image of the rugged American cowboy. Embodying the spirit of strength and adventurousness that tamed the wilderness with tenacity, grit, ingenuity, and honesty, the American cowboy symbolizes the ideals of America's Western heritage.

Vince Kontny is one of a few modern men who has taken these ideals to heart and transformed his life around them. Kontny, former president and CEO of a top-ranking Fortune 500 company, and his wife, Joan, moved from California to Colorado in 2003, returning to Vince's boyhood ranching roots to follow his passion and live the authentic rancher's life, honoring and preserving the traditions and culture of the Old West. A search for forgotten historic ranches that they could revive, restore, and eventually retire to led them in 1992 to purchase the Centennial Ranch property in Ridgway, Colorado, that is now their home and headquarters for their Double Shoe Cattle Company.

The 400-acre ranch has been completely rejuvenated. The ranch is now the architecturally beautiful and fully functional working cattle ranch that Kontny intended, completed with passionate attention to detail by a team of specialists and artisans who honor and conserve the culture of the American West. The new timber-frame horse barn is the hub of activity for the working cattle ranch.

Kontny has protected the ranch from development in perpetuity by putting it into a conservation easement. This preserves the wildlife habitat for such resident populations as bald and golden eagles, gray and red foxes, mountain lions, black bears, elk, and deer. In reviving the nineteenth-century traditions of the Old West, Kontny's twenty-first-century American cowboy has fulfilled his dream and his destiny.

Chronology
1879: Original homestead
1995: Horse barn (Ted Moews, architectural designer)
Owned by Vince and Joan Kontny

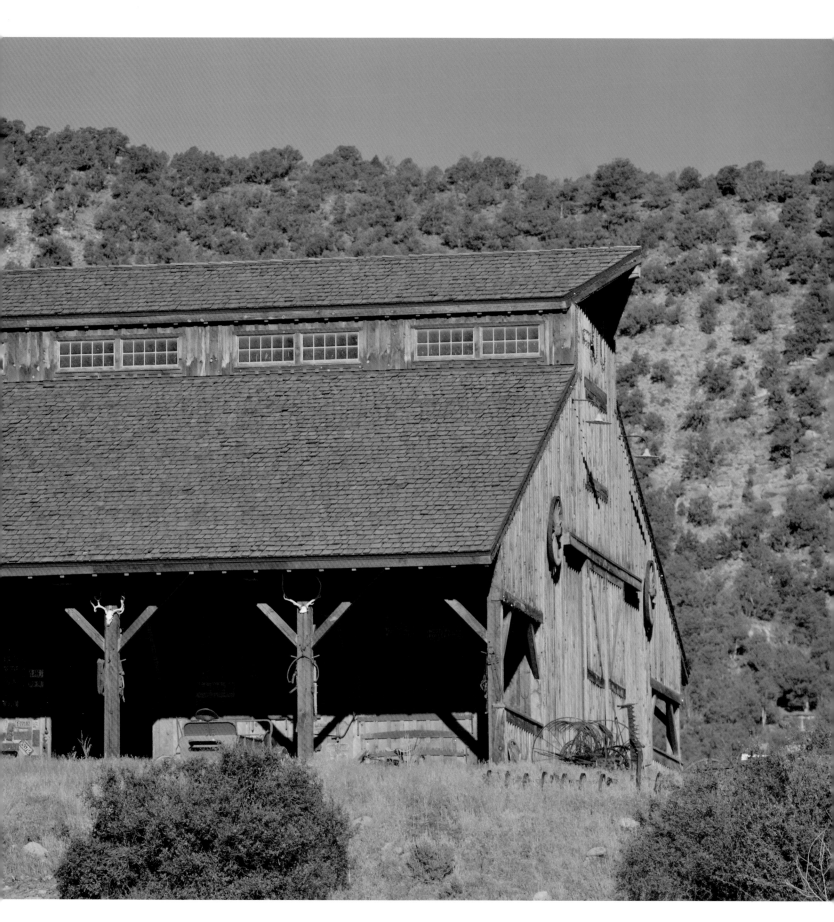

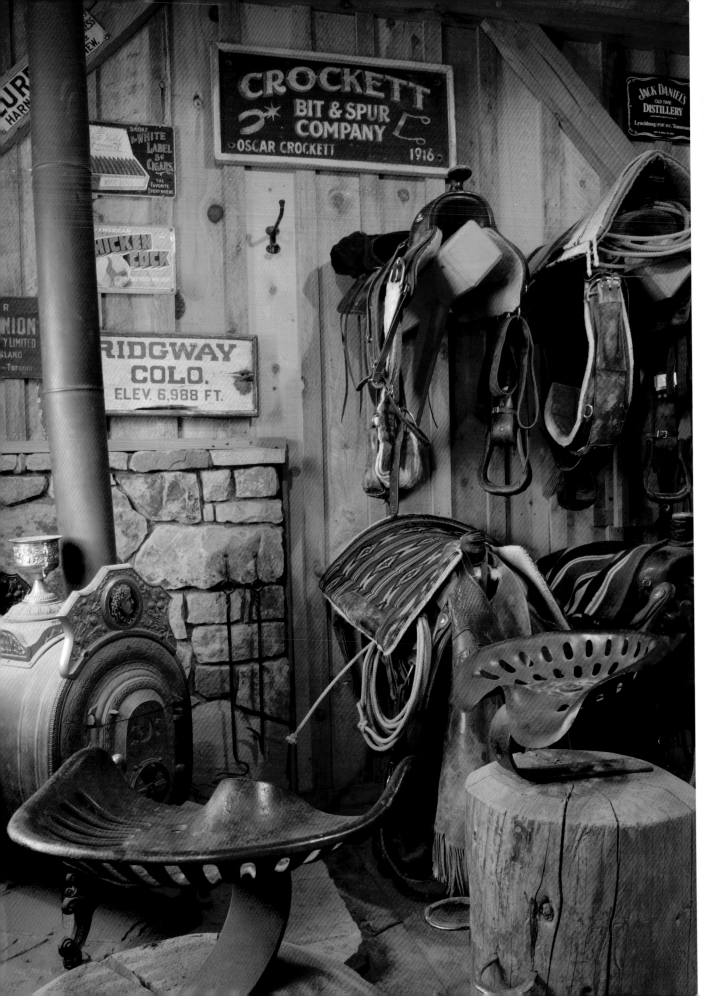

The tack room with numerous saddle racks and hooks for bridles, halters, chaps, slickers, and spurs is heated on cold mornings with an antique parlor stove for cowboys to enjoy a cup of coffee. Cast-iron seats from horse-drawn vehicles affixed to large wood chunks make comfortable seating.

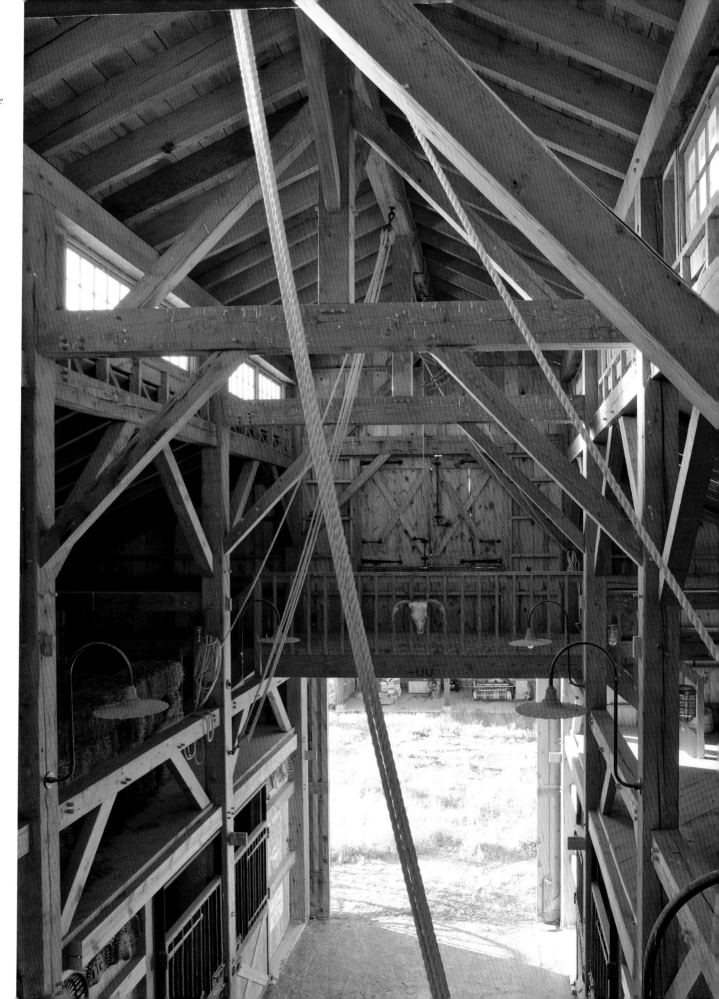

Haylofts on each side of the center aisle provide ample hay storage. The block-and-tackle pulleys are used for lifting the hay and other heavy materials into the lofts.

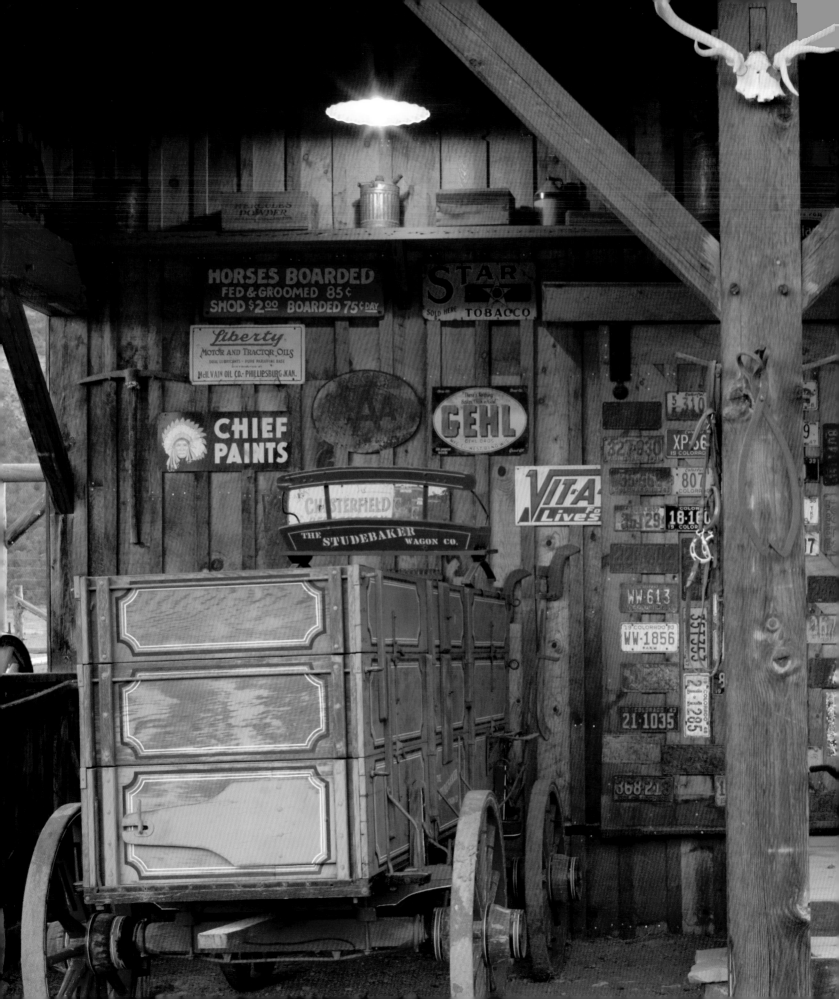

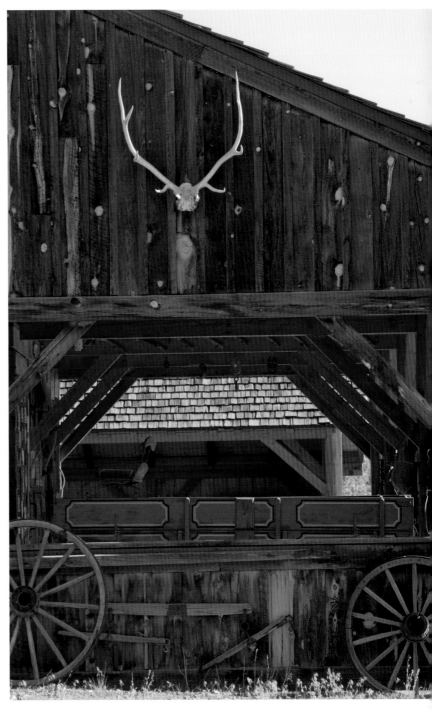

Owner Vince Kontny's extensive collection of old license plates, cast-iron horse-drawn implement seats, farm-related signs, and other antique memorabilia are displayed throughout the barn.

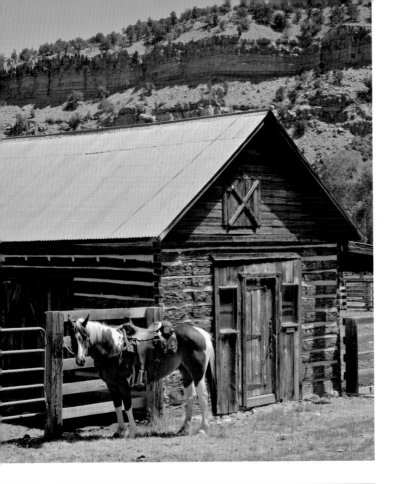

TOP LEFT *The original 1880 log homestead house is now used as a calving shed.*

BOTTOM LEFT *Belgian draft horses are used to pull a hay wagon for feeding the cows during the winter.*

OPPOSITE *Line cabins were used extensively in the Old West when cowboys required shelter and food when working away from the homestead. This is a replica, made of massive standing-dead spruce logs with axe-cut ends. It has neither electricity nor running water.*

FOLLOWING PAGES *The Belgian team is hitched to an early-twentieth-century Studebaker grain wagon.*

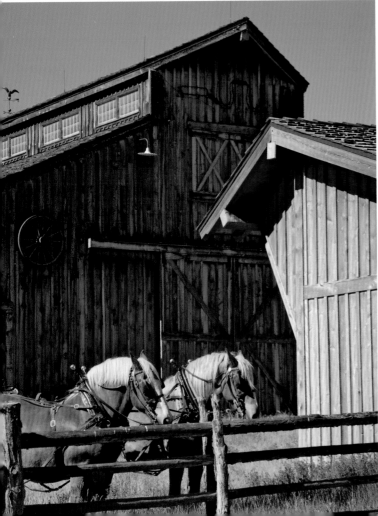

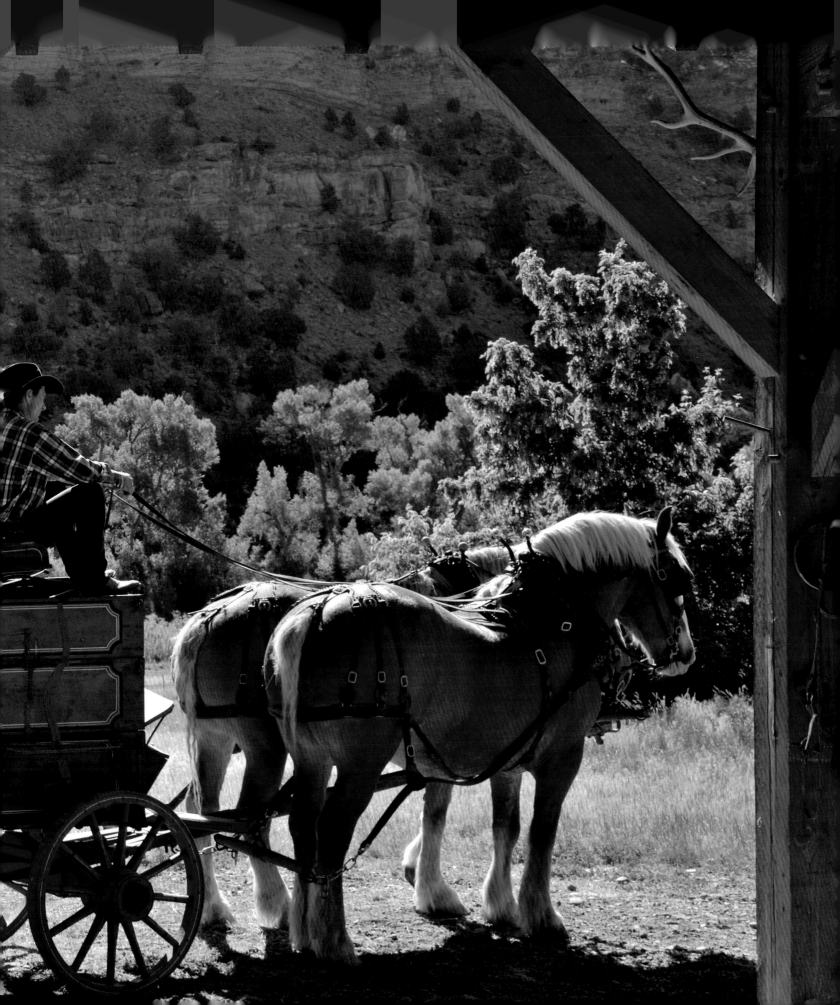

Afterword

The idea for this book came from photographer Paul Rocheleau. There was not a book that dealt with American stables that covered such a wide range of styles and various regions in the country, photographed in a way that evoked the structures as "homes" for horses and showed them in their most beautiful light. Stables that were chosen showed a wide variety of building materials, architectural styles, design features, size, purpose, and history. We were able to travel the country off and on for portions of five months during the good weather periods of spring and fall, visiting both large and small stables, commercial enterprises, private horse barns, high-tech stable complexes, and important historic American equestrian centers. We saw a good cross section of the Eastern and the Western United States. Unfortunately, we were not able to include many important and beautiful stables, nor were we able to represent each state, as the size of the book would not allow it. All of the stables that were chosen, however, show the wide variety of these structures in the United States and, most importantly, reflect the owners' love and care for their magnificent horses.

Acknowledgments

Natasha Adkins, Collections Manager/Curator: Gillespie County Historical Society, Fredericksburg, Texas

Peggy Augustus, Keswick Stables, Keswick, Virginia

Tommy Beach, architect, Middleburg, Virginia

Cricket Bedford, realtor, Thomas & Talbot Real Estate, Middleburg, Virginia

Perky Beisel, D.A., Assistant Professor, Department of History, Stephen F. Austin State University, Nacogdoches, Texas

Blackburn Architects, P.C., Washington, D.C., and San Francisco: John A. Blackburn, AIA, Sr. Principal; Daniel Blair, Sagamore Farm Project Manager; Carol Newman, Director of Marketing; Angie Mareino, Marketing Manager

Cayuse, Western and Native American art and artifacts, Jackson Hole, Wyoming

Jennifer L. Conte, Extension Program Educator, CCE Equine/4-H Horse Program, Cornell University Extension of Saratoga County, Saratoga, New York

Jerry S. Coxsey, General Contractor, JSC Construction, Middleburg, Virginia

Anne Coyner, Upperville, Virginia

Paul Cronin, Rectortown, Virginia

Priscilla M. deLeon, President, Saucon Valley Conservancy, Inc., Hellertown, Pennsylvania

Hand Dietz, Fredericksburg, Texas

Donamire Farm, Lexington, Kentucky: Linda Asher, Administrative Assistant; Debby Keener, Assistant to Don Ball; Thomas Lett, architect; Bensonwood Homes, contractor, Walpole, New Hampshire

Robert F. Ensminger, architectural historian, Bethlehem, Pennsylvania

Christine Fitzgerald, Development Communications Officer, Pegasus Therapeutic Riding, Brewster, New York

Maryann Fitzgerald, City of Saratoga Springs Historian, Saratoga Springs, New York

Sandra Forbush, Sandra Forbush Studio, Flint Hill, Virginia

Kent and Ramona Gaylord, Telluride, Colorado

Patricia Gebhard, author, Santa Barbara, California

Gigi Gerritsen, realtor-associate, Santa Ynez Valley Real Estate Company, Solvang, California

Linda and Jim Grimm, Museum of the Cowboy, Solvang, California

Gros Ventre River Ranch, Moose, Wyoming: Tori and Sean McGough, managers

Danna Gunther, researcher, Encinitas, California

Janet Hitchen, photographer, Middleburg, Virginia

Joy C. Houle, Executive Director, Brookside Museum, Saratoga County Historical Society, Ballston Spa, New York

Gregory D. Huber, architectural historian, Past Perspectives, Macungie, Pennsylvania

Cecily Hughes, Cecily Hughes Interior Design, Telluride and Grand Junction, Colorado

Lynn Kaye, Middletown, Rhode Island

Patrick Lawley-Watkins, Berryville, Virginia

Linda Langerhans, Austin and Fredericksburg, Texas

Doug Larson, Vice President, Piedmont Environmental Council, Warrenton, Virginia

Nancy Martin, interior designer, Burke-Martin, San Francisco, California

Christopher Miller, President, Piedmont Environmental Council, Warrenton, Virginia

Winkie Motley, *Keswick Life* magazine, Keswick, Virginia

Patricia P. Murphy, writer, Solvang, California

National Sporting Library, Middleburg, Virginia: Rick Stoutamyer, Director of Administration; Elizabeth Tobey, Ph.D., Director of Communications and Research; Lisa Campbell, Librarian

Jenny Neffendorf, realtor, ReMax Realty, Fredericksburg, Texas

New York Racing Association, Saratoga Springs, New York: John Lee, Director of Communications

New York Thoroughbred Breeders, Inc., Saratoga Springs, New York: Jeff Cannizzo, Executive Director

Newstead Farm, Upperville, Virginia: Cindy Perry, Administrative Assistant; Eric Connolly, Manager of Racing Stables/Administration; John "Buck" Moore, General Hand

Om El Arab International, Santa Ynez, California: Steve Shawl, designer

Nancy Parsons, Deputy Director for Development, Virginia Museum of Fine Arts, Richmond, Virginia

David Pashley, American Bird Conservancy, The Plains, Virginia

Pioneer Museum, Fredericksburg, Texas

Barbara Plante, Portsmouth, Rhode Island

The Preservation Society of Newport County, Newport, Rhode Island: Andrea Carneiro, Communications Manager; Paul Miller, Curator; John Rodman, Director of Sales & Marketing; Caroline Considine, Director of Development

Karen Puerini-Razza, Portsmouth, Rhode Island

Rallywood, Middleburg, Virginia: Charlie Evaskor, trainer

Rancho Esperanza, Santa Barbara, California: Mindy Smith, Rocky Mountain horse breeder, Freedom Ranch, Arroyo Grande, California; Perry Ferguson, construction manager

Neil Rizos, Neil Rizos Studio, Rileyville, Virginia

Laurel Roberts, Laurel Roberts Equine Design, Salinas, California

Kim Rocheleau, Atlanta, Georgia

Sagamore Farm, Glyndon, Maryland; Thomas Mullikin, Farm Manager; Graham Motion, Rick Violette, Mike Rogers, trainers; Diane Pelkey, Public Relations, Under Armour; Blackburn Architects, P.C., Washington, D.C., equestrian architects

Lilliana and Reza Sahami, Warrenton, Virginia

Paul and Sara Salaman, Pro Aves Colombia, Warrenton, Virginia

Saratoga County Chamber of Commerce, Saratoga Springs, New York: Greg Dixon, Vice President, Tourism

Saratoga County Historical Society and Brookside Museum, Ballston Spa, New York: Joy Houle, Executive Director

Saucon Valley Conservancy, Annual Fall Barn Tour, Hellertown, Pennsylvania

Cherrie Siegfried, The Lazy Moose Ranch, Wilson, Wyoming

John Charles Smith, John Charles Smith & Associates, landscape architects, Far Hills, New Jersey

Mary Ann and Bill Squires, Kentucky Horse Tours, Two Bucks Farm, Versailles, Kentucky

Stanford Equestrian Center, Stanford University, Palo Alto, California: Ray M. Purpur, Deputy Director of Athletics; Laurel Roberts, Laurel Roberts Equine Design, restoration, Equestrian Center; Vanessa Bartsch, Equestrian Program Manager; Jane Sunde, Stanford University student and equestrian; Margaret J. Kimball, University Archivist, Stanford University Special Collections & University Archives

Shannon Stimson, Fauquier County, Virginia

St. James Farm, DuPage County Forest Preserve, DuPage County, Illinois: Wayne Zaininger, Director; Beth Schirott, Sr. Public Affairs Specialist, Office of Public Affairs, Forest Preserve District of DuPage County

Rick Stoutamyer, Stoutamyer Fine Books, Marshall, Virginia

W. Barry Thomson, author, Peapack, New Jersey, and Williamsburg, Massachusetts

Thoroughbred Retirement Foundation, James Madison's Montpelier Estate, Montpelier Station, Virginia; Kim Wilkins, Farm Manager

Cindy Trapp, Trapp Communications, Lexington, Kentucky

Trinity Episcopal Church Annual Stable Tour, Upperville, Virginia

United States Equestrian Team Foundation, USET Center, Hamilton Farms, Peapack-Hamilton, New Jersey: Bonnie Jenkins, Executive Director; Paul Long, Public Relations; Maureen Pethick, Communications Coordinator

George Wallace, American Bird Conservancy, The Plains, Virginia

Melissa Wiedenfeld, architectural historian, Warrenton, Virginia

Special Thanks

My sincere thanks go to everyone who made this book possible. Foremost is photographer Paul Rocheleau, who had the idea for the book and brought it to life with incredible artistry. His work is magical, as you can see. My gratitude to Dr. Perky Beisel for her excellent, informative introduction. Jane Newman, the editor at Rizzoli, and Abigail Sturges, the designer, always do exceptional work. I would especially like to thank my husband, David Pashley, for his watchful eye and good suggestions.

Many thanks to all of the farm and ranch owners who shared their beautiful stables and horses with us. Special thanks to the following experts who generously shared much-appreciated information: Gregory D. Huber, architectural historian in Macungie, Pennsylvania; Barry Thomson, author in Peapack, New Jersey; Tommy Beach, architect in Middleburg, Virginia; Melissa Wiedenfeld, architectural historian in Warrenton, Virginia; Thomas Mullikin, farm manager at Sagamore Farm; Nancy Martin, interior designer in San Francisco; Monty, Pat, and Laurel Roberts and Debbie Loucks in Solvang, California; Elaine Rocheleau in Richmond, Massachusetts; Rick Stoutamyer, antiquarian bookseller in Marshall, Virginia, and Director of Administration, National Sporting Library, Middleburg, Virginia; Janet Hitchen, photographer in Middleburg, Virginia; Kentucky Horse Park in Lexington; Marshall Webb, Woodlands and Special Projects Manager, Rosalyn Graham, Director of Community Relations, and Julie Eldridge Edwards, Curator of Collections, at Shelburne Farms; and Peggy Vaughn, Director of Communications, at James Madison's Montpelier Estate.

Resources

Arthur, Eric, and Dudley Witney. *The Barn: A Vanishing Landmark in North America*. Ontario, Canada: M.F. Feheley Arts Company Limited, 1972, and New York, New York: New York Graphic Society Ltd., 1972.

Beisel, Perky. *The American Upper Class and the American Horse Industry from 1865 to 1929*. D.A. diss., Middle Tennessee State University, 2005.

Benway, Ann. *A Guidebook to Newport Mansions*. Newport, Rhode Island: The Preservation Society of Newport County, 2006.

Bowen, Edward L. "The Legend of Newstead," in sales brochure "Complete Dispersal of Thoroughbred Holdings of Newstead Farm Trust." Lexington, Kentucky: Fasig-Tipton Kentucky, Inc., 1985.

Chase, Harold S. *Hope Ranch: A Rambling Record*. Santa Barbara, California: Santa Barbara Historical Society and Pacific Coast Publishing Company, 1963.

Clarke, Denya Massey. "Huntland: A proud fixture of American foxhound history is saved at the eleventh hour." Berryville, Virginia: Masters of Foxhounds Association of America, *Covertside*. Fall 2008.

Endersby, Elric, Alexander Greenwood, and David Larkin. *Barn: The Art of a Working Building*. Boston and London: Houghton Mifflin Company, 1992.

———. *Barn: Preservation & Adaptation: The Evolution of a Vernacular Icon*. New York, New York: Universe Publishing, 2003.

Ensminger, Robert F. *The Pennsylvania Barn, Its Origin, Evolution, and Distribution in North America*. Baltimore, Maryland: Johns Hopkins University Press, 2003.

Farge, Olga Prud'homme, Alice Vayron de la Moureyre, and Gabrielle Boiselle. *Stables: Majestic Spaces for Horses*. New York: Rizzoli International Publications, Inc., 2006.

Fitchen, John, and Gregory D. Huber. *The New World Dutch Barn: The Evolution, Forms, and Structure of a Disappearing Icon*. Syracuse, New York: Syracuse University Press, 2001.

Gambrill, Richard V. N., and James C. Mackenzie. *Sporting Stables & Kennels*. New York: The Derrydale Press, 1935.

Gannon, Thomas. *Newport Mansions*. Newport, Rhode Island: The Preservation Society of Newport County, 2006.

Garman, James E. *A History of the Gentlemen's Farms of Portsmouth, R.I.* Portsmouth, Rhode Island: Hamilton Printing, 2003.

Huber, Gregory D. "Barn Roof Timbers that Helped Build the Early Pennsylvania German Culture: Liegender Dachstuhl and other Roof Systems," in *Der Reggeboge: The Journal of the Pennsylvania German Society*, vol. 42, no. 1, 2008.

——— "From the Distant Past: Early Type Fachwerk German Ground Barn in Central New Jersey," in *Der Reggeboge: The Journal of the Pennsylvania German Society*, vol. 42, no. 1, 2008.

Kimball, Fiske. *Domestic Architecture of the American Colonies and of the Early Republic*. New York: Charles Scribner's Sons, 1922, and Mineola, New York: Dover Publications, Inc., 2001.

Lee, Guy H. "Estates of American Sportsmen: Vernon Manor, Home of Richard Van Nest Gambrill, Esq., at Peapack, New Jersey," in *The Sportsman*, April 1931.

Leffingwell, Randy. *Ultimate Horse Barns*. St. Paul, Minnesota: Voyageur Press, 2003.

Lipke, William C., Ed. *Shelburne Farms: The History of an Agricultural Estate*. Burlington, Vermont: Robert Hull Fleming Museum at the University of Vermont, 1979.

McEvoy, Hallie. *Genuine Risk*. Lexington, Kentucky: Eclipse Press, 2003.

Olmsted, Frederick Law. *The Cotton Kingdom: A Traveler's Observations on Cotton and Slavery in the American Slave States*. New York, New York: Alfred A. Knopf, 1953 (first published by Mason Brothers, 1862).

Patterson, Augusta Owen. "Country Gentleman Interests at Peapack," in *Town & Counry*, Vol. 90, No. 4156, September 1935.

Routson, Rafael. *A Heritage in Iron*. Montrose, Colorado: Double Shoe Publishing Company, 2004.

———. *A Ranching Legacy*. Montrose, Colorado: Double Shoe Publishing Company, 2005.

Sadler, Julius Trousale Jr., and Jacqueline D. J. Sadler. *American Stables: An Architectural Tour*. Boston: New York Graphic Society, 1981.

Schleicher, William A., and Susan J. Winter. *Images of America: In the Somerset Hills: The Landed Gentry*. Dover, New Hampshire: Arcadia Publishing, 1997.

Sexton, R.W. "Country Life in America," in *Country Life Magazine*, vol. 72, no. 3, July 1937.

Slater, Kitty. *The Hunt Country of America Then and Now*. Upperville, Virginia: Virginia Reel, Inc., 1967, 1973, 1987, 1997.

Thomas, Joseph B. "Huntland: Middleburg, Loudoun County, Virginia" brochure reprint. New York: Joseph B. Talbot, 1919.

———. *Hounds and Hunting Through the Ages*. Garden City, New York: Garden City Publishing Co., Inc., 1928. Reprinted 1933, 1937.

Tinney, Jason. "Saving Sagamore," in *Maryland Life* magazine. Frederick, Maryland: Great State Publishing, LLC, May 1, 2008.

Turpin, John K., and W. Barry Thomson with Introduction by Mark Alan Hewitt. *The Somerset Hills: New Jersey Country Houses*, Vol. I. Far Hills, New Jersey: Mountain Colony Press, Inc., 2004.

Turpin, John K. and W. Barry Thomson. *The Somerset Hills: New Jersey Country Houses*, Vol. II. Far Hills, New Jersey: Mountain Colony Press, Inc., 2005.

Vlach, John Michael. *Barns*. New York: W.W. Norton & Company, Inc., 2003.

INDEX

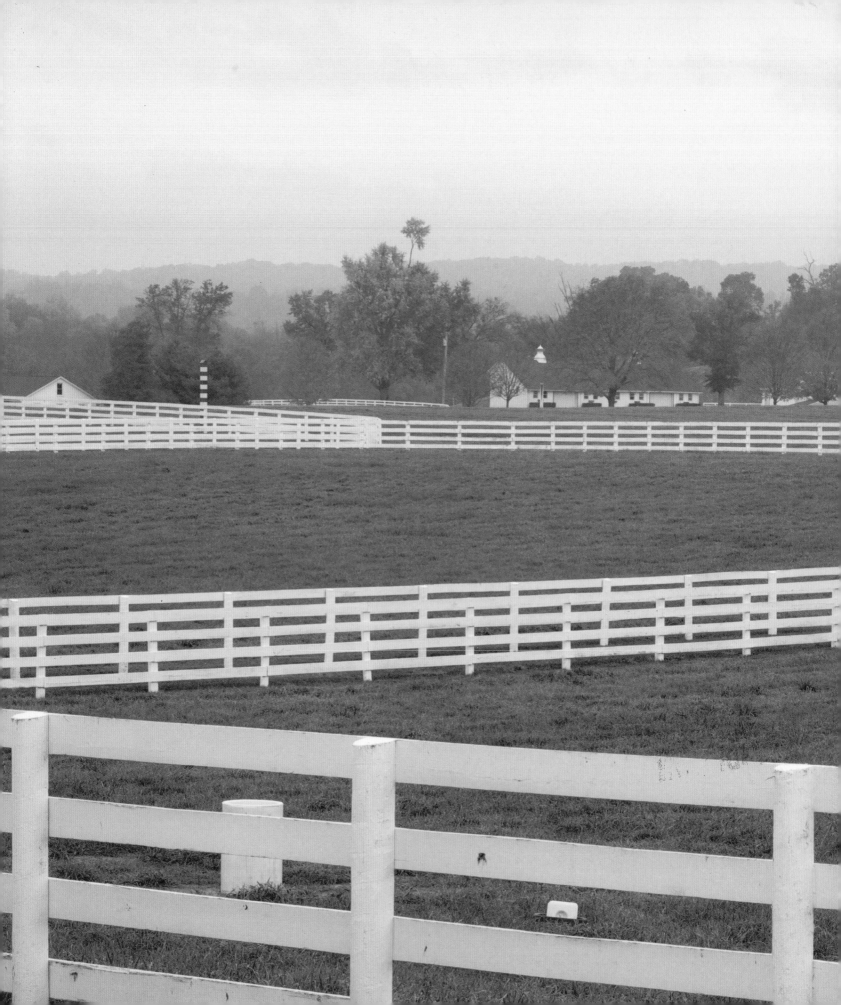